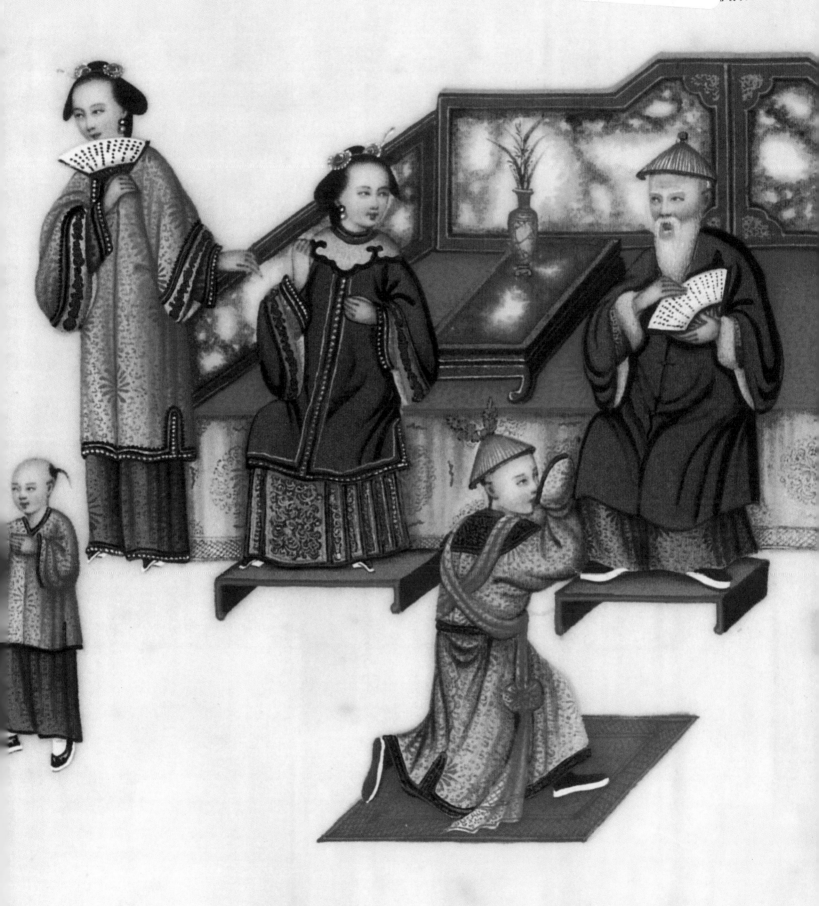

D1096139

AWN

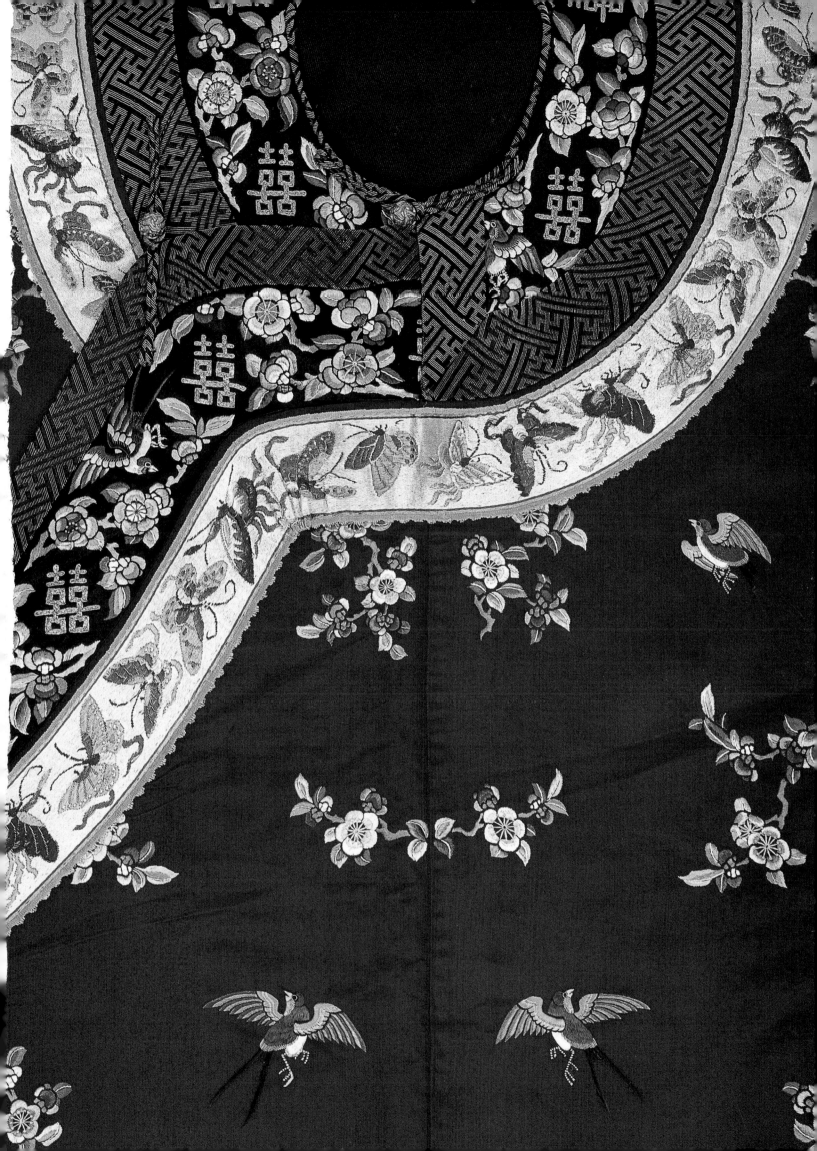

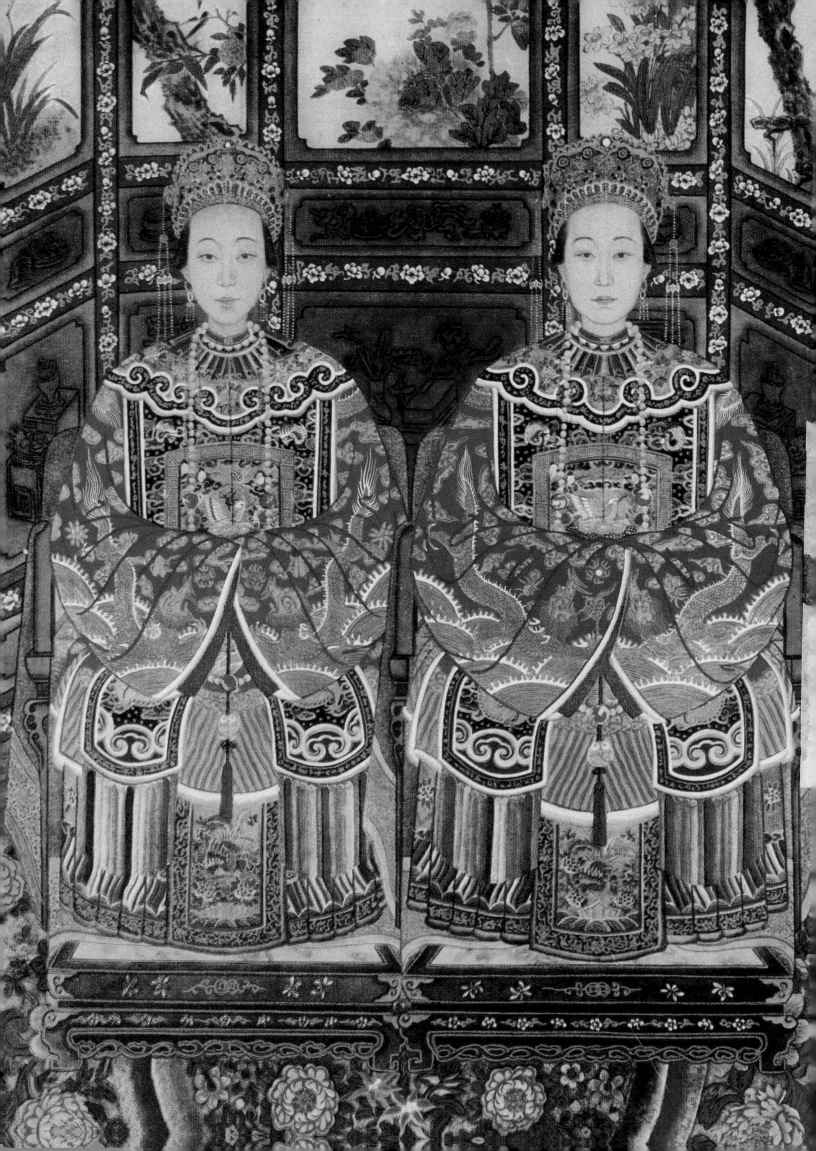

# CHINESE DRESS

## FROM THE QING DYNASTY TO THE PRESENT

Valery Garrett

TUTTLE PUBLISHING
Tokyo • Rutland, Vermont • Singapore

Published by Tuttle Publishing, an
imprint of Periplus Editions (HK) Ltd, with
editorial offices at 364 Innovation Drive,
North Clarendon, Vermont 05759, USA,
and 130 Joo Seng Road #06-01,
Singapore 368357.

Copyright © 2007 Valery Garrett

All rights reserved. No part of this publi-
cation may be reproduced or utilized
in any form or by any means, electronic
or mechanical, including photocopying,
recording, or by any information storage
and retrieval system, without prior writ-
ten permission from the publisher.

Library of Congress Control Number
2007921612
ISBN 13: 978 0 8048 3663 0
ISBN 10: 0 8048 3663 9

Printed in Singapore

Distributed by:
**North America, Latin America and
Europe**
Tuttle Publishing, 364 Innovation Drive,
North Clarendon, Vermont 05759, USA.
Tel: (802) 773 8930
Fax: (802) 773 6993
E-mail: info@tuttlepublishing.com
www.tuttlepublishing.com

**Asia Pacific**
Berkeley Books Pte Ltd, 130 Joo Seng
Road #06-01, Singapore 368357.
Tel: (65) 6280 1330
Fax: (65) 6280 6290
E-mail: inquiries@periplus.com.sg
www.periplus.com

11 10 09 08 07
6 5 4 3 2 1

TUTTLE PUBLISHING® is a
registered trademark of Tuttle Publishing,
a division of Periplus Editions (HK) Ltd.

**Page 1** Close-up of the neckline of a
Manchu lady's blue embroidered robe
with flowers and birds, with butterflies
and double happiness characters on
the borders.

**Page 2** Painting of two wives of a
mandarin, the bird on the rank badges
on their stoles artfully concealed by
the sleeves of their jackets to imply
a higher rank, 19th c.

**This page** Detail of a poster advertis-
ing soap and cold cream showing two
girls wearing the long cheongsam,
Shanghai, ca. 1935.

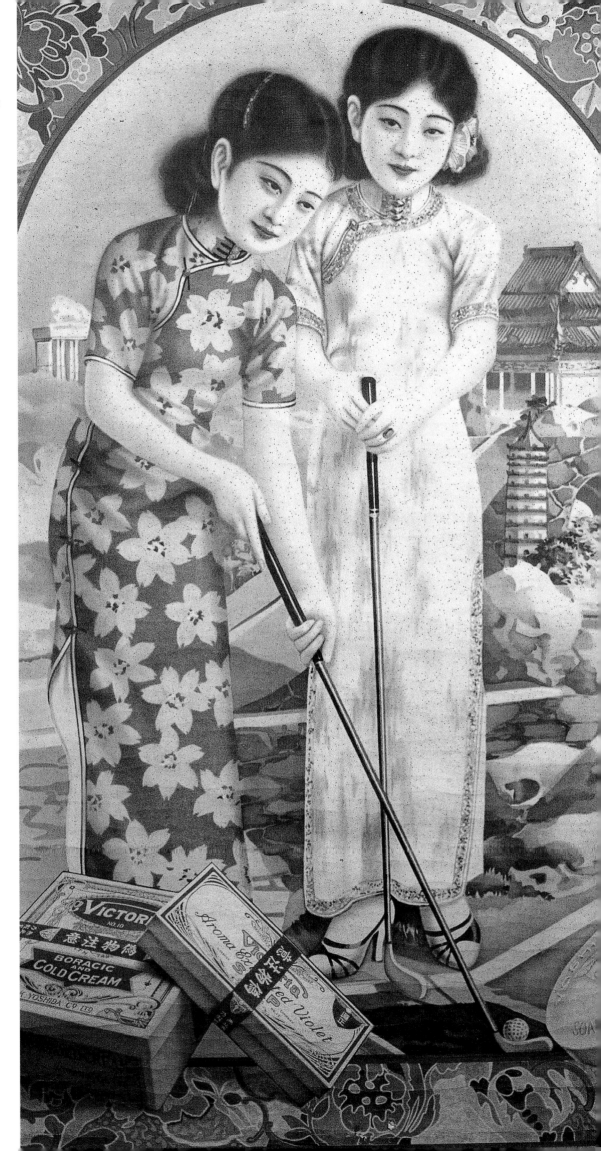

# CONTENTS

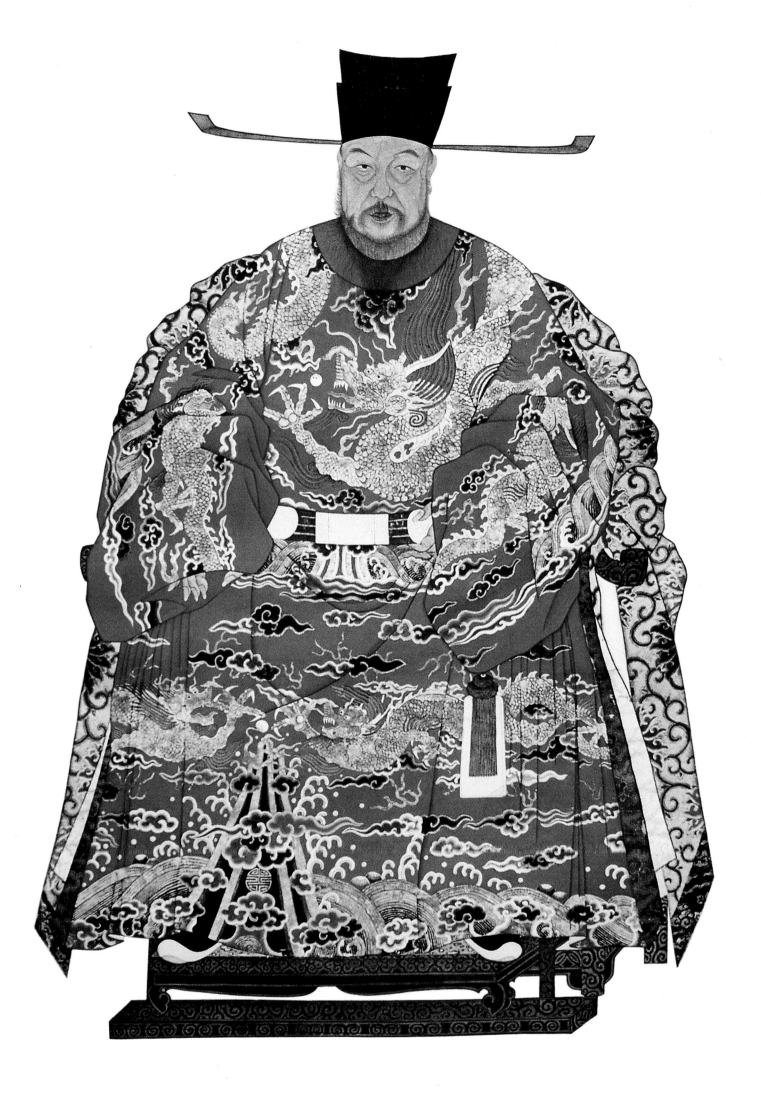

Chapter One

# THE DRESS OF THE QING MANCHU RULERS 1644–1911

## The Imperial Court

For almost 300 years, the Chinese emperors of the Ming dynasty (CE 1368–1644), cloistered inside the Forbidden City in Beijing, enjoyed a leisurely and scholarly lifestyle. After the overthrow of the Mongol-ruled Yuan dynasty, the court re-established the culture and traditions of their ancient and great civilization. Art and literature flourished, reaching a height seldom attained before or since.

But in 1644 all this would change. Despite the presence of the Great Wall, constructed in the Qin dynasty (221–206 BCE) to protect the fertile regions of central China from barbaric nomads who lived outside the wall's perimeters, invasion from the north was a constant fear during the Ming era. The greatest threat was from the Manchu, a group of settled tribesmen of Tungusic descent, as well as some Eastern Mongolian herdsmen from the region now called Manchuria. The Manchu raised reindeer, hunted, and traded sable furs and ginseng with the Ming army along the Liaodong peninsula. As a means of control, the Ming bribed the Manchu with dragon robes and silks as well as titles and favors (Fig. 1).

The supreme chieftain of all the Tungusic tribes in Manchuria was Nurhachi, who came from the Aisin Gioro clan. The first Manchurian chieftain of his time strong enough to be a great military leader, he was able to forge a new nation from people of differing origins and capabilities. By 1601 Nurhachi had organized the tribes into companies of 300 soldiers, with five companies forming a battalion, and had established a military organization known as the Eight Banners. The tribes moved around in battalions while hunting, and the system served both as a defense and a means of organizing taxes and land distribution for the whole Manchu population. On Nurhachi's death in 1626, his successor Abahai formally adopted the name Manchu for the collective tribes, and recruited Chinese border troops for the Manchu army.

By 1644 a Chinese rebel army had captured Beijing, an event that resulted in the Chongzhen Emperor (r. 1628–43) committing suicide in the palace gardens on Coal Hill behind the Forbidden City in Beijing. Ming border troops stationed on the Great Wall rushed back to defend the city. Abahai's younger brother Dorgon, who was appointed leader after Abahai's death in 1643, bribed the defending general Wu Sangui with a princely title and the promise of punishment for the rebels. General Wu allowed the Manchu through the Great Wall, and Dorgon and his army entered Beijing in June 1644, appointing his nephew, Abahai's seven-year-old son, as the first Manchu emperor, Shunzhi.

The Manchu renamed their new empire Qing, meaning "pure." Their intention was to remove the threat of invasion by taking control of the northern and western borders and to improve the quality of life by injecting better standards into an inefficient and corrupt government. During this dynasty, which would last for the next 267 years, China reached its greatest size with the inclusion of Tibet, Inner and Outer Mongolia, and Taiwan.

Once settled in the capital, the Manchu rulers divided Beijing into two cities (Fig. 3). The Chinese population was moved to the southern part or Chinese City, separated by a dividing wall, which then became the commercial hub of the capital. The larger

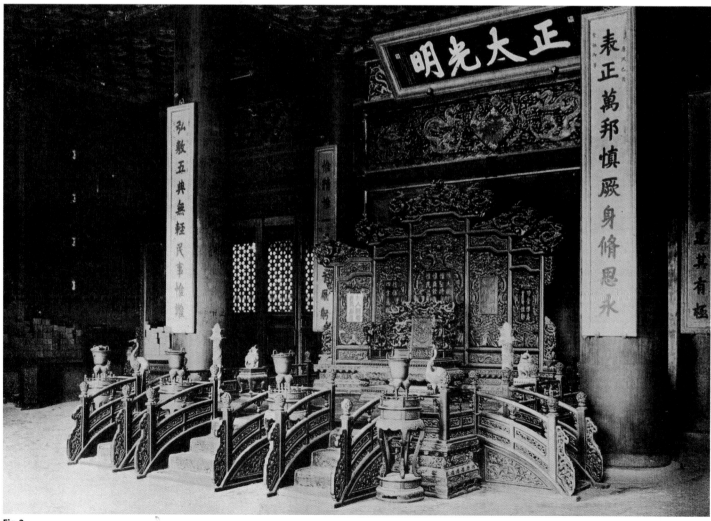

**Fig. 2**

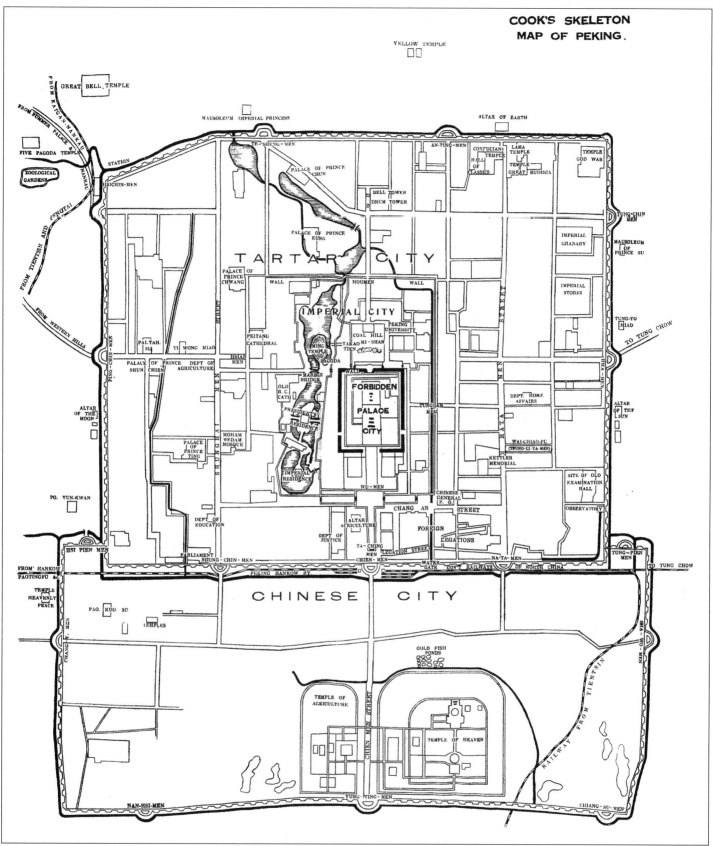

Fig. 3

---

**(Page 6)** **Fig. 1** Portrait of Wang Ao (1450–1524), a high-ranking Ming official, wearing a presentation robe with four-clawed dragons on the chest, back, down the sleeves, and around the skirt.

**Fig. 2** Imperial throne in the Palace of Heavenly Purity (Qianqinggong), one of the main palaces used by the emperors during the Qing dynasty, ca. 1910.

**Fig. 3** Map of Beijing showing the Tartar City and the Forbidden City in the center, and the Chinese City to the south of it, 1917.

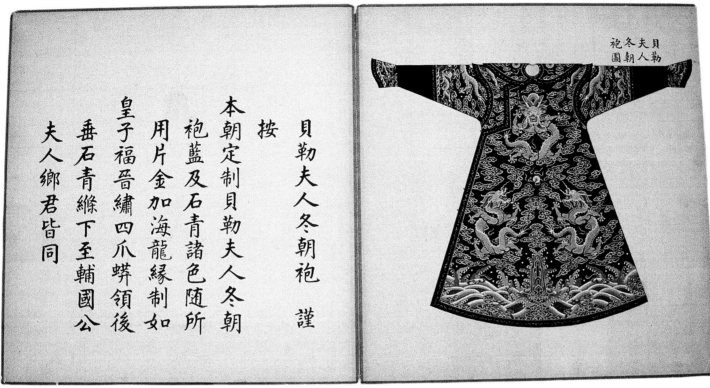

貝勒夫人冬朝袍<br>
圖朝人勒貝

夫人鄉君皆同

垂石青縧下至輔國公

皇子福晉繡四爪蟒領後

用片金加海龍緣制如

袍藍及石青諸色隨所

本朝定制貝勒夫人冬朝

按

貝勒夫人冬朝袍　謹

**Fig. 4**

northern section, known as the Tartar City, became the quarters of the banner troops, the princes' palaces, government buildings, foreign legations, temples and libraries. In the middle of the Tartar City was the walled Imperial City, with its great lakes, and at the heart of this was the Forbidden City (the "Great Within"), home to the Qing emperors.

The Forbidden City had been built during the Ming dynasty and was completed by 1420. Measuring some 3000 feet (900 meters) from north to south, and over 2300 feet (700 meters) from east to west, the high crimson-painted walls were surrounded by a moat. Entry was limited to four gates. Three of the gates led into the southern section where the main official buildings were sited. The fourth gate was situated in the rear to the north where the residential section consisted of many palaces separated by courtyards. Here were the private quarters of the emperor, his consorts, concubines, eunuchs, and children.

The southern section of the Forbidden City was the center of Qing government where matters of court and state were handled. Here were the government departments, the offices of the Imperial Household, the storehouses, workshops and stables, and the huge public halls and courtyards where government officials assembled for an audience with the emperor.

Within this section were three great ceremonial halls, set one behind the other. The largest and most notable was the Hall of the Supreme Harmony (Taihedian). This was the setting for important state events, such as the festivities at the Lunar New Year, the emperor's birthday, and most momentous of all, the emperor's enthronement, an occasion so sacred that his ascent of the throne was veiled from the gaze of such mere mortals as the nobles and officials waiting outside.

Many of the day-to-day affairs of state were dealt with in the halls and palaces to the rear of the ceremonial halls (Fig. 2). Within this compound was the emperor's office where he attended to routine matters and gave daily audience to officials. Here, too, were the emperor's private quarters, including his bedchamber. The emperor was the only male to spend the night in the Forbidden City, attended by female servants and eunuchs chosen for their inability to sire children and thus ensure the purity of the progenitor. Recruited from poor Chinese families, the 3000 eunuchs came to hold great power: they were the emperor's immediate attendants and were responsible for controlling household affairs.

## Manchu Dress Regulations

By 1759, the Qianlong Emperor (r. 1736–95), concerned that Manchu customs were being subsumed and diluted by Chinese ways, commissioned a massive work entitled *Huangchao liqi tushi* (Illustrated Precedents for the Ritual Paraphernalia of the Imperial Court), which was published and enforced by 1766. Its eighteen chapters laid out regulations covering such subjects as ritual vessels, astronomical instruments, and the regalia used in governing and on state occasions. In particular, there was a long section on the dress of the emperors, princes, noblemen and their consorts, as well as Manchu officials and their wives and daughters (Fig. 4). It also included dress codes for those Han Chinese men who had attained the rank of mandarin and were employed in the service of the Manchu government, and their wives, as well as those waiting for an appointment.

Clothing was divided into official and non-official wear, and then subdivided into formal, semiformal, and informal. Official formal and semiformal clothing would be worn at court, while official informal dress was intended when traveling on official business, when attending some court entertainment, and during important domestic events. Non-official formal dress was worn for family occasions.

There were also rules indicating what to wear in each season, and when to change clothing for the next season. Changes were made from fine silks in summer through to padded or fur-lined

satin for winter, and from one season to another on a set day, the timing being dictated by the Official Gazette from Beijing. This stated the month, day, and hour that the emperor would change his clothing from winter to summer and vice versa. At this time, all those wearing official dress had to follow suit and penalties were imposed on those who failed to comply.

Ritual worship was one of the most important obligations of the emperor and his governing officials. A strict dress code was observed in elaborate ceremonial sacrifices performed by emperors to Heaven and Earth and to the ancestors of the dynasty, as well as those rituals carried out by local government officials and senior family members. The emperor's responsibilities for ensuring the well-being of his people were tied to the performance of these ceremonies. If an emperor ruled well, Heaven, which cared about the welfare of the people, would smile on Earth, and send good weather and abundant crops. If he were incompetent or corrupt, drought, famines, and floods would devastate the land. This gave the people the right to rebel and overthrow the emperor, with the "mandate of Heaven" passing to his successor.

Robes decorated with dragons were first recorded in the Tang dynasty (618–906) and again in the Song (960–1279). Because the Mongols who ruled China during the Yuan dynasty (1279–1368) had formally sanctioned the use of dragon robes, the Ming deliberately did not adopt the robe officially. Despite this, dragon robes were worn, especially as informal wear. Dragon robes became very fashionable in the early years of the sixteenth century with many officials ordering them freely, and ignoring the laws of 1459 which forbade anyone from having dragon robes made for himself, and regulations were eventually codified for lower-ranking noblemen and officials.

The Manchu were already familiar with robes decorated with dragons, as these had been presented to them both as gifts and bribes by the Ming court. Thus, despite their determination to impose their own culture and customs on the conquered Chinese, they did adopt the decorative patterns of the dragon robe, if not its shape. The Manchu, having been hunters, had developed their own style of clothing from the skins of the animals they caught. The sedentary lifestyle dictated by the ample Ming robes was abhorrent to the Manchu, and they reworked the cumbersome and impractical robe into a slimmer Manchu style to suit their more active way of life.

The symbolic properties of the five colors favored by the Ming continued to have much the same significance for the Manchu. Yellow denoted center and the earth. Blue represented spring and the east, and the Manchu adopted this as their dynastic color. White represented autumn and the west, but this was considered an unlucky color to wear, as it was associated with death. Black stood for winter and the north. Red symbolized summer and the south, but this color was generally avoided as it had been the dynastic color of the Ming, and so was only worn occasionally by the

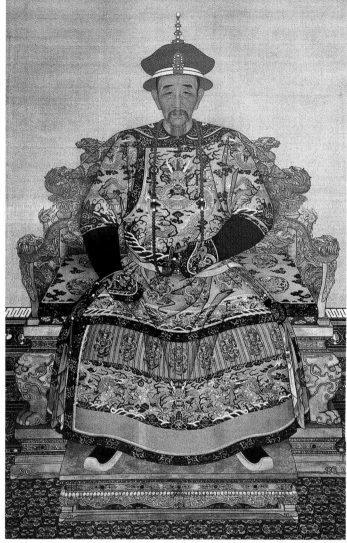

**Fig. 5**

emperor for the annual sacrifice at the Altar of the Sun. However, the Han Chinese considered it a lucky color because of its connections with the Ming rulers, and it was used extensively at weddings and other celebrations.

The colors of the robes were carefully controlled and certain ones were restricted for use by the emperor and his immediate family (Fig. 5). Bright yellow, representing central authority, was reserved for the emperor, although he could wear other colors if he wished or as occasion demanded, such as when worshipping at the ceremony at the Altar of Heaven when he wore blue robes. The heir apparent wore "apricot yellow," while sons of the emperor wore "golden yellow", *jin huang*, which was, in fact, more of an orange. First to fourth degree princes and imperial dukes wore blue, brown, or any colour unless "golden yellow" was conferred by the emperor. Lower-ranking princes, noblemen, and high-ranking officials wore blue-black.

**Fig. 4** Painting on silk from the Regulations showing the second style of summer court robe and flared collar for the wife of an imperial duke.

**Fig. 5** Portrait of the Kangxi Emperor (r. 1662–1722) in full summer court attire, his yellow satin robe (with matching collar) edged with brocade and decorated with dragons over the chest and back, and with a row of roundels above the band on the skirt. A yellow silk girdle, from which hang purses and kerchiefs, is tied around the waist. A court necklace and a conical-shaped hat with thick red floss fringing and a tall gold finial studded with sixteen Manchurian pearls, completes his outfit.

## Court Attire

The *chao pao* or court robe was the most important of all robes and was worn for momentous ceremonies and rituals at court. Its use was restricted to the highest in the land: members of the imperial family, princes, nobles, dukes, and high-ranking mandarins at court. Together with the collar, hat, girdle, necklace, and boots, the *chao pao* formed the *chao fu*, literally "court dress," and was designated official formal attire.

Ming robes were already familiar to the Manchu as gifts in exchange for tribute to the Ming court. Despite their determination to establish their own culture and customs, they did adopt the pattern of the Han Chinese dragon robes, if not the style of them. To form the *chao pao*, the Manchu, for example, imposed some of their nomadic features on the Ming robes, reducing their bulk. The garment was cut across the middle just below the waist. The upper part was made narrower below the arms and became a short side-fastening jacket with a curved overlapping right front, which could have derived from animal skins added for extra covering and protection. It was fastened with loops and buttons, another nomadic practice. The lower skirt was reduced in width to fit the upper part by folding it into a pair of pleated aprons joined to a narrow waistband which attached to the jacket. This modified form continued to give the necessary impression of bulk traditionally associated with festival dress, but resulted in a less cumbersome garment. At the side of the waistband was a small square flap called a *ren*, whose original function, it is thought, was to disguise the fastening.

Like Ming court robes, early Qing robes were decorated with a large dragon on the front curling over one shoulder, with another on the back curling over the opposite shoulder. A band of dragons above mountain and wave motifs encircled the pleated skirt. According to the Regulations, court robes for the emperor and crown prince should have a row of nine or seven roundels, respectively, containing coiled dragons above the band of dragons on the front and back of the skirt. No one else was allowed to wear roundels on the skirt, although they did make an appearance on robes belonging to the lower ranks towards the end of the dynasty.

The Twelve Symbols of Imperial Authority, explained in more detail below, were avoided at first by the Manchu as being associated with the Ming and preceding Chinese dynasties. The Qianlong Emperor reintroduced them in 1759, when they first appeared on court robes and were later extended to the less formal dragon robes.

Another standard feature of Manchu robes was the alteration made to the long, wide sleeves of the Ming robes. The sleeves were cut above the elbow and the lower portion replaced with plain or ribbed silk, thought to have evolved so that the wearer could bend his arms more easily when hunting. The ribbed silk indicated the folds that occurred when the sleeves were pushed up the arms. Cuffs resembling horses' hooves, originally made to protect the hands when riding in bad weather, continued to cover the hands on formal occasions during the Qing dynasty, when it was considered impolite to expose them.

There were three styles of men's court robe: two for winter wear and one for summer. The first style of winter *chao pao* was lined and

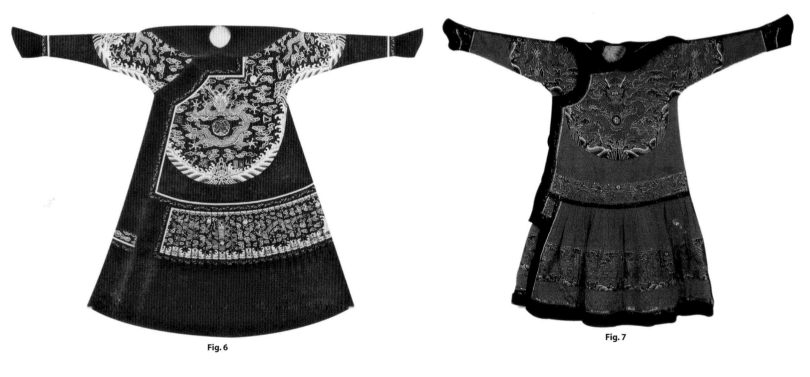

Fig. 6                                                      Fig. 7

---

**Fig. 6**  Painting on silk from the Regulations showing the emperor's first style of winter court robe, with the Twelve Symbols of Imperial Authority on the upper part. The robe is faced with sable on the cuffs, collar, and side opening and forms a deep band of the fur on the hem.

**Fig. 7**  Second style of winter court robe, in red satin trimmed with otter, worn for the sacrifice at the Altar of the Sun, early 18th c.

**Fig. 8**  Woodblock printed page from the Regulations showing the emperor's summer court robe and flared collar.

**Fig. 9**  Summer court hat of a prince, with a gold and pearl finial.

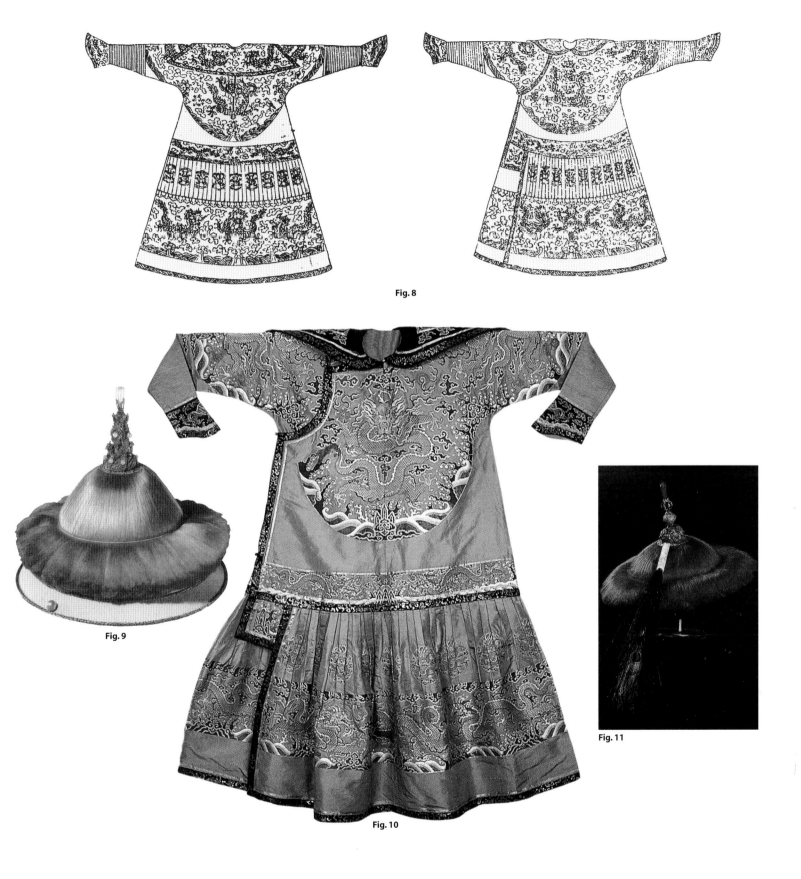

**Fig. 8**

**Fig. 9**

**Fig. 10**

**Fig. 11**

**Fig. 10** Emperor's summer court robe in yellow silk brocade with a front-facing dragon on the chest grasping the pearl of wisdom, nine small roundels on the front and back of the skirt above the panel of two profile dragons and one front-facing dragon, and a flared collar attached to the robe, early Qianlong, mid-18th c. The Twelve Symbols, missing on this robe, did not make an appearance until after 1759 when they were prescribed for use on the emperor's court robes.

**Fig. 11** Winter court hat of a high-ranking official, with a finial and "double-eyed" peacock feather plume, the latter awarded on merit by the emperor, 19th c.

lavishly faced with sable on the cuffs, side-fastening edge, and collar, and was trimmed with a deep band of fur round the hem (Fig. 6). Because of the amount of fur required – and its scarcity – this style was restricted to use by the imperial family, the first three ranks of civil mandarins, and the first two ranks of military mandarins. The second style of winter *chao pao* and the summer one were the same in design, the only difference being in the fabrics used. The winter style was trimmed with otter fur, whilst the summer robe was made of satin or gauze and edged with brocade (Figs. 7, 8, 10).

A flared collar known as a *pi ling* was worn around the neck. This feature may have developed from a hood, opened out along the top of the crown to extend beyond the shoulders. The *pi ling* matched the robe in style and fabric, being embroidered or woven in brocade or *kesi* (literally "cut silk," a fine tapestry weave). Dragons were dispersed across the main field, with one facing the front and four in profile above a sea wave base with a border around the edge corresponding to the edging on the court robe. It was attached to the neck of the court robe or fastened independently.

A hat was the most significant and visible part of official dress and as such was worn on every public occasion. Indeed, the codes

for hats precede each set of Regulations for court dress, indicating the importance of headwear for both men and women. Official hats were subdivided according to season and worn with the requisite official robes. Summer hats were worn from the third month of the lunar calendar until the eighth month when they were replaced by winter ones. The emperor, princes, noblemen, and high officials wore a court hat (*chao guan*) with formal court attire. For winter, this had a turned-up brim of sable or fox fur and a padded crown covered in red floss silk teased at the edges to make it stand out (Fig. 11). For summer, the hat was conical in shape to shield the face from the sun. It was made of finely woven split bamboo covered with silk gauze edged with a narrow band of brocade, with a circle of brocade at the apex for the hat finial to rest upon. A fringe of red floss silk covered the crown from apex to edge (Fig. 9).

The insignia on top of the hat was its most notable accessory. Dating back to 1636, before the conquest of the Ming, Manchu laws recognized the advantages of a readily visible means of identification for the different ranks of officials (Fig. 12). For the imperial family, the insignia was in the form of a tall, gold finial intricately adorned with dragons, images of the Buddha, and tiers of pearls, the number of tiers depending on the importance of the wearer.

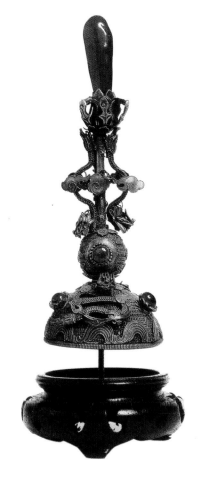

**Fig. 12**

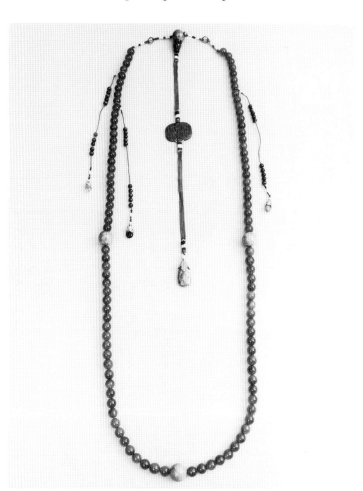

**Fig. 13**

**Fig. 12** Gilt silver filigree hat finial for a prince or nobleman with red clear glass stones *en cabochon* to simulate polished ruby gemstones, and an additional collar of clouds and vertically facing dragons, ca. 1800.

**Fig. 13** Court necklace of amber beads interspersed with four jade beads, the counting strings and counterweight made of lapis lazuli.

**Fig. 14** Emperor's formal court *chao dai* with wide blue silk streamers for wearing with the *chao fu*. Suspended from side rings on the yellow woven silk girdle is a pair of drawstring purses, a knife purse, and a toothpick case.

**Fig. 15** Emperor's yellow felt boots decorated with pearls and coral beads, the tops embroidered and edged with brocade.

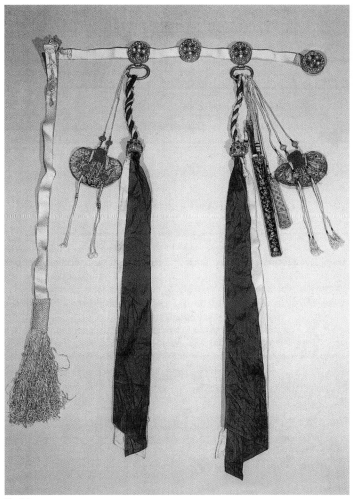

**Fig. 14**

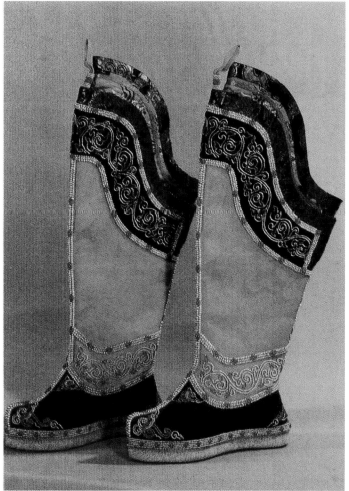

**Fig. 15**

The *chao zhu* or court necklace developed from a Buddhist rosary sent in 1643 by the Dalai Lama to Shunzhi, who became the first Qing emperor. The necklace comprised 108 small beads with four large beads of contrasting stone representing the four seasons, placed between groups of 27 beads (Fig. 13). These necklaces had a practical purpose too: for rapid – and private – calculations if no abacus were to hand. A long drop extension, down the back, served as a counterweight as well as an ornament. The Manchu also added three counting strings – two on the left and one on the right. The court necklace worn by the emperor was made of Manchurian pearls, coral, and jade, while necklaces worn by other members of the imperial family were made with any semiprecious stones other than pearls.

Another form of rank identification for both the Ming and Manchu was the *chao dai* or girdle, and the ornamental plaques embellishing it. While the Ming court favored a stiff, hooped leather belt ornamented with jeweled plaques, the Manchu girdle was made of tightly woven silk. Since there were no pockets in the robes, girdles were worn tightly belted over the robe around the waist to carry the articles which were frequently needed. These girdles were also a symbol of status and thus were mentioned in the Regulations, the colors being appropriate to the color of the robe and to the status of the wearer.

The Manchu girdle was also adorned with two ribbons or ceremonial kerchiefs, a pair of drawstring purses, a knife case, and other items hanging from it (Fig. 14). When worn with the *chao fu*, the kerchiefs were wide and pointed at the end. Because the Manchu had been a nomadic race, it is thought that the girdle and kerchiefs

were originally made of a stronger material, such as woven hemp, and could have replaced a broken bridle if necessary. The girdle was covered with four ornamental plaques made of gold or silver set with semiprecious stones or other materials, plus center ones forming an interlocking belt buckle.

The drawstring purses of the Manchu harked back to their nomadic origins, since such purses had developed from a circle of leather gathered up to contain pieces of flint needed to strike a flame for a fire. Once settled in China, the Manchu emperors stored areca (betel) nuts in them. The purses also held scented cotton or aromatic herbs to sweeten the sometimes putrid air.

Later, as the Manchu became more established, items suggesting a more leisurely and scholarly existence replaced the knife case and compass. These included a fan case, *da lian* purse (used to carry valuables), spectacle case, and kerchief holder, although the original drawstring purses were retained.

To match his yellow silk court robes, the emperor wore knee-high yellow silk brocade or felt boots decorated at the cuff and on the vamp with black brocade trimmed with rows of seed pearls and coral beads (Fig. 15). The thick soles were made of layers of felted paper with a final layer of leather, and whitened round the edges. A loop at the top of the boot allowed a garter to be passed through to prevent the boot from slipping down the leg. The inflexible soles originally allowed the Manchu wearer to stand up in the stirrups when on horseback, but the soles were made shorter than the uppers at the toe for ease of walking. For informal wear, the emperor wore plain black satin knee-high boots, which were also worn for general use by princes and noblemen.

## Dragon Robes

Despite the early reluctance of the Manchu to wear the same kind of robes as their Ming predecessors, by the reign of the Kangxi Emperor (r. 1662–1722) the use of richly ornamented dragon robes for semiformal court occasions and official business was widespread in China. Because dragon robes were also worn by lower-ranking officials as well as members of the imperial family, they are the most common type of official robe to survive from the Qing dynasty, particularly as the high status of court robes meant they were used as burial wear. Dragon robes were known as *ji fu* or festive dress, a term of great antiquity, which suggested their considerable importance.

The Qing dragon robe was a full-length coat with sleeves and a curved overlapping right front, much like the top half of the *chao pao*. Its shape is believed to have derived from the use of animal skins, two at the front and one at the back. To make it easier to ride in, the Manchu added slits at the center seams, at the front and back hem, to those already at the sides. Like the court robe, the dragon robe was worn belted, but with the streamers narrower and straighter, and with purses containing daily necessities hanging from the girdle.

Circular roundels depicted imperial status and were a continuation of the Ming tradition. For the higher ranks, early robes displayed eight roundels containing front-facing *long* (five-clawed dragons), while side profiles of either *long* or *mang* (four-clawed dragons) were depicted on robes of the lower ranks. The original Ming arrangement, whereby the roundels were positioned in the center of the skirt, did not suit the Qing robe with its slits at the front and back seams of the skirt (Fig. 16).

Prior to the 1759 Regulations, the court was free to decide for itself the pattern of these less formal robes, as long as they were cut in the Manchu style and complied with the laws regarding color and the number of dragon claws. The distribution of dragon motifs was not regulated and early robes continued the Ming tradition of having large curling dragons over the chest and back.

The most common robes, however, were those with dragons dispersed over the entire surface of the garment. For the emperor and princes, nine embroidered dragons were *de rigueur*: one on the chest, back, and each of the shoulders, and two above the front hem and back hem. The dragons on the upper part of the robe were usually facing the front, while those on the lower skirt were in profile. By the mid-eighteenth century, the size of the upper dragons became smaller and the lower dragons bigger, until on most robes they were the same size (Figs. 18, 19). The symbolic ninth dragon was placed on the inside flap of the robe. The number nine, and the fact that the ninth was hidden, had important symbolic connotations that drew on knowledge of the relationship between tenant and landlord, known as the "well-field system." The Chinese character for "well" is written as two vertical lines crossing two horizontal lines, creating nine equal compartments. Eight farmers worked each of the eight fields around the perimeter, while all helped to farm the central ninth field (Vollmer, 1980: 22).

Robes with five-clawed dragons, known as *long pao*, continued to be the prerogative of the emperor, heir apparent, and high-ranking princes, although the emperor could bestow this honor on lesser officials if he wished. *Mang pao* or four-clawed dragon robes were worn by third-ranking princes and below. Towards the end of the Qing dynasty, when many laws were disregarded, most

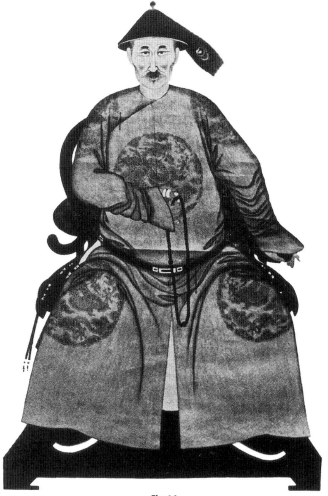

**Fig. 16**

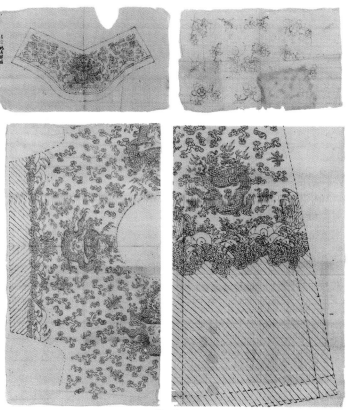

**Fig. 17**

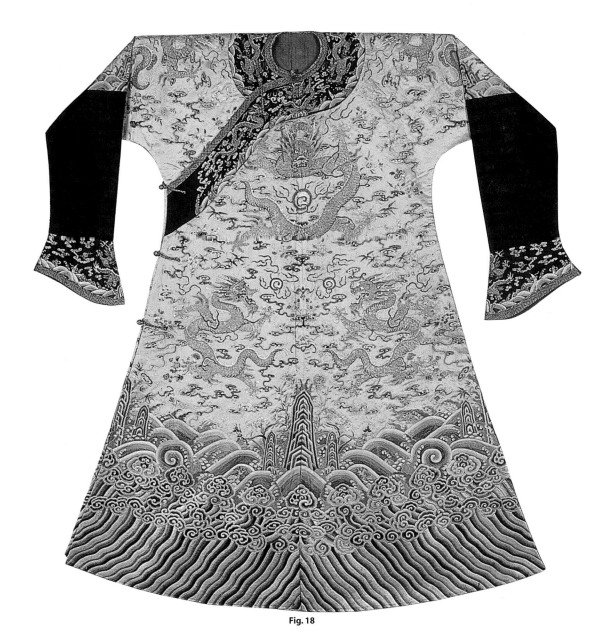

**Fig. 18**

robes were of the five-clawed variety, along with the hidden ninth dragon, and worn by all the ranks, as it was unthinkable to be seen wearing the four-clawed dragon. Colors for the *long pao* and *mang pao* were in accordance with those for the *chao pao*. The emperor wore yellow, the heir apparent and the emperor's sons wore shades of yellow, and lower-ranking princes and noblemen wore brown, blue, or blue-black (Fig. 20).

Scattered around the dragons on the robe were cloud patterns, and at the hem, waves, stylized mountains, and *li shui*, the diagonal stripes of the five colors representing deep, standing water. In the early part of the dynasty, the mountains were towering and bold, but later became stunted and unnatural, while the *li shui* became much longer and the waves more dominant. By the end of the

nineteenth century, the background of the robe was cluttered with a multitude of symbols and lucky charms, especially the Eight Buddhist and the Eight Daoist emblems: "The *ch'i-fu* [*ji fu*] is a schematic diagram of the universe…. The lower border of diagonal bands and rounded billows represents water; at the four axis of the coat, the cardinal points, rise prism-shaped rocks symbolizing the earth mountain. Above is the cloud-filled firmament against which dragons, the symbols of imperial authority, coil and twist. The symbolism is complete only when the coat is worn. The human body becomes the world axis; the neck opening, the gate of heaven or apex of the universe, separates the material world of the coat from the realm of the spiritual represented by the wearer's head" (Vollmer, 1977: 50).

**Fig. 16** Manchu nobleman wearing a robe with eight roundels and dragons in profile, mid-18th c.

**Fig. 17** Cartoon for a dragon robe. One piece contains the drawing for the skirt up to the base of the front-facing drag-on on the chest and back. The upper piece shows the chest and back drag-ons, shoulder front-facing dragons, *li shui* at the sleeve edges, and a line drawn across to indicate the shoulder fold. The overall finished measurement of the robe would have been 60 inches (154 cm) long and 24 inches (61 cm) from center front/back to sleeve edge. The cuff was drawn on paper 12 inches (30 cm) high and 20 inches (52 cm) wide; only the neckband is missing.

**Fig. 18** Yellow satin dragon robe embroidered with nine five-clawed dragons in a natural setting of flowers above wavy *li shui* and the halberd, a rebus for "rise up three grades," first half 18th c.

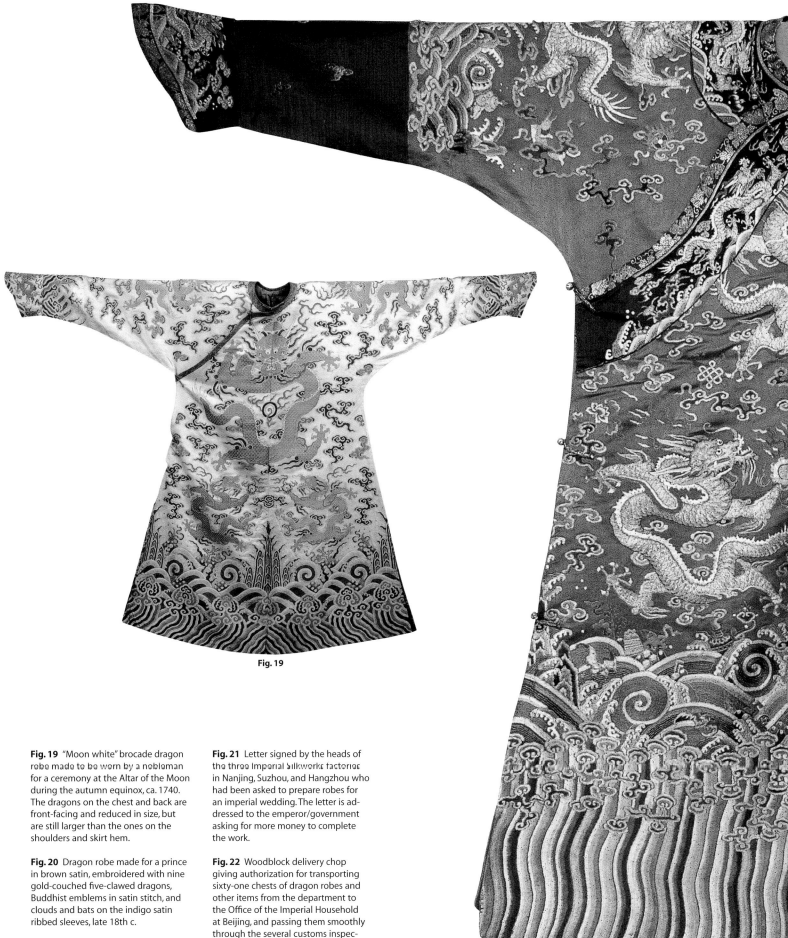

Fig. 19

Fig. 20

**Fig. 19** "Moon white" brocade dragon robe made to be worn by a nobleman for a ceremony at the Altar of the Moon during the autumn equinox, ca. 1740. The dragons on the chest and back are front-facing and reduced in size, but are still larger than the ones on the shoulders and skirt hem.

**Fig. 20** Dragon robe made for a prince in brown satin, embroidered with nine gold-couched five-clawed dragons, Buddhist emblems in satin stitch, and clouds and bats on the indigo satin ribbed sleeves, late 18th c.

**Fig. 21** Letter signed by the heads of the three Imperial Silkworks factories in Nanjing, Suzhou, and Hangzhou who had been asked to prepare robes for an imperial wedding. The letter is addressed to the emperor/government asking for more money to complete the work.

**Fig. 22** Woodblock delivery chop giving authorization for transporting sixty-one chests of dragon robes and other items from the department to the Office of the Imperial Household at Beijing, and passing them smoothly through the several customs inspection posts en route. The chop, which is printed in blue ink on paper, is marked with red ticks as each hurdle was safely passed.

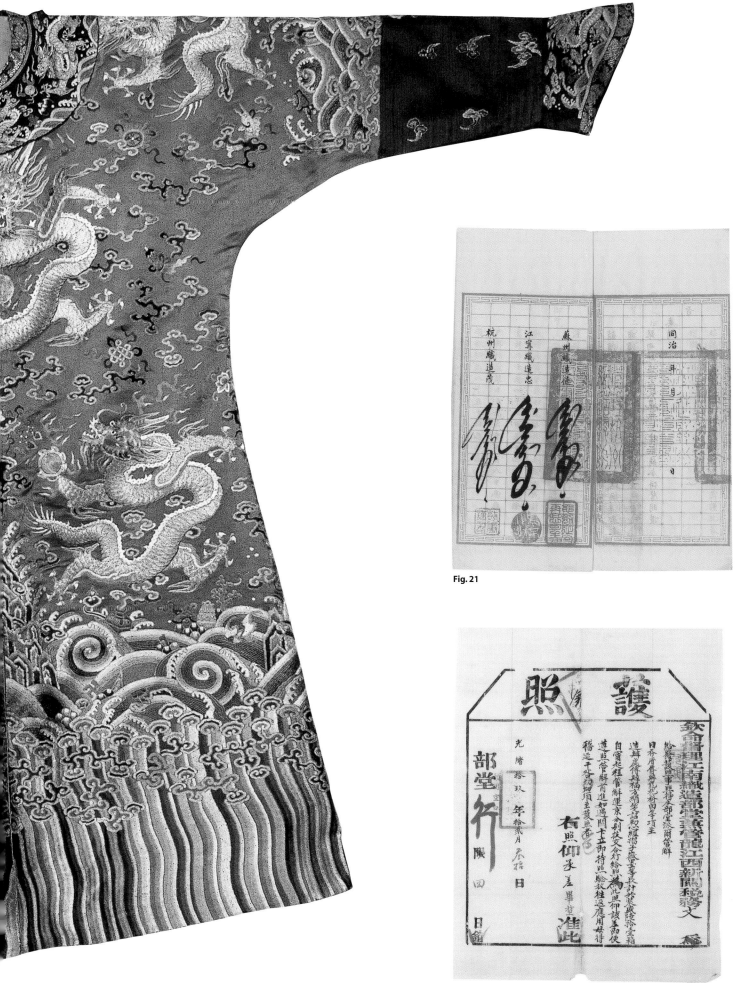

**Fig. 21**

**Fig. 22**

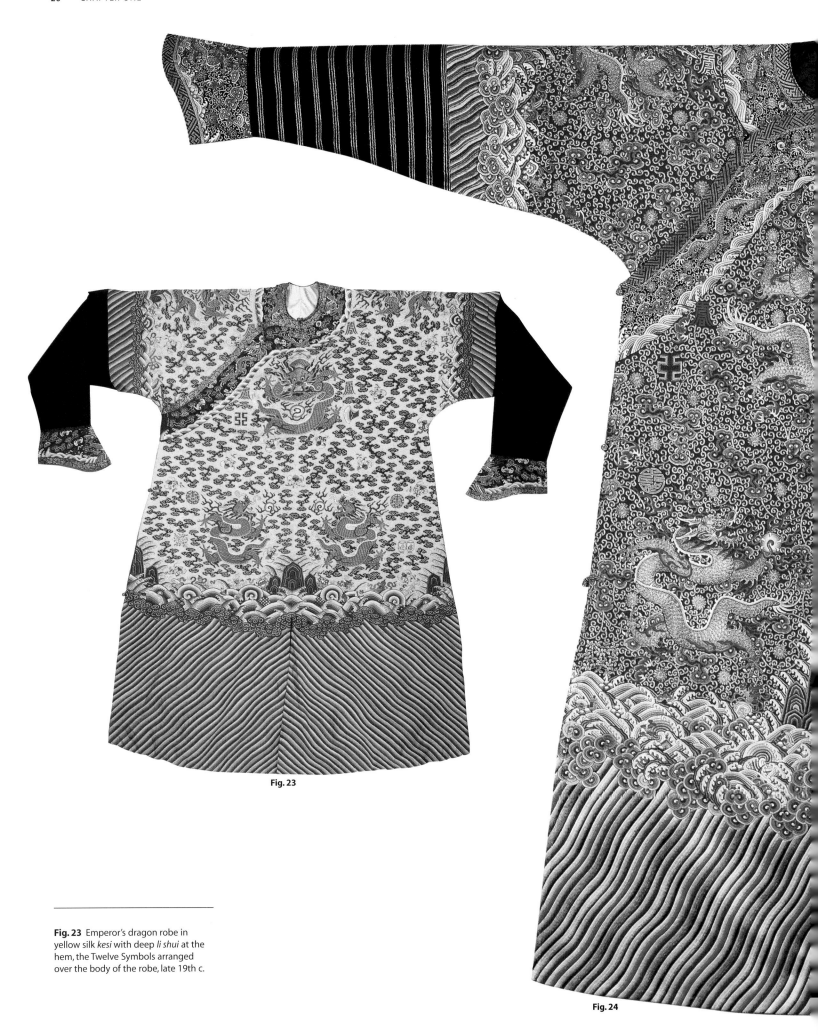

**Fig. 23**

**Fig. 23** Emperor's dragon robe in
yellow silk *kesi* with deep *li shui* at the
hem, the Twelve Symbols arranged
over the body of the robe, late 19th c.

**Fig. 24**

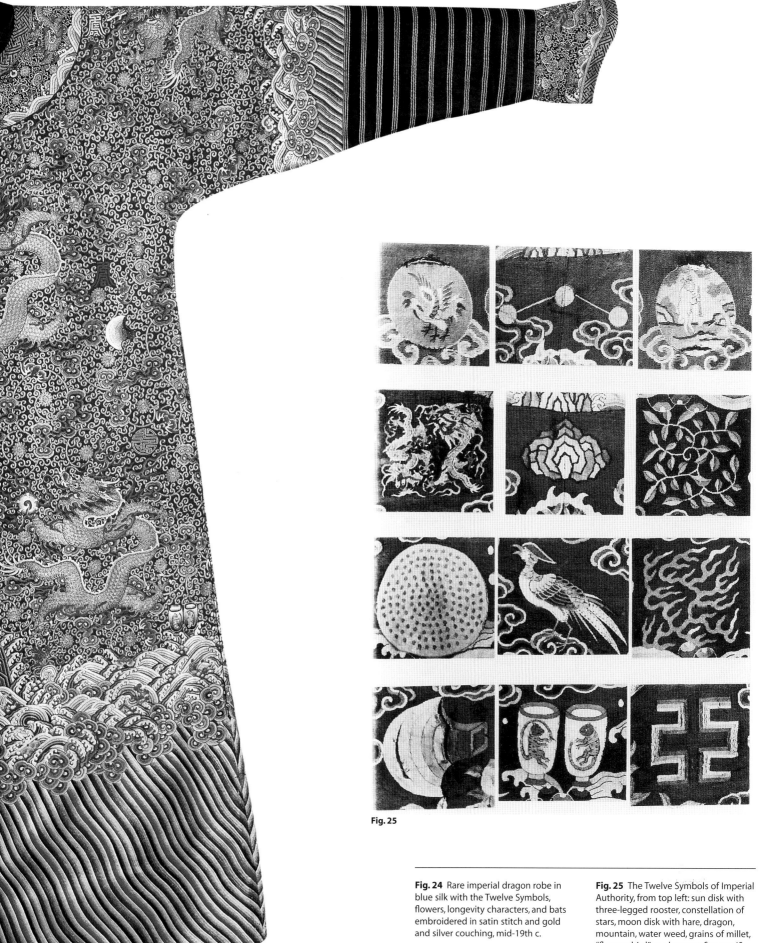

**Fig. 25**

**Fig. 24** Rare imperial dragon robe in blue silk with the Twelve Symbols, flowers, longevity characters, and bats embroidered in satin stitch and gold and silver couching, mid-19th c.

**Fig. 25** The Twelve Symbols of Imperial Authority, from top left: sun disk with three-legged rooster, constellation of stars, moon disk with hare, dragon, mountain, water weed, grains of millet, "flowery bird" or pheasant, fire, sacrificial axe, sacrificial cups, and *fu* symbol or Symbol of Discrimination.

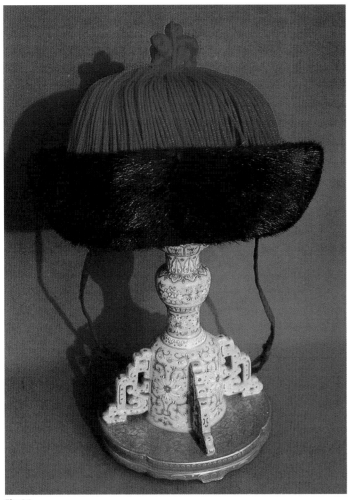

**Fig. 26**

The Twelve Symbols of Imperial Authority were the most important of all the motifs on the background of court and dragon robes, and their use was strictly confined to the emperor (Fig. 25). The full twelve symbols had first appeared in the Zhou dynasty (ca. 1050–256 BCE) on sacrificial robes, and then again in the Han dynasty (206 BC–AD 220). Placed on the outer jacket and skirt of these early robes, they assumed cosmic significance when worn, with the emperor representing the Ruler of the Universe. Six symbols were depicted on the jacket: the sun and moon disk on the left and right shoulders, the constellation of seven stars of the Big Dipper above the mountain on the back, and dragons and pheasants on each sleeve. A further six symbols were placed on the skirt, each appearing in a pair and together forming four columns: the sacrificial cup, water weed, grains of millet, flames, sacrificial axe, and *fu* symbol representing the forces of Good and Evil. The first three symbols of sun disk, moon disk, and constellation of stars, which were now reduced from seven to three, could only be worn by the emperor (Figs. 23, 24). However, he could, if he desired, confer the right to use the Twelve Symbols on others.

Whenever the court required new dragon robes, a request was sent by the eunuchs to the Imperial Weaving and Dyeing Office, a department within the Imperial Household (Neiwufu). Set up during the reign of the Kangxi Emperor, the office supplied the patterns for the robes as well as the dyes. Some weaving was done on site, but most was carried out in studios in Suzhou, Hangzhou, and Nanjing. Branches of the Imperial Silkworks were established in these three southern cities in the Ming dynasty, although silk weaving had been carried out there for many centuries. The

Silkworks were supervised by the Office of the Imperial Household from 1652 until they went out of production in 1894.

Before an important robe was embroidered, the main design would be drawn in black ink on heavy rice paper, with one half colored in as appropriate. The panels of the robe were joined down the center seams, then the designs were transferred to the silk either by tracing them with a fine line in black ink, or by pricking the cartoon and pouncing a white powder, which was then fixed onto the cloth with an adhesive. Roller frames were not used for large, important pieces of embroidery, as the areas rolled up would be flattened and spoilt. Instead, the marked silk was stretched over a large rectangular frame and several embroiderers would sit around it to work on the design together. The important center motifs, such as the main dragons, were worked over the central seam, thereby disguising it.

For a less important robe, the outline would be drawn, but the colors simply jotted down on the appropriate areas rather than colored in (Fig. 17). The design for the late nineteenth-century dragon robe shown here has been drawn on two pieces of rice paper in ink. Not included are the lower sleeve parts, which would have been left plain. The design includes five-clawed dragons surrounded by clouds, bats, coins, the *wan* emblem (a desire to live for ten thousand years), and some of the Eight Buddhist emblems, including a pair of fish.

Regulations governed procedures at the Imperial Silkworks factories. By the laws of 1652, the Silkworks "were ordered to send annually to Peking [Beijing] two robes of silk tapestry (*k'o-ssu*) [*kesi*] with five-clawed dragons, one of yellow with blue collar and cuffs, and one of blue with dark blue collar and cuffs. These were to be sent alternately in the Spring and Fall of each year to the Palace Storehouse in Peking. At the same time, other weaving in *k'o-ssu* was forbidden" (Cammann, 1952: 117). Once the Silkworks had fulfilled their annual quota of fabrics for the imperial court, they

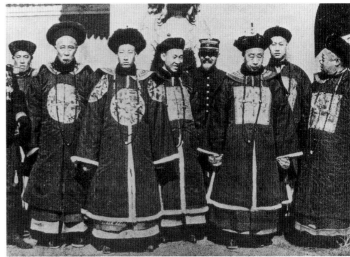

**Fig. 27**

**Fig. 26** Emperor's winter hat with a red silk knob, worn on semiformal occasions with the dragon robe. Red silk fringing or dyed red horse or yak hair was used instead of the floss silk used on the court hat.

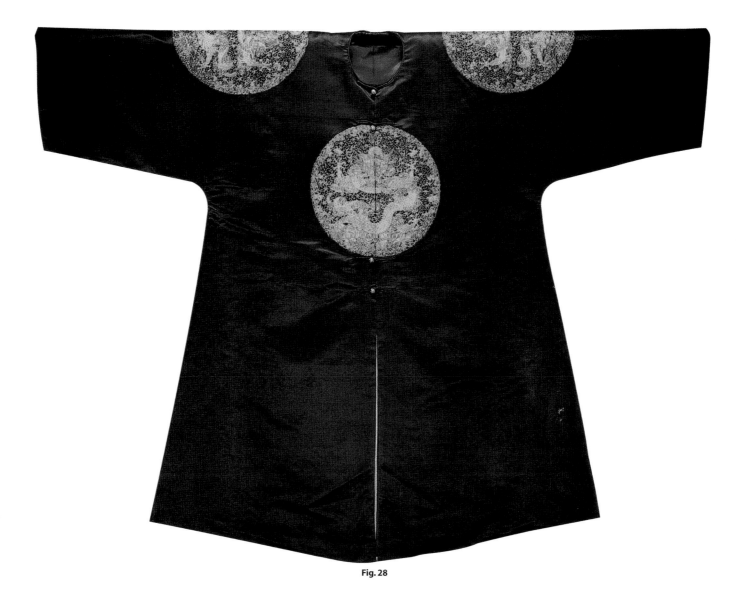

**Fig. 28**

were then free to take on other orders from wealthy families.

When the robes were completed, they were sent to the capital (Fig. 21). A delivery chop accompanied any consignment, such as the one shown here for dragon robes made in Nanjing and dispatched to Beijing in the late nineteenth century (Fig. 22). This chop was issued to a subordinate by the chief superintendent of the Imperial Silk Manufactory in Nanjing, who was concurrently a senior customs commissioner in Jiangxi province to the south. The woodblock chop gave authorization for the transportation of sixty-one chests of dragon robes and other items from the department to the Office of the Imperial Household at Beijing, and their smooth passage through the several customs inspection posts en route.

On semiformal occasions in winter, the emperor wore a winter hat (*ji guan*) topped with a red silk knob, with his dragon robe. Red silk fringing or dyed red horse or yak hair was used instead of the floss silk on his court hat (Fig. 26).

## Imperial Surcoats and Rank Badges

The circular embroidered roundel reserved for the imperial family was extended to the *gun fu* or imperial surcoat, which became official court dress after 1759 and was worn over court or dragon robes. It was a plain satin calf-length, center-fastening coat made in a color denoting rank – as with the other robes – and was mandatory wear for all who appeared at court (Fig. 27). The plain background was specially designed to show off the badges of rank displayed on it. Four circular roundels – placed at the chest, back and shoulders – were the prerogative of members of the imperial family as an indication of their status (Figs. 28–30).

These roundels on surcoats were filled with five-clawed dragons depicted facing the front for higher ranks or in profile for lower ranks. The Qianlong Emperor, who loved pomp and pageantry, added the first two of the Twelve Symbols of Imperial Authority, the

**Fig. 27** The Guangxu Emperor (r. 1875–1908, third from left in front) and members of the imperial family wearing surcoats with dragon roundels, the lower-ranking members wearing square insignia badges, ca. 1900.

**Fig. 28** Imperial surcoat with four roundels with front-facing five-clawed dragons embroidered in gold thread, with three of the Twelve Symbols: the moon on the right shoulder, the sun on the left shoulder, and the *shou* symbols on the front and back roundels, early 19th c.

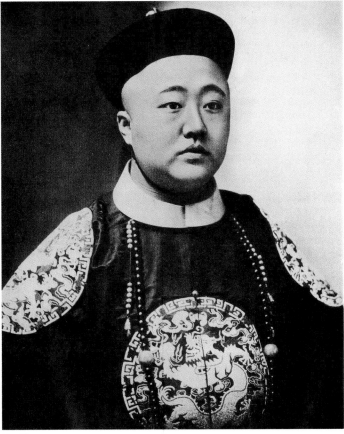

**Fig. 29**

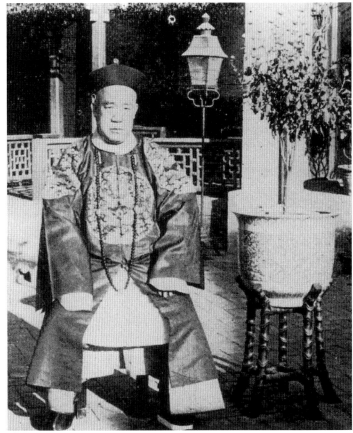

**Fig. 30**

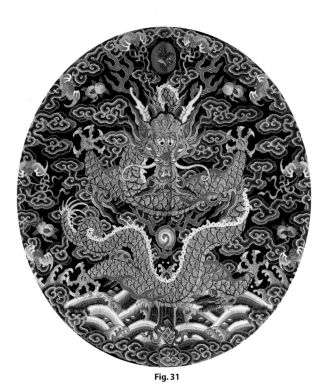

**Fig. 31**

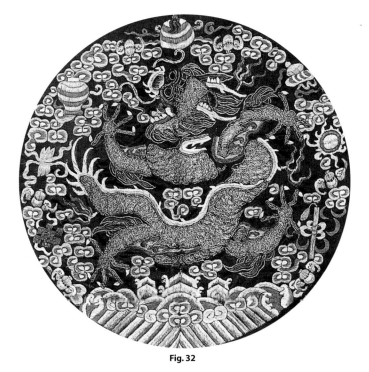

**Fig. 32**

**Fig. 29** Prince Zaixun, brother of the Guangxu Emperor, in a surcoat with four roundels containing dragons in profile, ca. 1908.

**Fig. 30** Prince Su wearing an imperial surcoat embellished with four roundels, 1905.

**Fig. 31** Roundel in *kesi* from an emperor's surcoat, featuring the sun, a cockerel, and front-facing five-clawed dragons surrounded by eight bats for happiness, the *wan* emblem, and peaches for longevity, early 19th c.

**Fig. 32** Roundel embroidered on a surcoat, bearing a five-clawed dragon in profile surrounded by bats and the Eight Buddhist emblems.

sun and moon, to the shoulder roundels on his *gun fu*, while the roundels at the chest and back contained the *shou* symbol for longevity. Beginning in the middle of the nineteenth century, the constellation of three stars was added to the front roundel and the mountain to the back one (Figs. 31, 32).

Imperial dukes and noblemen wore square insignia badges depicting the *long* or *mang* on the chest and back of the surcoat (Fig. 33). Later, towards the end of the nineteenth century, squares with hoofed dragons appeared, possibly for low-ranking noblemen not entitled to wear the clawed dragons (Fig. 34).

## Informal Robes

Official informal clothing was worn for events not connected with major ceremonies or government matters. Ordinary dress, *chang fu*, consisted of a *nei tao* or plain long gown of silk, usually reddish brown, gray or blue, cut in the same style as the dragon robe. Originally a Manchu garment designed for use on horseback, the *nei tao* had long sleeves and narrow horse-hoof cuffs to protect the hands, and center splits at the front, back and sides for ease of movement when mounting or dismounting horses. On some there was a section at the lower right side above the hem, which could be detached when riding. On more formal occasions, the cuffs would be worn down to cover the hands as it was considered impolite to expose them, but for informal occasions the cuffs could be turned back and the sleeves pushed up (Fig. 35).

During the second half of the nineteenth century, it became fashionable to wear a small, plain, stiffened collar called a *ling tou*, which fitted over the neck of the surcoat or jacket when worn with the dragon robe or informal robe. The collar was made of dark or light blue silk, velvet, or fur, according to the season, mounted onto a narrow shaped neckband (Figs. 36, 37). When the *ling tou* was made of silk or velvet, it had an extended piece, which buttoned at the front and hung down at the back and was worn inside the robe.

In 1727, the Yongzheng Emperor (r. 1723–35) issued an edict introducing a secondary kind of hat insignia to that of the hat finials, for use on less formal occasions in order to avoid confusion over ranks when insignia squares were not worn or when belt plaques, which were also an indicator of rank, were covered by the surcoat. On semiformal and informal occasions, the emperor himself wore a hat embellished with a knot of red silk (Fig. 38), while noblemen and officials wore a simpler form of round hat jewel, later known as a mandarin button (see page 70). Later, the Regulations stipulated a large pearl in a gold collar could be worn by the emperor and heir apparent on the semiformal hat, and the knot of red silk cord reserved for the informal hat. The ranks of the imperial kinsmen were expanded into a hierarchy of eighteen. Only those in the first six ranks could wear either a red-knotted button on the hat, a three-eyed peacock feather, or a circular rank badge embroidered with a dragon.

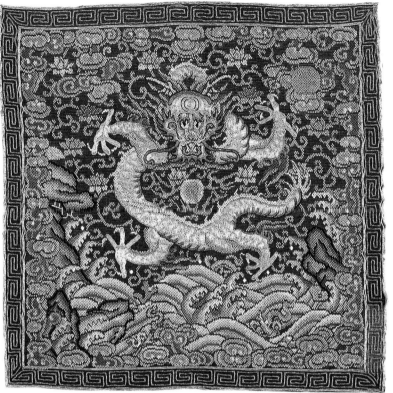

**Fig. 33**

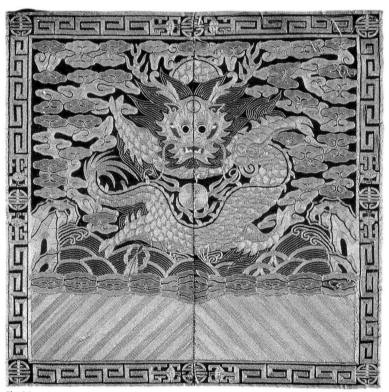

**Fig. 34**

**Fig. 33** Square insignia badge from an imperial duke's surcoat, showing a front-facing four-clawed dragon made with counted stitches on silk *gauze*, ca. 1800.

**Fig. 34** Square insignia badge embroidered in couched gold and silver thread for a nobleman's surcoat, showing an unusual front-facing hoofed dragon, mid-19th c.

## Military Uniforms

China's rulers often attempted to pacify potential aggressors with titles and sumptuous robes, but incursions and warfare followed when such tactics failed. In times of peace, emperors and high officials wore ceremonial armor on occasion as a display of might and magnificence.

The Manchu, with their history of successful conquests, placed great emphasis on military training. During their rule they established two main armies, the Manchu Ba Qi or Eight Banners, and the Chinese Lu Ying or Green Standard Army. The Eight Banners was originally an exclusively Manchu army, instrumental in the overthrow of the Ming empire. Although the Manchu system of military organization continued to be collectively called the Eight Banners, from the start of the Qing it comprised twenty-four banners made up of eight banners of Manchu soldiers, eight of Chinese soldiers, and eight of Mongolian soldiers who were direct descendants of those who had assisted in the conquest of China.

The kinsmen of Nurhachi were imperial princes descending from the first to eighth rank. Beneath them were the banner noblemen whose high status was a result of military success, followed by the rest of the bannermen. Every adult Manchu was entitled to belong to the Eight Banners and share in the benefits thereof. At the bottom of the scale were the bondservants who had often been prisoners of war, and who worked as household servants. Initially the male descendants were subsidized by the state, but as time went on and the lineage grew, these payments were reduced. Descendants of the conquest heroes were favored, resulting in a few wealthy and privileged princes with many impoverished descendants. With succeeding generations, titles were downgraded and those entitled to perpetual inheritance reduced to a very small group.

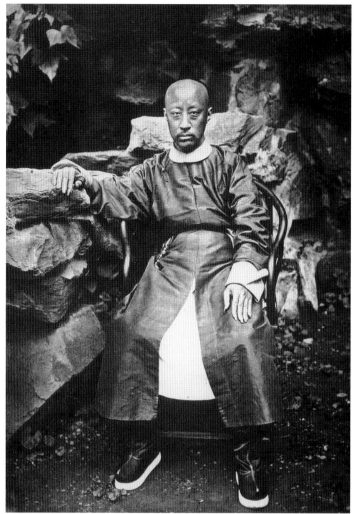

**Fig. 35**

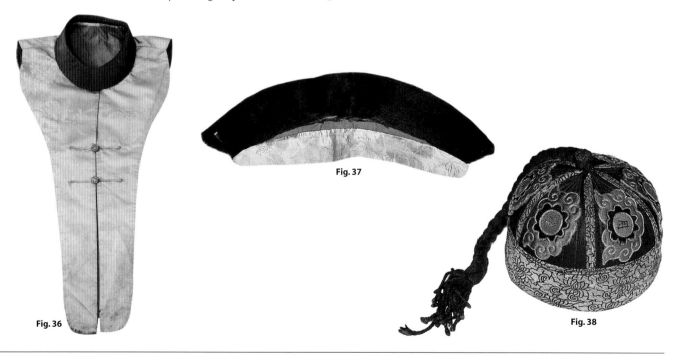

**Fig. 36**

**Fig. 37**

**Fig. 38**

**Fig. 35** Prince Gong Yixin, brother of the Xianfeng Emperor (r. 1851–61), wearing a plain long gown with the cuffs turned back informally over a plain inner gown, a *ling tou* collar and black boots, ca. 1870.

**Fig. 36** Blue silk collar worn with a surcoat, with an extended piece in cream silk worn inside the coat.

**Fig. 37** Fur collar lined in blue cotton with a blue silk neckband.

**Fig. 38** Informal skullcap in dark blue satin, appliquéd with *shou* characters and topped with a red silk knot and tassel.

**Fig. 39** The emperor, transported in a sedan chair in a procession during a grand tour of the provinces, being greeted by his subjects. The Manchu on horseback are wearing yellow *ma gua*.

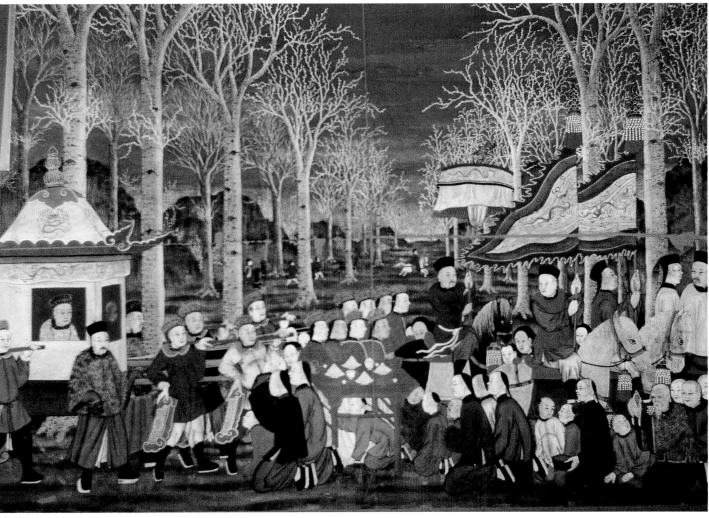

**Fig. 39**

Each of the Manchu battalions followed a *qi* or banner of yellow, white (actually a buff shade), blue, and red. These colors were based on "a mystic system whereby the yellow is made to represent the center; the red the south; and the white, the west; the north should have been black, but for this, as of bad omen, was substituted the blue; and to the east … was assigned … the green, which the native troops were directed to assume as their standard" (Wade, 1851: 252–3) (Fig. 40). In 1615, when most of northern China came under Nurhachi's rule and the army was reformed, four more banners were added by trimming the first three with red, and the red one with white.

All banner garrisons were commanded by Manchu generals, of which more than half were stationed in Beijing, the rest in walled sections of major cities throughout the empire, theoretically to control the local Chinese. These bannermen were forbidden to marry into the conquered Chinese population. Within the metropolitan areas were eight ranks of commissioned officers, both principal and subordinate, and in the provinces six ranks plus the lower-ranking non-commissioned officers and soldiers.

During the first half of the Qing dynasty, the emperors, dressed in suits of ceremonial armor, held triennial reviews of troops during which they inspected the armies to assess their strength and witnessed demonstrations of cavalry, archery, and combat techniques. Whilst these inspections did not take place on a regular basis after the reign of the Qianlong Emperor, ceremonial suits of armor remained a part of the imperial wardrobe and continued to be made, if never worn.

The armor was made of bands of copper gilt plates alternating with brocade and copper studs. The jacket and skirt were made up of loose sections held together with loops and buttons, while shoulder flaps and a center flap at the lower edge of the jacket were covered in studs. Each section was heavily padded and lined with blue silk.

Earlier suits of armor were even more elaborate, such as that worn by the Qianlong Emperor when reviewing his troops (Fig. 41). Here, the upper garment was made of yellow silk embroidered with dragons and studded all over, with more dragons around the borders at the bottom of the skirt. The emperor wore a helmet made of iron with a silver gilt inlay design of tassels and dragons topped by a tall spike with silk fringing finishing with a large pearl.

Ceremonial armor for noblemen and high-ranking officials was similar in style to that worn by the emperor, but was made of satin padded with cotton, trimmed and lined with blue silk, and covered with gilt studs. The separate sections of bodice, skirt, sleeves, shoulder capes, armpit gussets, and groin apron were fastened together with loops and buttons. The helmet, worn over a black silk padded under-hat, was made of lacquered animal hide decorated with copper gilt and topped with a silk plume. Thousands of sets were made in the imperial workshops in Hangzhou and when not worn were stored at the Western Gate of the Forbidden City.

Ceremonial armor for bannermen was made in plain silk in the color of their banner. Imperial guardsmen, whose duty it was to guard the Forbidden City, wore white satin tunics (Fig. 42), while

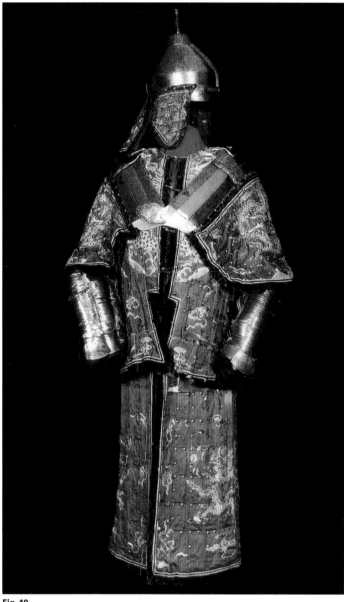

Fig. 40

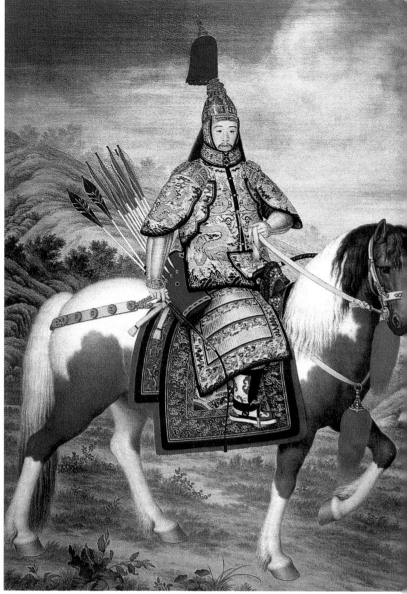

Fig. 41

cavalry brigade troops wore dark blue satin. A *ma gua* or riding jacket in the color of the banner to which a man belonged was a distinction highly coveted, and worn when accompanying the emperor on his travels. However, the highest honor bestowed by the emperor as a reward for military services was the riding jacket in imperial yellow, *huang ma gua* (Fig. 39). This was also exceptionally awarded to two foreigners: M. Giquel for military services and the establishment of the arsenal at Fuzhou, and in 1863 to General Gordon for his role in ending the Taiping Rebellion.

The uniform for a lower-ranking Manchu officer was made in the color of the banner to which he belonged. A short, loose, sleeveless jacket was worn in either the plain or bordered color of the banner over a white tunic, with stockings of the same color as the

jacket, and black cloth boots. Large banners were carried indicating the division, while smaller flags were placed in flag holders strapped to the soldiers' backs.

Dressed for battle, a soldier wore a long coat of quilted nankeen cotton or a thickly wadded jacket made of "thirty to sixty layers of tough bark-pulp paper" (Williams, 1931: 94), covered with thin plates of metal surrounded by brass studs. A girdle round the waist held a knife and chopsticks in an attached case, and a purse for tobacco. A box carried in front held arrowheads and bowstrings. A conical helmet made of leather and iron was topped with a spear and a tassel of dyed horsehair. Weapons comprised bows and arrows, pikes, sabers, matchlocks, and muskets, while rattan shields provided some protection (Fig. 43).

**Fig. 40** Armor of an officer of the Chinese Green Standard Army dating from the Kangxi period. The sleeveless jacket and skirt of dark green satin are embroidered with four-clawed dragons in gold thread. The arm defenses comprise lamella iron arm pieces and iron shoulder guards linked with embroidered satin flaps over the upper arms. The iron helmet also has embroidered ear and neck flaps. All the satin elements are lined with blue cotton and inside the layers of cloth are small overlapping iron plates held with metal rivets that are visible on the outside. This form of armor using overlapping iron plates was popular in Europe from the end of the 14th century to 1600, and jackets made of it are called Brigandines.

**Fig. 41** Painting by Castiglione of the Qianlong Emperor in ceremonial armor riding to the Grand Review.

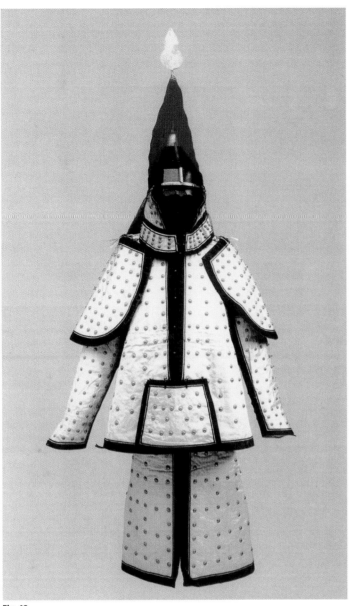

**Fig. 42**

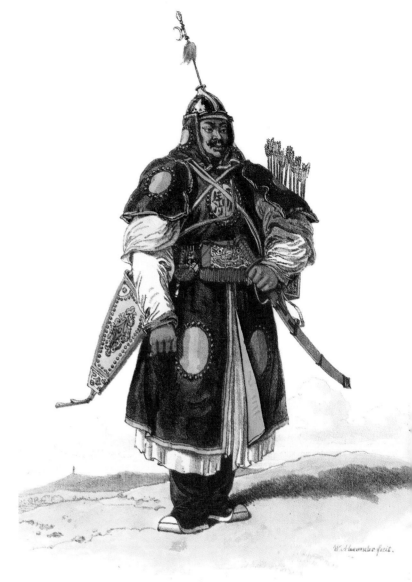

**Fig. 43**

Soldiers on active service wore the *diao wei* or sable tail, originally part of the uniform worn on imperial hunting expeditions. Two fur tails were arranged in a V shape and fixed to the crown of the winter hat, standing out at the back. They were subsequently worn by all military ranks, from general to private (Figs. 44, 46).

Away from the battlefield, an ordinary soldier wore a short nankeen cotton jacket in black, blue, red, brown, or yellow trimmed with cloth of another color (Figs. 45, 48). Circular plaques at front and back with black characters denoted his company and corps. Jackets were worn over the civilian long blue gown and loose blue trousers pushed into black cloth boots with thick paper soles for the higher ranks, or stockings of quilted cotton and shoes for the lower ranks. Paired aprons were worn, plus a rattan helmet or a turban.

Any formation of archers, musketeers, pikemen, cavalry, and artillerymen on the battlefield was led by shield-bearers known as *ten nai* or "tiger men." With their brightly colored and ferocious-looking dress, they were assigned to break up enemy cavalry charges with their sabers and grappling hooks.

The uniform of these shield-bearers comprised a long-sleeved jacket with yellow and black stripes imitating the skin of a tiger, worn with matching leggings and boots. The cloth helmet with ears was made to resemble a tiger's face. They carried woven rattan shields on which were painted a monster in grotesque style with large eyes, with the character for "king" (the tiger being considered the king of beasts) at the top, placed there to further instill fear into the enemy (Fig. 47).

---

**Fig. 42** Manchu military ceremonial uniform worn by members of the Imperial Guards. Made of cream satin edged with dark blue, wadded and lined, and covered with brass studs, the jacket's separate sections are held together with loops and brass buttons. The helmet is of black lacquer with brass armatures, topped with a red horsehair plume. Qianlong reign mark on inside, 18th c.

**Fig. 43** Soldier in full uniform: "The dress of the troops is clumsy, inconvenient, and inimical to the performance of military exercises, yet a battalion thus equipped has, at some distance, a splendid and even warlike appearance; but on closer inspection these coats of mail are found to be nothing more than quilted nankeen, enriched with thin plates of metal, surrounded with studs, which give the *tout-ensemble* very much the appearance of armour…. From the crown of the helmet (which is the only part that is iron) issues a spear, inclosed with a tassel of dyed horse-hair. The characters on the breast-plate, denote the corps to which he belongs" (Alexander, 1805).

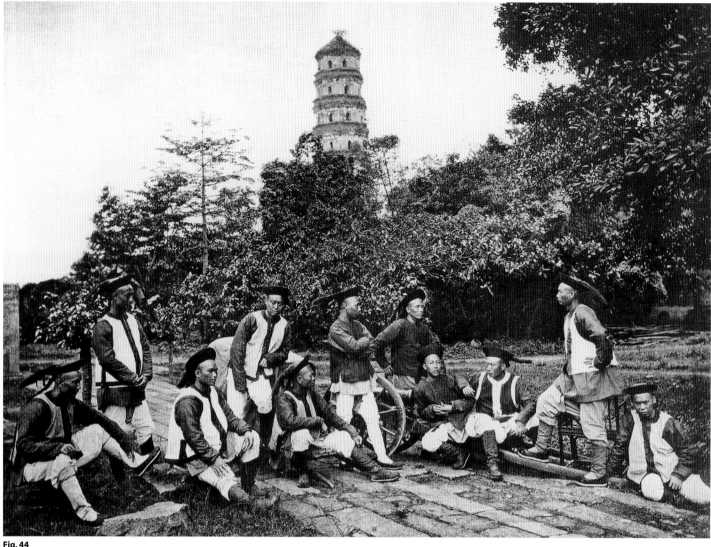

**Fig. 44**

**Fig. 45**

**Fig. 44** Manchu bannermen wearing sable tails and jackets in the colors of the banner to which they belonged, stationed in Guangzhou where they formed the guard for the British Consul, ca. 1870.

**Fig. 45** Infantry soldiers wearing bamboo helmets and holding rattan shields, the character for *ting* or "patrol" on their tunics, late 19th c.

**Fig. 46** Manchu bannermen at a parade ground in the northern part of the walled city in Guangzhou, mid-19th c.

**Fig. 47** A "Tiger of War" by William Alexander, the artist officially attached to the 1792 embassy led by Lord Macartney to the Qianlong Emperor, 1797.

**Fig. 48** Part of the bodyguard for the governor of Shanxi province, late 19th c.

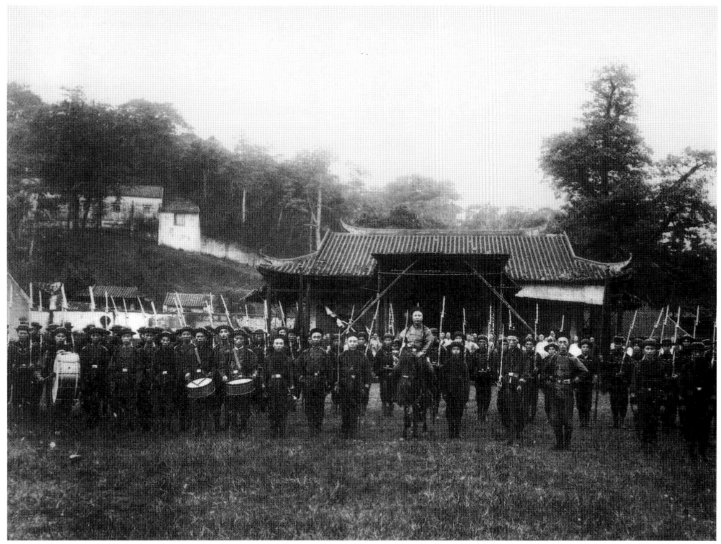

**Fig. 46**

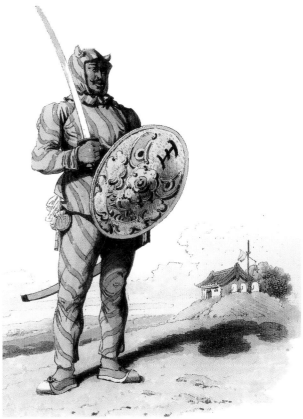

**Fig. 47**

**Fig. 48**

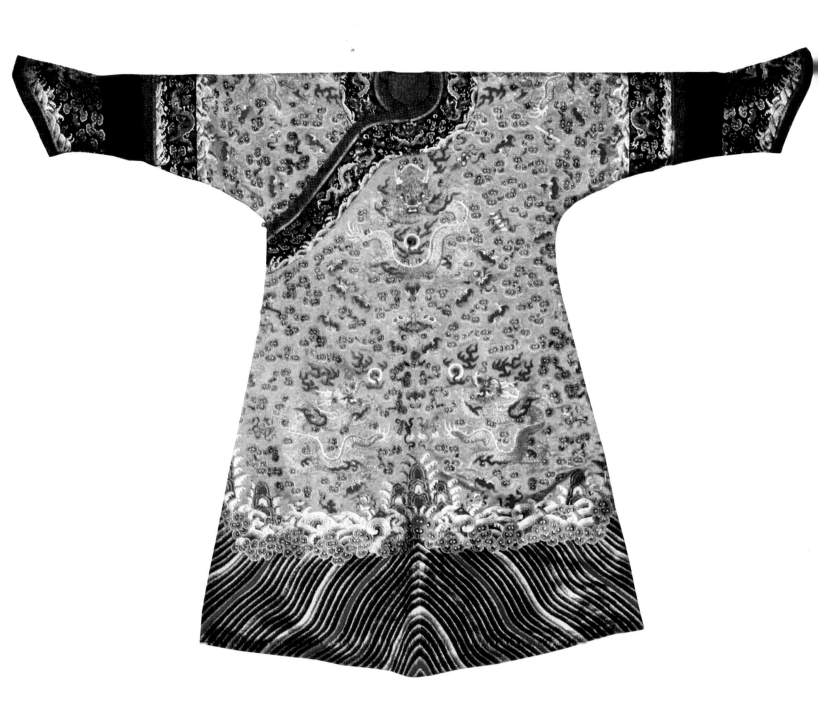

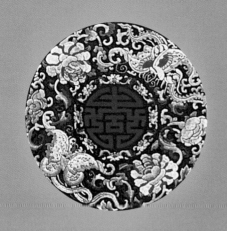

# Chapter Two

# THE DRESS OF THE MANCHU CONSORTS 1644–1911

## Life in the Forbidden City

In order to maintain the "purity" of the Qing dynasty line, emperors chose their wives from among daughters of eminent Manchu families. For reasons of political alliance, they were sometimes selected from important Mongol families, but were never from among the Chinese. Qing emperors continued the Ming system of polygamy to produce many offspring, thus ensuring the succession.

In addition to wives, the emperors had many consorts, recruited every three years from among the important military families of the Eight Banners to become Excellent Women (*xiu nu*). Parents could be punished if they did not register their daughters' names for selection. If chosen, the girls, aged between twelve and fifteen, would live inside the Forbidden City until they were twenty-five when they were "retired" and were free to leave if they so wished.

Another group of women in the palace were the daughters of the imperial bondservants who took care of the personal duties of the emperor and his family. At whim, the emperor could also select a girl from this group to be his concubine or even his next wife (Fig. 50). Marriage between bannermen and bondservants was forbidden, but sometimes bondservant's daughters were brought into the palace as maidservants, and could be promoted into the imperial harem. For instance, Empress Xiaogong was the daughter of a bondservant, who became a maidservant, and went on to gain the favor of the Kangxi Emperor as a third-rank imperial consort.

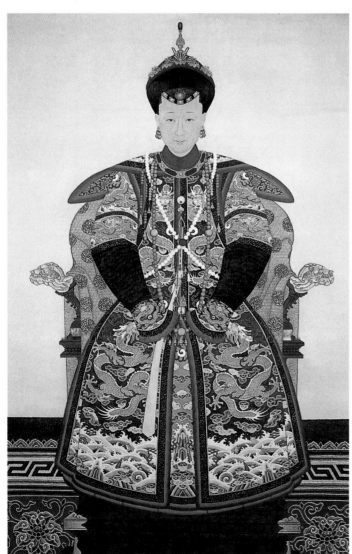

**Fig. 50**

She bore him three sons and three daughters, and eventually became Empress Dowager once her son ascended the throne as the Yongzheng Emperor.

The emperor's consorts fell into eight ranks: the empress was pre-eminent, followed by the *huang guifei* or first-rank imperial consort, and on down to the seventh rank. Manchu women held no official role in the government, but an empress dowager could act as regent during a ruler's minority, and held even more power than the reigning emperor himself on occasion, due to the importance attached to filial piety. For example, the Empress Dowager Cixi (1835–1908), co-regent for her son and then for her nephew, virtually controlled the government of China between 1860 and 1908. Other women's appearances in public were limited to occasions when they accompanied their husband, though there were some ceremonial events when women from the imperial family would officiate in their own right.

## Court Robes

Little is known about early imperial female robes before 1759 when court and official dress became standardized. Following standardization, women's clothing, like that for men, was separated into official and non-official, and subdivided further according to degree of formality. Rules for clothing also followed the seasons, and changes were made from silk gauze in summer, through to silk and satin, to padded or fur-lined for winter.

Official formal dress worn by women at court comprised a full-length garment called a *chao pao*, with a square-cut lapel opening and projecting shoulder epaulettes, the latter thought to be a pre-Qing costume feature for protecting the wearer's arms from bad weather. As with men's robes, the ground color and arrangement of dragons indicated rank. Over the top of the *chao pao* women wore a full-length sleeveless vest called a *chao gua*, which opened down the center; its antecedent was a sleeveless vest of trapezoidal shape worn by the Ming empresses, although the deeply cut armholes and sloping shoulder seams appear to be derived from an animal skin construction. Under the *chao pao*, a skirt made from a single length of silk with eighteen pleats fell from a plain waistband. The skirt was embroidered with small roundels along the hem, filled with the *shou* character, flowers, and dragons. A hat and a large flaring collar (*pi ling*) completed the outfit. Whereas the colors of the women's robes matched those of their husbands, the daughters of the emperor and lower-ranking consorts wore a greenish yellow (*xiang se*) robe.

The various types of seasonal *chao pao* ranged from thick, heavy winter costumes to light summery ones. The first type of winter *chao pao* comprised a long gown with projecting epaulets, embellished all over with front-facing and profile dragons, with wave motifs at the hem, but without the *li shui* diagonal stripes until almost the end of the dynasty. Bands of coiling dragons decorated the upper part of the long sleeves above the plain dark lower sleeves, which ended in horse-hoof cuffs. The robe was lined with white fur and edged with sable. The second style of winter court robe was very similar to the men's *chao pao*, being made in two sections with a pleated skirt attached to a jacket similar in construction to the first style. A four-lobed yoke pattern of dragons extended over the chest, back, and shoulders, with a band of dragons above the seam of the top and skirt. Another band of dragons was placed on the lower part of the skirt. The third style was similar to the first, but with a split in the center of the skirt at the back, which was

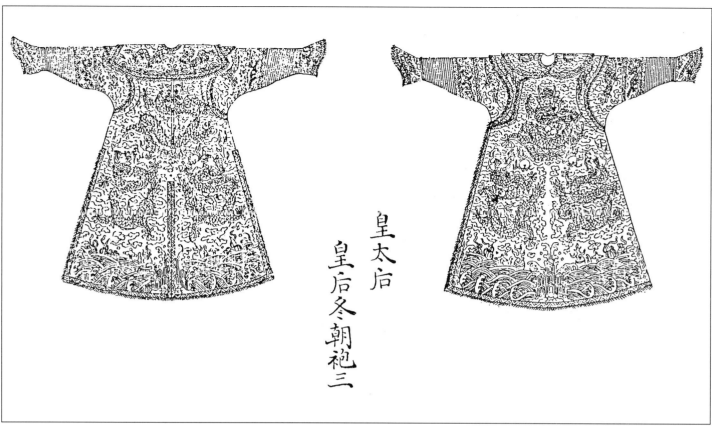

皇
太
后

皇
后
冬
朝
袍
三

**Fig. 51**

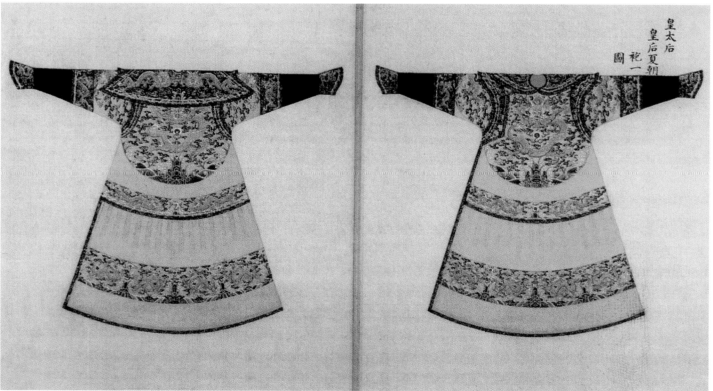

**Fig. 52**

**(Page 32) Fig. 49** First semiformal style five-clawed dragon robe in orange silk, embroidered in satin stitch with nine dragons couched in gold thread. Orange was regarded as an off-shade of imperial yellow and restricted to use by the emperor's consorts of the

second and third degree and the wives of the emperor's sons. The fact that the lower dragons have not clasped the pearl suggests that the robe was made for an imperial daughter-in-law or consort, mid-19th c.

**Fig. 50** Imperial princess wearing a court vest over a court robe, both edged in fur, with a flared collar, winter court hat, diadem, torque, three necklaces, and pointed kerchief.

**Fig. 51** Woodblock printed page from the Regulations showing the back and front views of the third style winter court robe.

**Fig. 52** Painting on silk from the Regulations showing the first style summer court robe in yellow, belonging to an empress or empress dowager.

trimmed with black fox fur. Unlike the first two styles, this style was permissible for Manchu women other than those belonging to the imperial family (Fig. 51).

Summer court robes were of two types. The first was made of two sections, like the second type of winter robe (Fig. 52). The second summer style was identical to the third kind of winter robe, but made of gauze or satin and edged with brocade (Fig. 55).

Three different styles of full-length, sleeveless *chao gua* court vests made of dark blue silk edged with brocade were worn over the *chao pao*. The first style was made in three sections: an upper part, a section from waist to knee, and a section from knee to hem (Fig. 53). Five horizontal bands embroidered with four- or five-clawed dragons and lucky symbols, depending on rank, encircled the vest. The second type of *chao gua* was similar to the second style

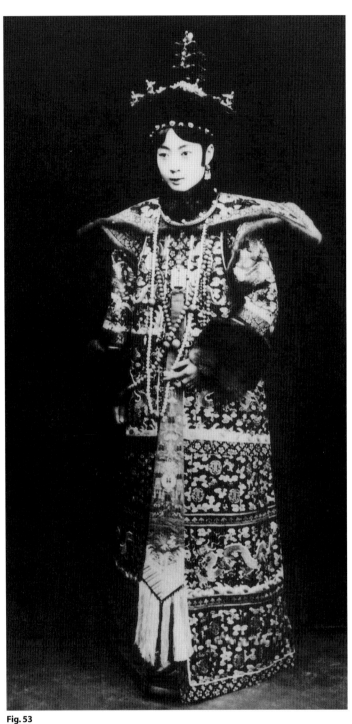

Fig. 53

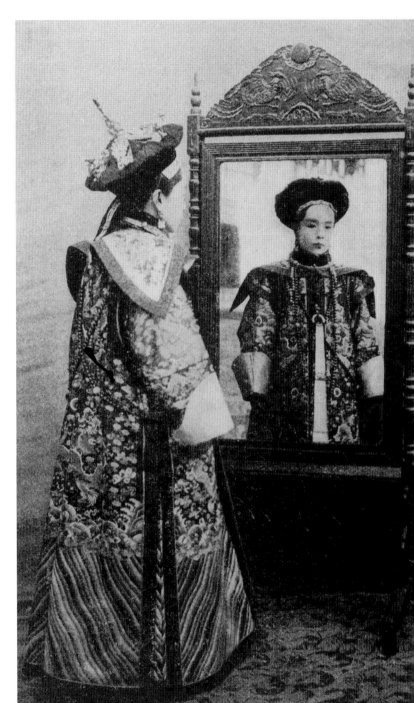

Fig. 54

**Fig. 53** Wanrong, wife of the Xuantong Emperor (r. 1909–12), taken at the time of their marriage in 1922, wearing the first style court vest, court hat, flared collar, three court necklaces, together with the pointed kerchief attached to the button on her court vest, a diadem, torque, earrings, and hat finial with three phoenixes.

**Fig. 54** Princess Su, whose husband gave his palace to the Christians during the Boxer siege, in the third style court vest, ca. 1900.

**Fig. 55** Second style summer court robe with flared collar, 18th c.

**Fig. 56** Painting on silk from the Regulations of the second style summer court vest for an imperial consort.

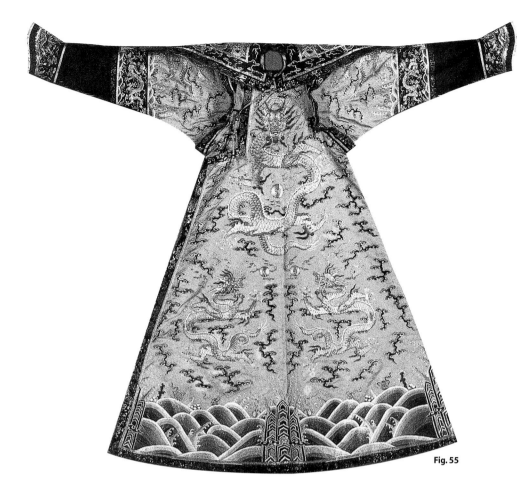

**Fig. 55**

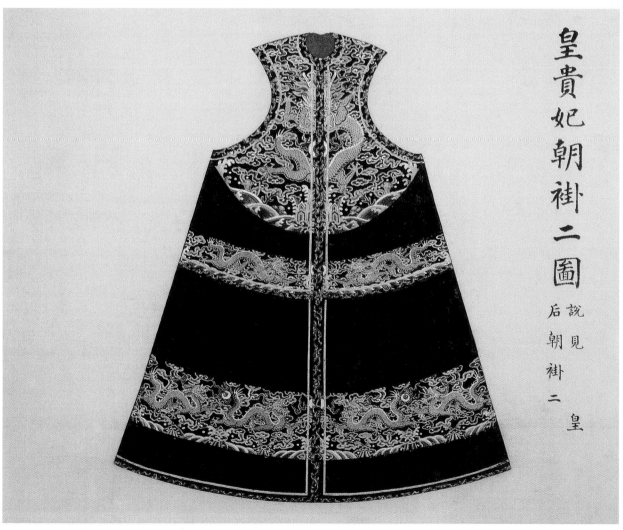

皇貴妃朝褂二圖

說見
后朝褂二皇

**Fig. 56**

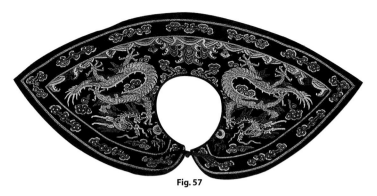

**Fig. 57**

**Fig. 58**

of *chao pao*, with a sleeveless body part joined to a pleated skirt (Fig. 56). This is very rare and, like the first, was worn only by members of the imperial family. The third style, decorated with ascending dragons presented in profile as well as wave motifs and, later, *li shui*, was acceptable wear for women of all ranks (Fig. 54). Lower-ranking noblewomen and officials' wives wore either the third style of winter *chao pao* or the second style of summer *chao pao*. This was worn with the third style of *chao gua* and the *pi ling* collar (Fig. 57).

## Accessories

An important accouterment of court dress worn by female members of the Imperial Household was the *chao guan* or court hat. At the beginning of the dynasty, different hats were worn in summer and winter, but by the reign of the Kangxi Emperor the winter style had been adopted for use throughout the year. The *chao guan* was similar in shape to the men's winter hat, with a fur brim and a crown covered with red floss silk tassels, but it had an additional back flap shaped like an inverted gourd, made of fur. In summer, the hat brim and back flap were faced with black satin or velvet.

Seven elaborately ornamented gold phoenixes graced the crown of a first-rank imperial consort's summer *chao guan*, while lesser imperial concubines wore five. At the back of the hat, a golden pheasant supporting three strings of pearls anchored by a lapis lazuli ornament hung down over the flap (Figs. 58, 59). The crowns of hats worn by princesses were covered with red floss silk and decorated with golden pheasants, while the hats of lower-ranking noblewomen had small jeweled plaques secured to the base of the crown just above the brim.

As ordained by the Regulations, the hat finials of the empress, empress dowager, and first rank imperial consort were composed of three tiers of golden phoenixes and pearls (see Fig. 59). Lesser-ranking imperial concubines were allowed to wear finials comprising two tiers of phoenixes and pearls. Lower-ranking noblewomen wore a simpler, smaller version of the man's hat finial (Fig. 60).

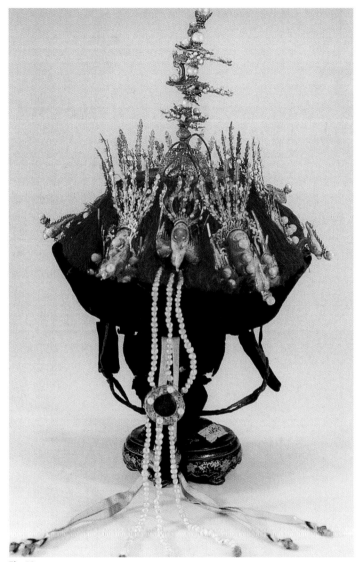

Fig. 59

**Fig. 57** Woman's large flaring collar worn on top of a court robe, with two dragons in profile on either side of a mountain, the background filled with clouds and lucky emblems. Men's collars usually had five dragons.

**Fig. 58** Painting on silk from the Regulations of a winter court hat belonging to an imperial noblewoman.

**Fig. 59** Summer court hat of a first-rank imperial consort. The brim and back flap are in black velvet, with red floss silk fringing covering the crown, seven gold phoenix ornaments set with pearls placed around the crown, and three phoenixes on the finial.

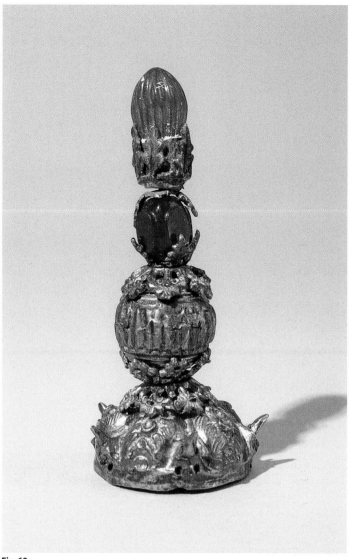

**Fig. 60**

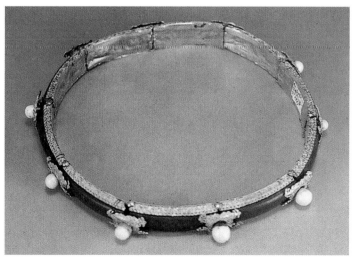

**Fig. 61**

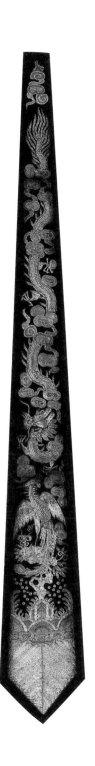

**Fig. 62**

**Fig. 60** Noblewoman's hat finial of brass with amber jewels. This would have been sewn to the hat through the tiny holes around the base, instead of being fixed with a long screw through the crown.

**Fig. 61** Diadem of gold inlaid with lapis lazuli and pearls.

**Fig. 62** Black satin headband for a Manchu nobleman's wife decorated with four-clawed profile dragons couched in gold and silver thread, one on each side of a flaming pearl.

On each of the pendants, which hung down the back, there is a long coiling dragon and a phoenix of a similar design.

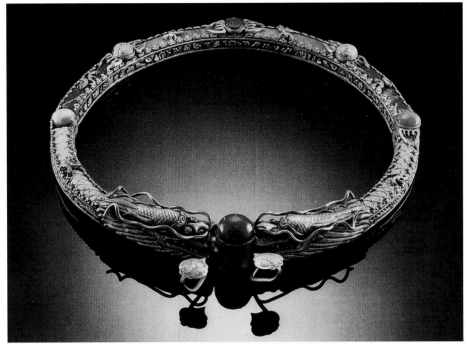

**Fig. 63**

The court hat rested on a diadem or coronet (*jin yue*), which encircled the forehead (Fig. 61). Diadems were also an indicator of rank and appear in the Regulations after the section on hats. The diadems of women in the imperial family were made of several sections of gold joined together and inlaid with precious stones such as lapis lazuli and pearls. Although not shown here, either five or three strings of pearls, depending on rank, hung down the back, anchored at the top and just above midway by two oval plaques.

On official occasions, lower-ranking women, ranging from the wives of dukes down to the wives of seventh-rank mandarins, wore a silk headband on the forehead in place of a diadem or coronet (Fig. 62). Composed of a band of black satin, it was decorated with semiprecious stones in the form of a dragon and phoenix chasing a flaming pearl. Two pendants embroidered in similar fashion hung down the back. Tiny loops at the top enabled the band to be hooked over a jeweled hairpin, which was pushed into the hair just under the back fastening of the headband.

Women from the imperial family and Manchu noblewomen had their ears pierced to accommodate three pairs of drop earrings (*erh-shih*) in each ear when wearing court dress.

A jeweled collar or torque was listed in the Regulations as an essential part of court dress for members of the imperial family and noblewomen (Fig. 63). Called a *ling yue*, it was made of gold or silver gilt inlaid with semiprecious stones such as pearls, coral, rubies, and lapis lazuli, the number of stones determining rank. Silk braids, the colors corresponding to those of the robes, hung down from the back opening, ending in drop pendants of matching semiprecious stones.

Another essential item of court dress for the ladies of the imperial family, noblewomen, and wives of high officials was the court necklace (*chao zhu*), which was similar in style to the one worn by their husbands but with the addition of two necklaces crossing from left shoulder to right underarm, and vice versa. When wearing the dragon robe on semiformal occasions, a single necklace was appropriate. Only the empress or empress dowager could wear a main necklace formed of Manchurian pearls, the other two being made of coral. Amber and coral necklaces were worn by lower-ranking consorts and princesses, while other members of the family were permitted to wear any type of semiprecious stone not restricted to the empress and empress dowager.

Another symbol of rank listed for women in the Regulations was the *zai shui*, a long pointed kerchief made of yellow, red, or blue silk and embroidered with auspicious emblems like the dragon and phoenix (Fig. 64). Suspended from a jeweled ring, it fastened to a center button on the court vest or to the side top button on the dragon robe. Silk cords with charms made from jade or other semiprecious stones hung from the jewel, with a jeweled bar approximately one-third the way down from the top.

## Semiformal and Informal Attire

For semiformal official occasions and during festivals, the women within the imperial family wore the *long pao*, a side-fastening robe embroidered with nine five-clawed dragons, its long sleeves ending in horse-hoof cuffs, and in colors corresponding to rank. Unlike those worn by men, women's dragon robes had no splits at the cen-

**Fig. 63** Torque made of gilt-bronze finely worked with a pair of dragon heads confronting a lapis lazuli "flaming pearl" forming the clasp, each set with a *ruyi* hook inset with turquoise, lapis lazuli, and coral plaques incised with scales, floral motifs, and butterflies, late Qing.

**Fig. 64** Woodblock printed page from the Regulations showing the pointed kerchief designed for the empress, to be embroidered in green and other colors with the Abundant Harvest of the Five Grains pattern on a bright yellow ground. The same design was permitted to imperial consorts and

ter back and front hem since women did not sit astride horses. Additional bands of dragons at the seams linking the upper and lower sleeves were, in theory, restricted to the empress and highest-ranking princesses, although in practice were adopted by all Manchu women.

As with the formal court robe, there were three types of semi-formal dragon robes. The first, worn by all women, was complete-ly covered with dragon motifs with a wave border along the hem, with the color and number of dragons indicating rank (Fig. 66; see also Fig. 49). Lower-ranking noblewomen and officials' wives wore the *mang pao*, the four-clawed dragon robe in the same style. Later, in the nineteenth century, the sleeves of these robes degenerated, ending in wide horse-hoof cuffs. Although the use of the Twelve Imperial Symbols was, in theory, restricted to the emperor, he sometimes conferred the right to use them on others (Fig. 66).

The second style of *long pao*, decorated with nine dragon-filled roundels and a wave pattern hem, was officially the preserve of the empress (Fig. 67). However, some robes made later in the dynasty, with the degenerated sleeves and wide horse-hoof cuffs popular by this time, have this same roundel pattern and were worn by noble-women. The third type, officially worn only by the empress, was embellished with roundels but no wave pattern (Fig. 68).

The semiformal dress of the empresses and imperial consorts was not complete without a *ji guan* or festive hat. The *ji guan* resem-bled the emperor's winter hat, having red silk tassels and a fur brim, while for summer the brim was faced with black satin. The hats of empresses, or those women at court given the right, were topped with a pearl. The hat was worn over a silk band with a jewel at the center, which replaced the gold diadem.

Lower-ranking noblewomen wore more elaborate hats, the crowns of which were covered with red or blue satin decorated with embroidery or semiprecious stones and topped with a red silk knot (Fig. 65). Two wide streamers, embroidered with dragons chasing the flaming pearl, were inserted through a horizontal slit in the brim and hung down the back to below the waist. Other designs on the streamers include the Eight Buddhist emblems. Two small bouquets of flowers were often tucked in the hat just above the ears.

For official informal occasions, dragon robes were made of plain-colored silk damask edged with bands of embroidered drag-ons at the *tou jin* or curved opening at the neck, and on the sleeves, although they were cut in the usual dragon style with horse-hoof cuffs (Fig. 69). Being relatively plain, these robes are quite scarce.

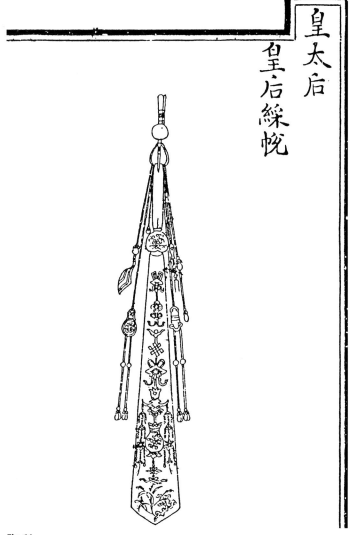

**Fig. 64**

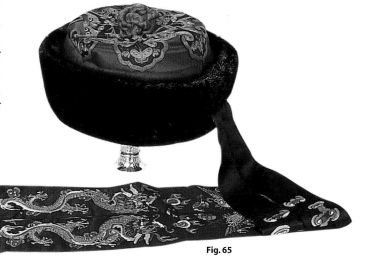

**Fig. 65**

consorts of princes, while the ones worn by princesses and noblewomen were plainer.

**Fig. 65** Semiformal winter hat of a noblewoman, with a black sable fur brim (for summer, the brim would be made of black satin), the crown cov-

ered with red satin and embroidered in a design of bats and butterflies, a red silk cord knob at the apex, and

two streamers decorated with couched gold dragons on blue satin chasing the flaming pearl and phoenixes.

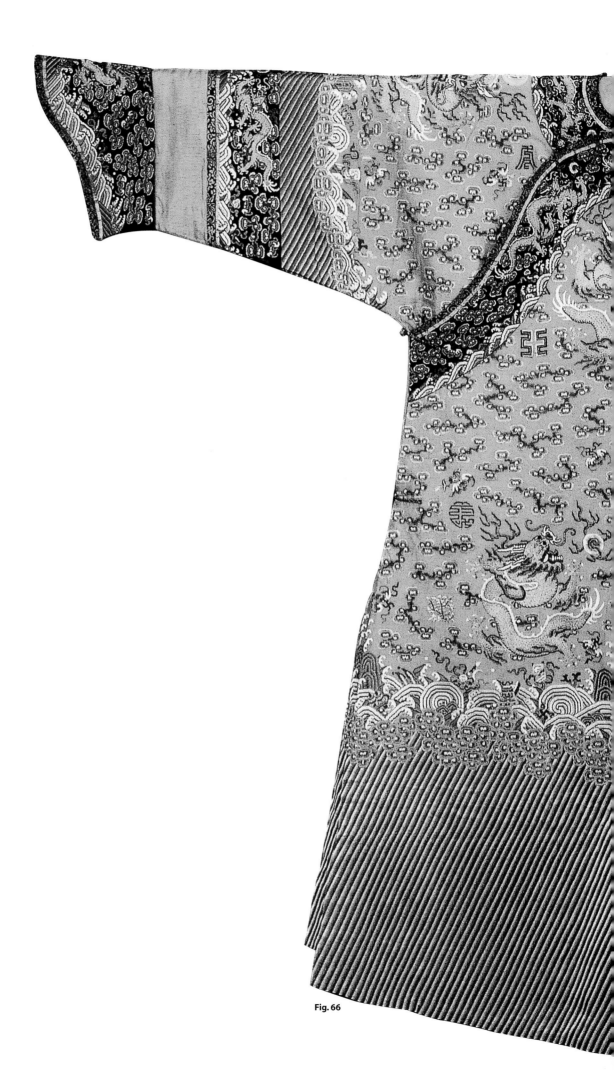

**Fig. 66**

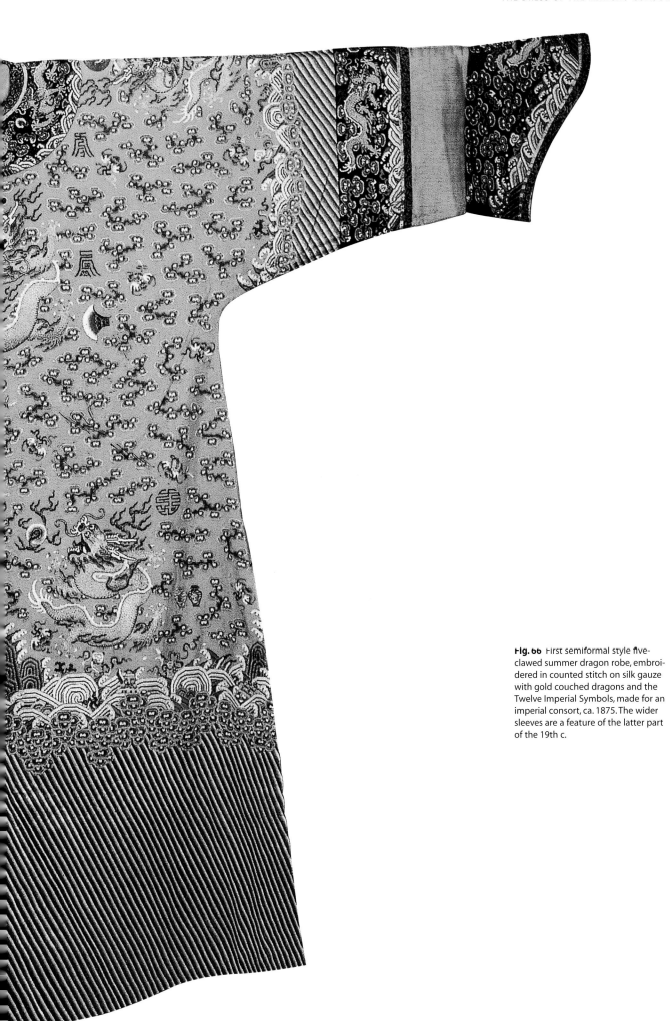

**Fig. 66** First semiformal style five-clawed summer dragon robe, embroidered in counted stitch on silk gauze with gold couched dragons and the Twelve Imperial Symbols, made for an imperial consort, ca. 1875. The wider sleeves are a feature of the latter part of the 19th c.

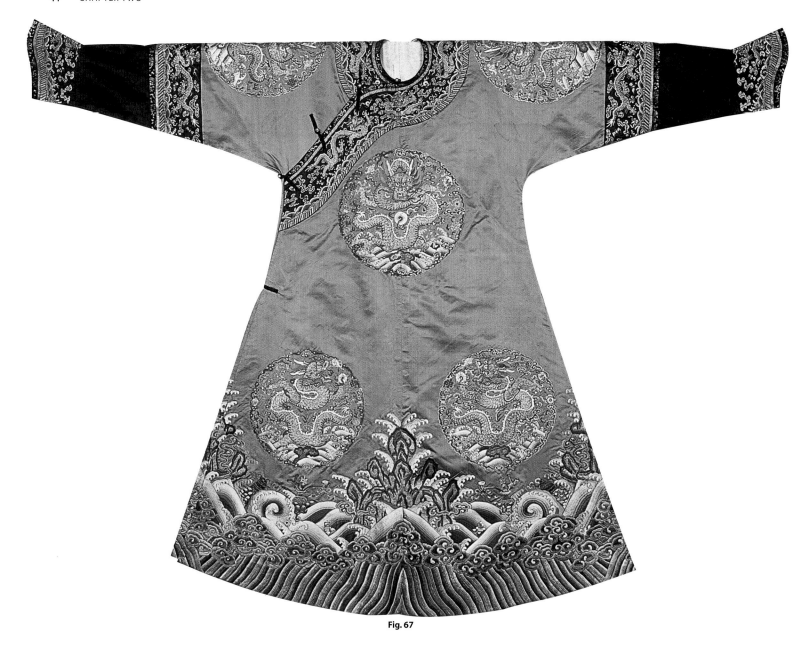

**Fig. 67**

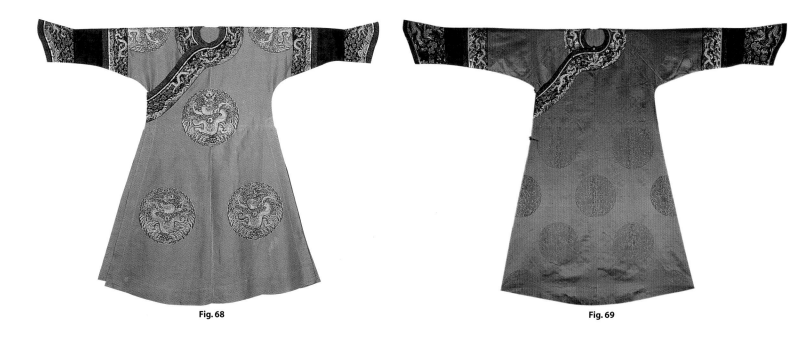

**Fig. 68**                                                    **Fig. 69**

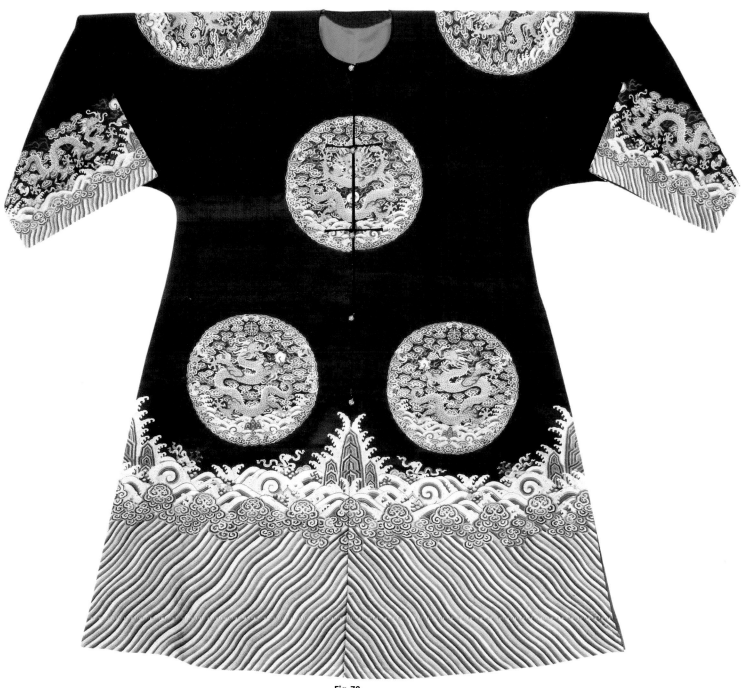

**Fig. 70**

**Fig. 67** Second semiformal style five-clawed dragon robe in turquoise satin and lined in yellow silk, with *li shui* at hem, made for a low-ranking imperial consort or imperial daughter-in-law,

ca. 1800. Of the nine dragon roundels embroidered on the robe, the upper four contain front-facing dragons, the lower four, plus the one hidden on the inside flap, have dragons in profile.

**Fig. 68** Third semiformal style five-clawed dragon robe, no *li shui* at hem, in apricot silk gauze with eight dragon roundels, the four upper ones with front-facing dragons, the four on the skirt with dragons in profile (none on the inside flap), mid-19th c. The robe's color indicates it was probably made for the consort of the crown prince.

**Fig. 69** Official informal robe for an imperial consort in turquoise, with embroidered facings and damask weave roundels.

**Fig. 70** High-ranking ladies surcoat in *kesi*, with four facing dragon roundels on the upper body, and four profile dragon roundels on skirt, early 19th c.

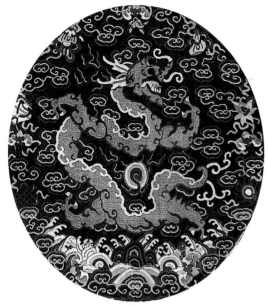

Fig. 71

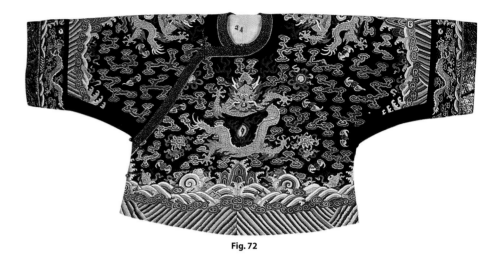

Fig. 72

In public, empresses, high-ranking consorts, and noblewomen were required to wear a *long gua* – a full-length, center-opening, wide-sleeved surcoat in blue-black satin or gauze with dragon roundels arranged over it – over their *long pao* or five-clawed dragon robe (Figs. 70, 71). They were of two types: the first had eight roundels of dragons displayed on the chest, back, shoulders, and front and back hem of the coat, together with the *li shui* pattern, similar to that on the second style of *long pao* (Fig. 73). The other style had eight roundels without the wave border, as in the third style of *long pao*. Several empresses in the nineteenth century added the first four of the Twelve Imperial Symbols to the upper four roundels.

Imperial princesses were expected to wear the upper four or two roundels on a plain surcoat or *pu fu* to match their husbands' rank, although it seems they preferred to wear the *long gua* with *li shui*. Lower-ranking noblewomen were required to wear the surcoat with eight roundels of flower motifs surrounding the *shou* character, with or without *li shui*, as with dragon robes (Fig. 74).

Dragon jackets are not common (Fig. 72). They do not appear in the Regulations, but because of their similarity to dragon robes, with the dragons and *li shui*, they are clearly intended for formal use at important events within the family, such as weddings. It is likely Manchu women wore them, as the proportions of the jacket indicate they were worn over a long gown. Personal preference would dictate their use, and the fact they were cheaper to produce than a full-length robe may have added to their attraction.

Manchu women wore a *dianzi* headdress on informal festive occasions. The one shown here (Fig. 75) is made of wire lattice woven with black silk ribbon and decorated with kingfisher feather inlay and gold filigree in the style of the "endless knot," with butterflies and the *shou* character.

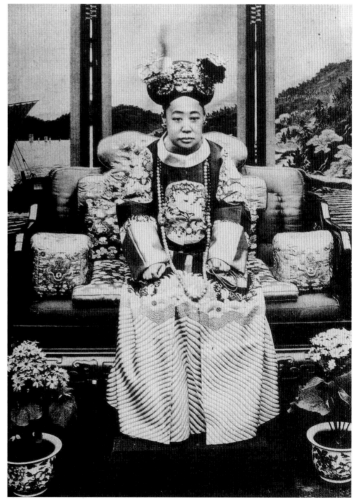

Fig. 73

---

**Fig. 71** Roundel with a two-toed profile dragon in *kesi*, from a Manchu ladies surcoat, mid-19th c.

**Fig. 72** Manchu lady's dragon jacket in *kesi*, with four five-claw front-facing dragons surrounded by Buddhist emblems, ca. 1825–50.

**Fig. 73** The Guangxu Emperor's consort, Dowager Duan Kang, wearing the first style surcoat over a matching five-clawed dragon robe, its wide cuffs turned back over the surcoat, ca. 1913.

**Fig. 74** Lower-ranking noblewoman's official surcoat with eight roundels, each containing the *shou* character surrounded by bats and peonies, a wish for happiness and long life, the *li shui* at the hem embroidered with Buddhist emblems, early 19th c.

**Fig. 74**

**Fig. 75**

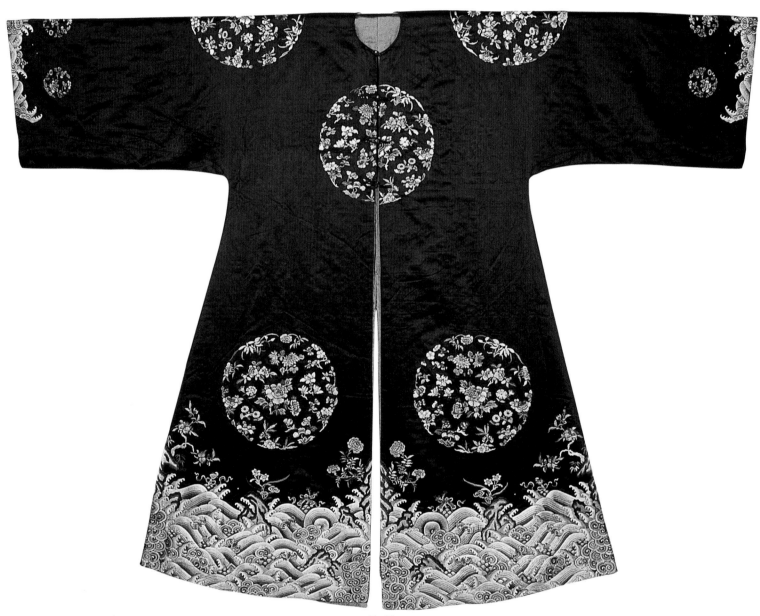

**Fig. 76**

**Fig. 75** Manchu headdress called a *dianzi* for informal festive occasions such as birthdays, ceremonies, and New Year celebrations, made of wire lattice woven with black silk ribbon

and decorated with kingfisher feather inlay and gold filigree in the style of the Endless Knot, with butterflies and the *shou* character.

**Fig. 76** Non-official formal surcoat for a lower-ranking noblewoman, with eight floral roundels and *li shui* hem, early 19th c.

**Fig. 77** Non-official formal robe with eight floral roundels, Qianlong period.

**Fig. 78** Manchu bride, with her maid, wearing a surcoat with eight roundels, with no *li shui*, ca. 1870.

## Non-official Dress

Non-official formal robes were worn for weddings and other important family occasions not connected with the court. Towards the end of the nineteenth century, formal robes, like the dragon robes of this period, had wide sleeves with horse-hoof cuffs, and a plain band rather than a ribbed one between the cuff and upper sleeve (Fig. 77). In practice, these robes were the same as those worn for official formal occasions by noblewomen and wives of officials. Eight roundels with *shou* or, later, other motifs were dispersed over the robe, which had either a *li shui* or plain hem. Worn with a surcoat having eight roundels with *shou* or floral patterns, some had the *li shui* pattern at the hem and cuffs, while others did not (Fig. 76).

A Manchu bride of an official wore a non-official formal robe with horse-hoof cuffs and eight roundels on the gown. Later in the dynasty, these garments were predominantly made in red, reflecting the Han influence of this auspicious "Chinese" color (Fig. 79). A dark blue surcoat was worn over this robe, and an elaborate headdress completed the outfit (Fig. 78).

Non-official semiformal robes were very lavishly embroidered, particularly those worn by the Empress Dowager Cixi, who favored pastel shades of blue, lilac, and pink as she felt the yellow dragon robes were unflattering to her ageing skin tone (Figs. 80, 81). The contrasting borders on clothing after the middle of the nineteenth century were based on Han styling, and indicated assimilation into Chinese culture.

In addition to the rules governing the types of fabric for certain times of the year, each season was identified with a particular flower and these appeared as motifs on semiformal robes. The flower for spring was the peony (since 1994 the peony has been the national flower of China, symbolizing love of peace and the pursuit of happiness), for summer the lotus flower, for autumn the chrysanthemum, and for winter the plum blossom. For ladies at court in the late nineteenth century, to wear the wrong flower was to disobey the imperial decree and risk incurring the wrath of the Empress Dowager (Figs. 82, 83).

Non-official robes of this period often had three very wide bands running around the edges of the robe: the outer made of brocade, the middle a wide border of embroidery, and the inner a multicolored woven ribbon (Fig. 84). Semiformal robes had wide sleeves with turned-back cuffs, which were then lavishly embroidered on the underside. In place of the *zai shui* pointed kerchief, women of the imperial family in informal dress wore a narrow band of silk embroidered with auspicious symbols and decorated with jewels. It looped around the neck, with one end tucked into the top of the gown.

Informal robes were plainer than semiformal ones, and comprised a silk damask body with a less elaborate border on the straight cuffs, around the neck, and down the side, and sometimes around the hem, although this was more common on the more formal robes (Fig. 85). They were worn with a long or short sleeveless waistcoat fastening down the center or at the side, with a wide decorated border, or a short jacket (Figs. 86–88).

The clothing of servants in the palace reflected their lowly status, as recalled by a palace maid: "We had to be completely unobtrusive. Our clothes were provided by the Palace. Come the spring, we would be measured for four sets of vest, blouse, robe and waistcoat. Except in October (the month of the empress dowager's

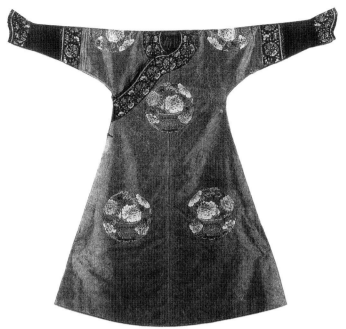

**Fig. 77**

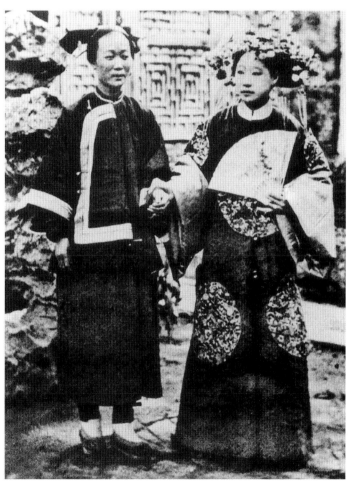

**Fig. 78**

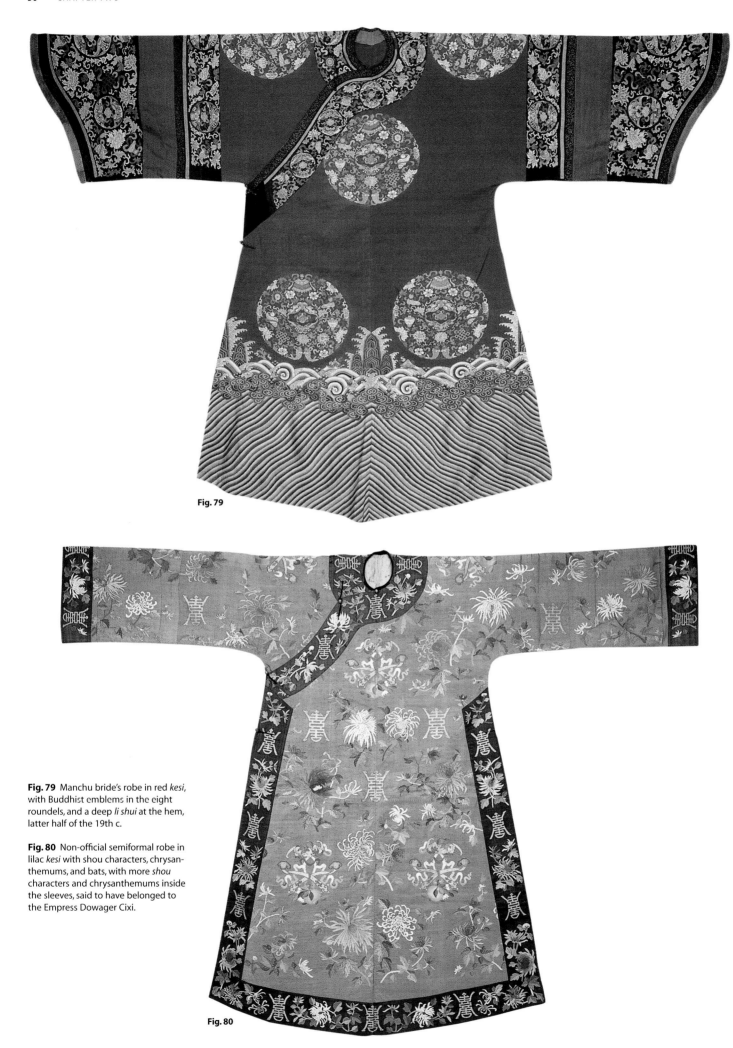

**Fig. 79** Manchu bride's robe in red *kesi*, with Buddhist emblems in the eight roundels, and a deep *li shui* at the hem, latter half of the 19th c.

**Fig. 80** Non-official semiformal robe in lilac *kesi* with shou characters, chrysanthemums, and bats, with more *shou* characters and chrysanthemums inside the sleeves, said to have belonged to the Empress Dowager Cixi.

Fig. 79

Fig. 80

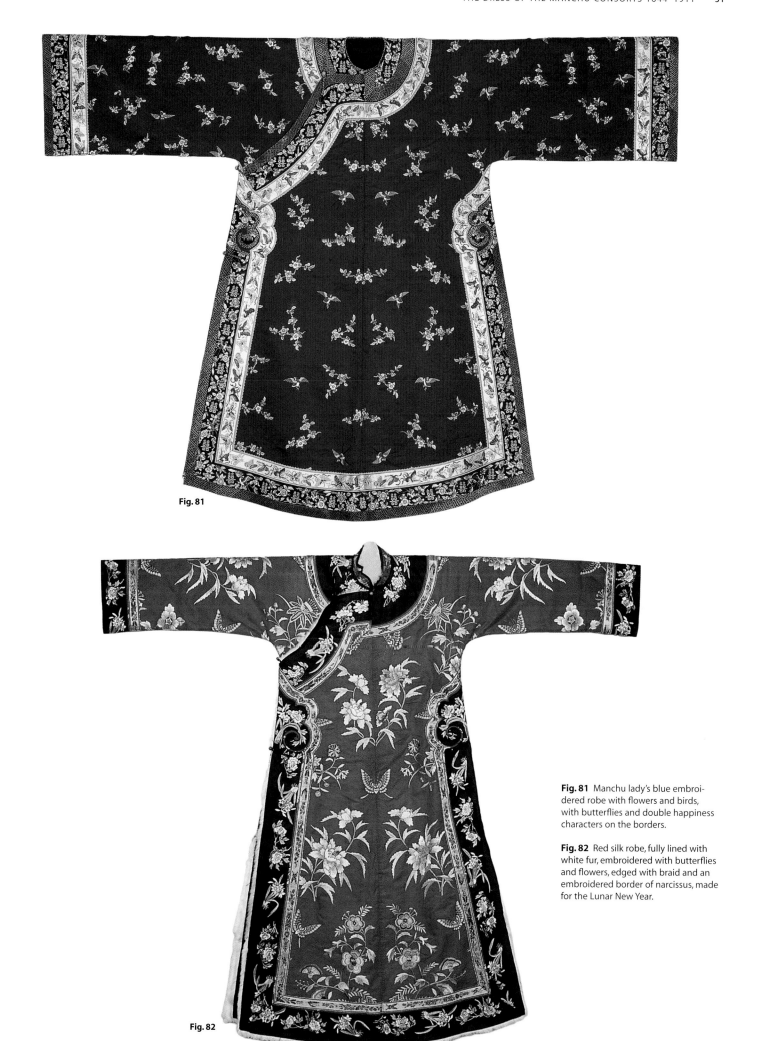

**Fig. 81**

**Fig. 82**

**Fig. 81** Manchu lady's blue embroidered robe with flowers and birds, with butterflies and double happiness characters on the borders.

**Fig. 82** Red silk robe, fully lined with white fur, embroidered with butterflies and flowers, edged with braid and an embroidered border of narcissus, made for the Lunar New Year.

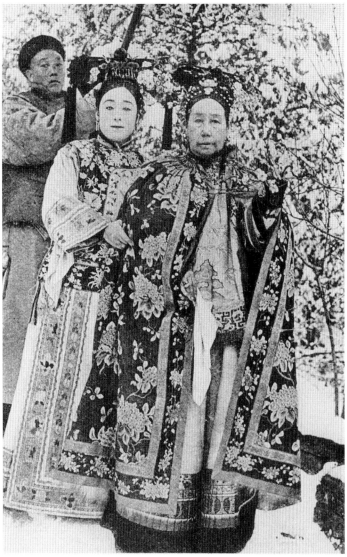

**Fig. 83**

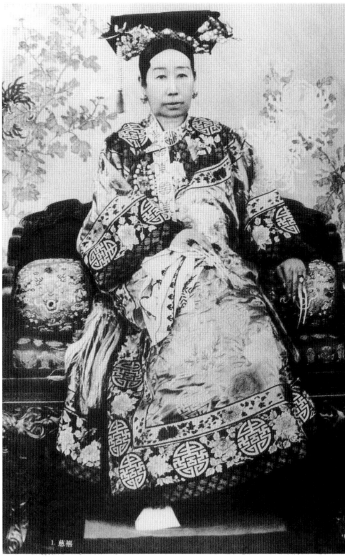

**Fig. 84**

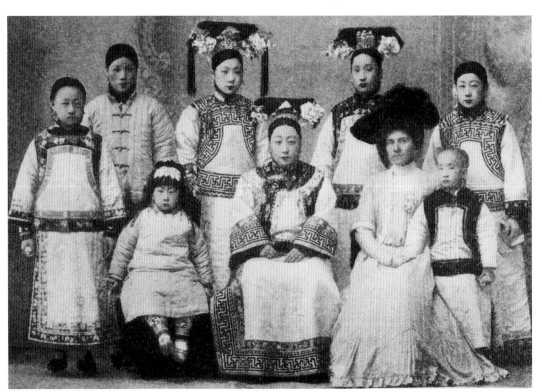

**Fig. 85**

**Fig. 83** The Empress Dowager Cixi
in the garden of the Summer Palace,
wearing a full-length cape pleated into
a neckband and falling straight to the
hem, designed for cooler weather,
ca. 1905. She is attended by her lady-
in-waiting, Princess Der Ling.

**Fig. 84** The Empress Dowager Cixi
wearing a non-official semiformal robe
emblazoned with *shou* characters, late
19th c. Note the neckband and nail
extenders.

**Fig. 85** Daughters-in-law of Prince
Ding in informal dress, with Mrs Head-
land, wife of I. T. Headland, author of
several books on China, ca. 1910.

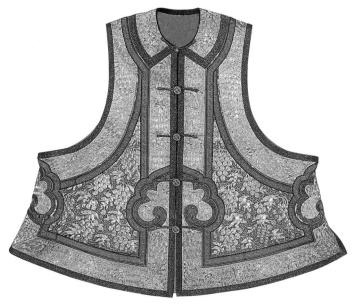

Fig. 87

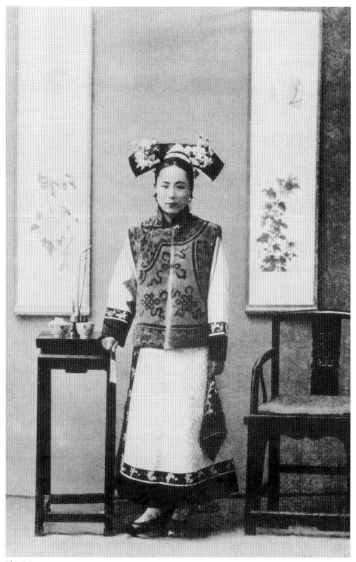

**Fig. 86** Manchu woman in non-official informal dress, consisting of a long robe and sleeveless waistcoat and headdress, late 19th c.

**Fig. 87** Manchu woman's informal vest with fine couched gold and silver thread in a design of grapes and leaves on a blue and pink silk background, edged with bands of the key fret design to form the *ruyi* shape, a desire that all wishes will come true, the gold buttons bearing characters for "double happiness."

**Fig. 88** Two seated Manchu women at a ceremony in a country yamen where a Manchu official held office, ca. 1904.

Fig. 86

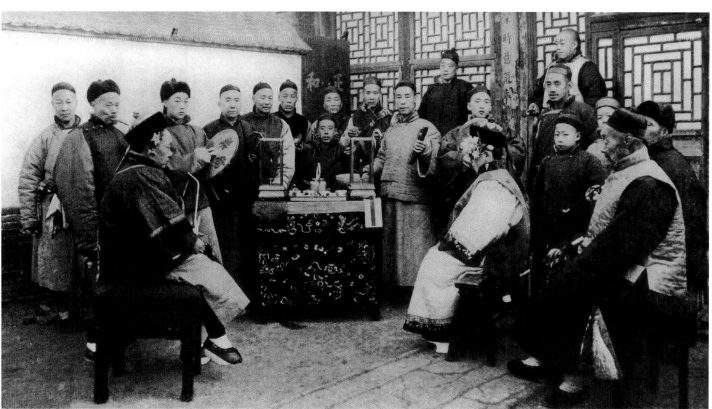

Fig. 88

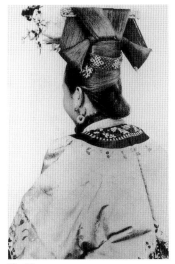

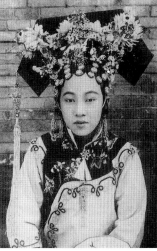

**Fig. 89**

**Fig. 90**

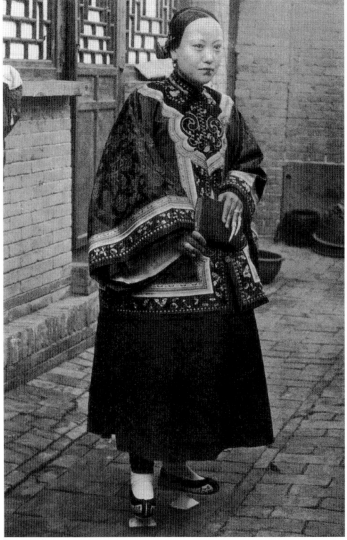

**Fig. 91**

birthday), when we were allowed to wear red, most of the year we were confined to a few colors – in spring and summer we dressed in pale blue or green, in autumn and winter a purplish brown. We wore our hair in a thick plait, tied at the end by a short red ribbon" (Holdsworth and Courtauld, 1995: 85).

On non-official occasions, Manchu women wore an unusual headdress called a *liang ba tou*, with batwing-like shapes formed from false hair or black satin arranged over a frame which was anchored with hairpins to the natural hair (Fig. 89). Literally "two handfuls of hair," the hair itself was originally set and shaped this way, but during the nineteenth century was replaced by black satin as being more practical and easier to maintain. As the Qing dynasty drew to a close, the headdress became larger. Artificial blossoms were placed at each side, silk tassels were hung down the sides, and the whole creation was embellished with jeweled ornaments (Fig. 90). However, older women continued to wear a smaller, less elaborate *liang ba tou* made of stiffened black satin formed over a crosspiece of gilded silver and mounted on a wire base.

Most people of gentility cultivated at least one long fingernail to show that they did not engage in manual work. To preserve the treasured nail, women – though not men – wore 3 inch (7 cm] long nail guards made of gold, silver gilt, enamel, or tortoiseshell in filigree designs of coins or longevity and other auspicious symbols. Often two different pairs were worn on the third and fourth fingers of each hand (Fig. 91).

Unlike Han Chinese women, Manchu women did not bind their feet. Instead, those from high-ranking families wore a special shoe, exaggeratedly elevated, with a concave heel in the center of the instep (Fig. 93). The bottom of the shoe was padded with layers of cotton to prevent jarring when walking. The vamp was made of silk and embroidered with designs of flowers, birds, and fruit (Fig. 92). As well as allowing the Manchu women to imitate the swaying gait resulting from bound feet, the shoes also made them tower over the diminutive Chinese: "... the shoes stand upon a sole of four or six inches [10 or 15 cm] in height, or even more. These soles, which consist of a wooden frame upon which white cotton cloth is stretched, are quite thin from the toe and heel to about the center of the foot, when they curve abruptly downwards, forming a base of two or three inches square [5 or 8 cm]. In use they are exceedingly inconvenient, but ... they show the well-to-do position of the wearer. The Manchu are ... a taller race than the Chinese, and the artificial increase to the height afforded by these shoes gives them at times almost startling proportions" (Hosie, 1904: 157).

Empress Dowager Cixi is often shown raising the hem of her gown to reveal a splendidly decorated shoe. Even late in life, she retained her love of finery and the heels of her elevated shoes are dripping with strings of pearls matching her pearl collar. Shoes with concave heels must have been quite difficult to walk in, however, and for informal wear, and among the lower ranks of Manchu women, shoes with boat-shaped convex soles were worn.

**Fig. 89** "Batwing" headdress made of false hair, worn by a Manchu noble-woman.

**Fig. 90** "Batwing headdress" covered in black satin with jewels and artificial peonies, worn by a young Manchu woman.

**Fig. 91** Manchu woman in North China wearing elevated shoes and nail extenders, ca. 1910.

**Fig. 92** Uncut vamps in *kesi* for a pair of Manchu woman's shoes with a finely detailed design of phoenixes and peonies.

**Fig. 93** Manchu women's shoes with a satin vamp embroidered with flowers and cotton-covered soles.

**Fig. 94** Dragon robe for a young prince, with the Twelve Imperial Symbols and nine gold-couched five-clawed dragons embroidered onto yellow satin, ca. 1800.

Fig. 92

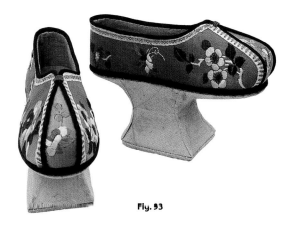

Fig. 93

## Manchu Children's Clothing

The wife of an emperor, together with his many consorts and concubines, produced sufficient offspring to ensure the emperor's succession. The Kangxi Emperor, for example, sired thirty-five sons from among his fifty-six children. Since the eldest son in the imperial family was not the only one eligible to succeed as emperor, Qing rulers took care to have all their sons educated to a high standard, so that each could be capable of ruling. A school was established within the Inner Court of the Forbidden City, and here the young princes studied the Confucian classics in the Chinese, Manchu, and Mongol languages, and military skills like riding and archery. Their teachers were graduates of the capital's prestigious Hanlin Academy.

Sons of the emperor and members of the Manchu court wore smaller versions of court and dragon robes, although surviving examples are rare (Figs. 94, 95, 96). Apart from shades of yellow, other dragon robes were in colors determined by rank, such as brown and blue. Red was also included as being a color right for festive occasions (Fig. 97).

On other occasions, a surcoat bearing a rank badge was worn, along with a hat, court necklace, and boots, all miniature versions of those worn by adults (Figs. 98, 99). For informal occasions, the young princes wore a hip-length *ma gua* jacket over a side-fastening long gown or *chang shan*, or an ordinary gown without slits at the hem, or the *chang shan* alone (Figs. 100, 101, 103). A skullcap completed the outfit.

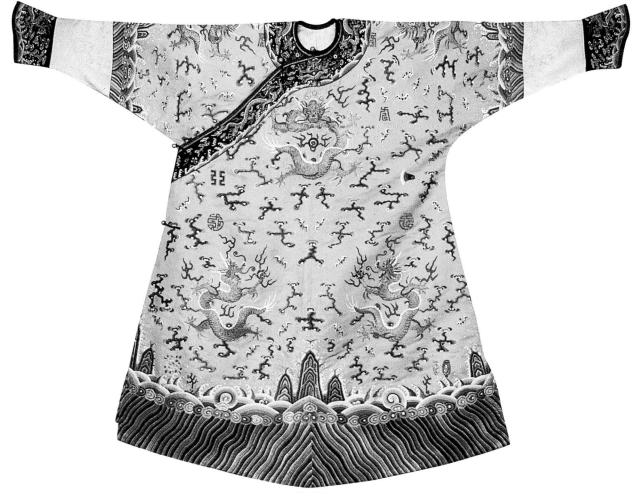

Fig. 94

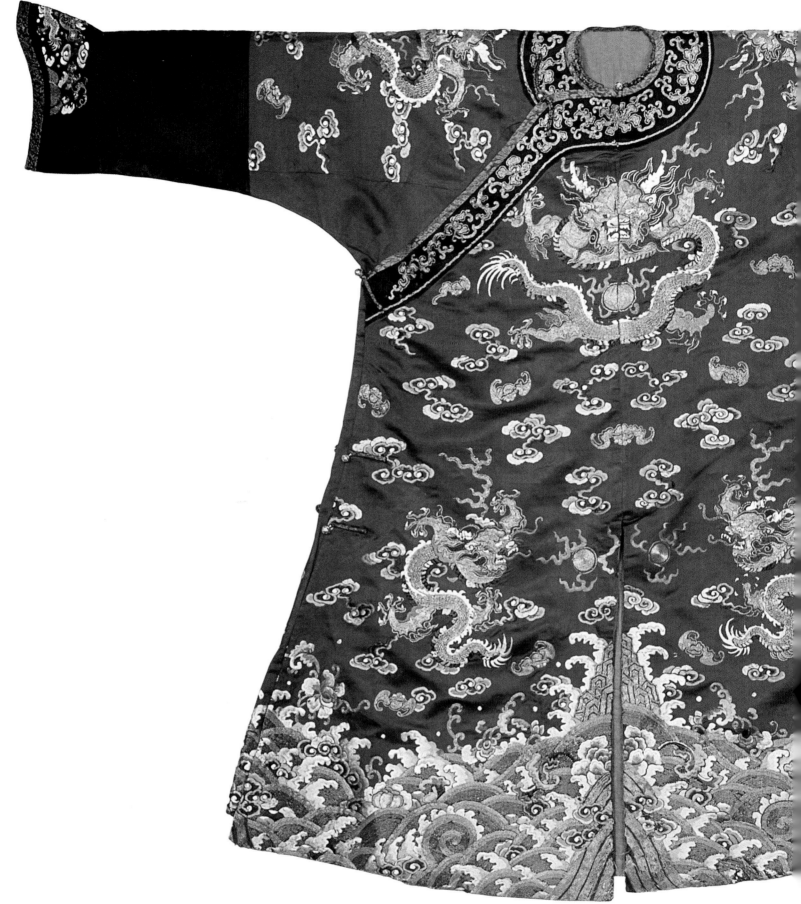

**Fig. 95**

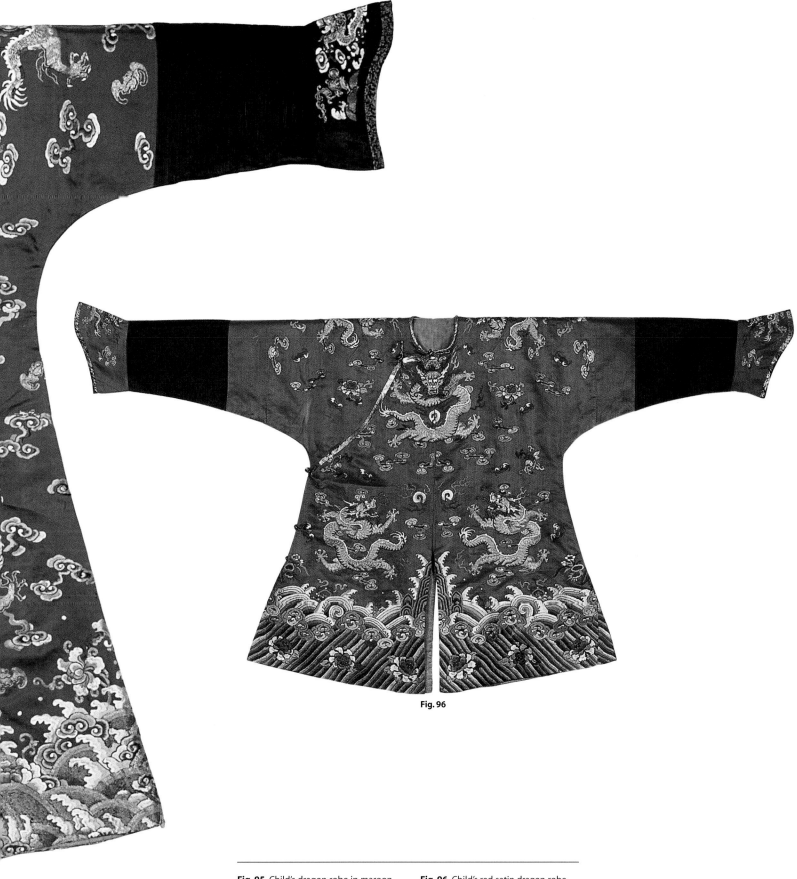

**Fig. 96**

**Fig. 95** Child's dragon robe in maroon satin, with eight dragons in couched gold thread, the upper four front-facing, the four on the skirt in profile, surrounded by bats and clouds, the lower sleeves of ribbed dark blue satin, early 19th c.

**Fig. 96** Child's red satin dragon robe, with eight dragons in couched gold thread, the upper four front-facing, the four on the skirt in profile, surrounded by flowers, bats, and clouds, the lower sleeves of dark blue satin, mid-19th c.

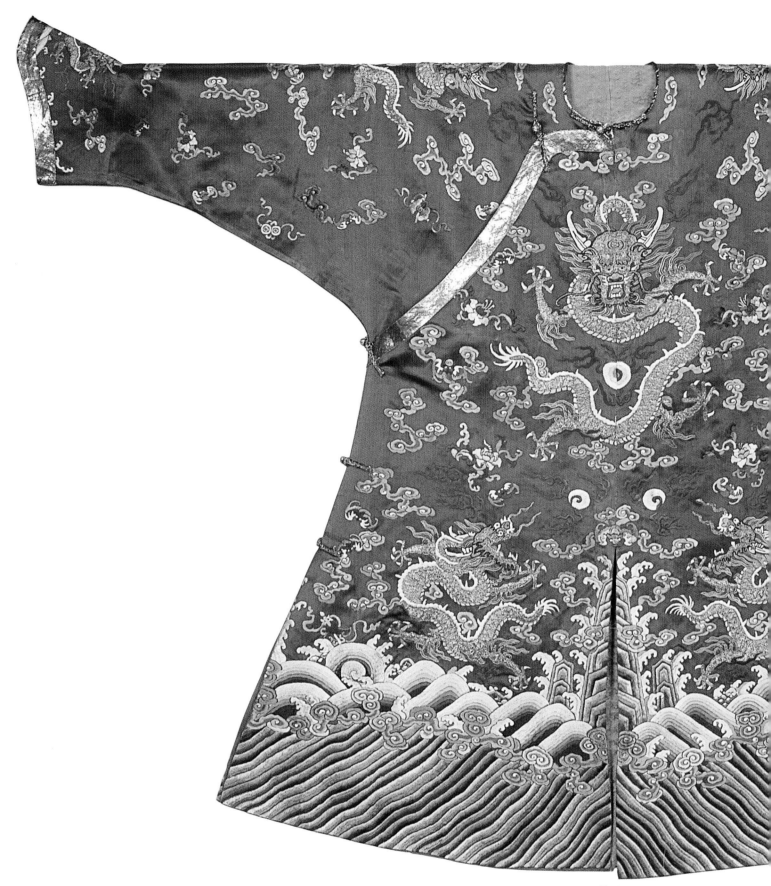

**Fig. 97**

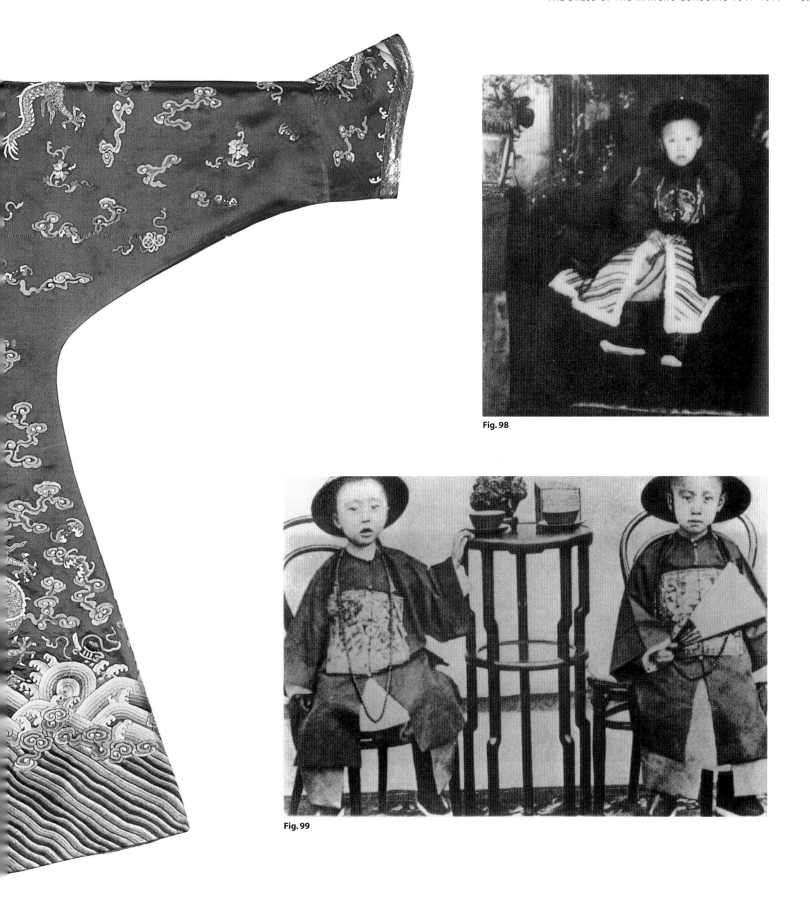

**Fig. 98**

**Fig. 99**

**Fig. 97** Child's brown satin dragon robe, with eight dragons in couched gold thread, the upper four front-facing, the four on the skirt in profile, surrounded by bats, flames, clouds, and auspicious emblems, mid-19th c.

**Fig. 98** The Emperor Xuantong, known as Puyi, wearing a surcoat with an embroidered roundel over a fur-trimmed dragon robe, 1911.

**Fig. 99** The future Guangxu emperor and his brother Prince Chun II (father of the last emperor, Puyi), wearing surcoats with square rank badges, ca. 1875.

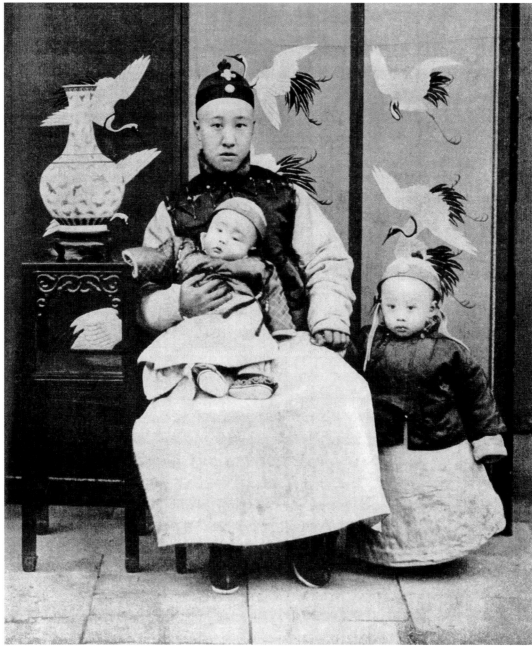

**Fig. 100**

Given the lowly status of women in China, young girls – even high-ranking ones in the imperial court – were denied any personal identity. They were always referred to by birth order, such as "elder sister" or "third sister." Princesses were not given personal names either, and instead took the identity of their fathers, and later their husbands. In lower-ranking families, women's births were not recorded in family genealogies at all. However, emperor's daughters, like imperial princes, were given ranks, which entitled them to certain privileges. Titles presented on a woman's marriage would also determine the title of her husband. These marriages were intended to forge political alliances, and were often to men from Mongol tribes, in a deliberate move to integrate Mongolia into the Manchu empire.

Young female members of the Imperial Household wore robes ranging in color from shades of yellow to turquoise, brown, and blue, depending on their status. Highly embroidered robes were worn on formal occasions, while for less formal wear they wore the *qi pao* or banner gown, a long gown which fell straight from the shoulders to the ground, fastening over to the right side, and a waistcoat (Figs. 102, 103).

**Fig. 100**  Prince Chun II with his sons, the two-year-old Puyi standing and his younger brother Pujie seated, all wearing informal black hip-length jackets over side-fastening long gowns, and skullcaps, ca 1907.

**Fig. 101**  Prince Yi Huan (grandfather of Puyi) with his sons, who are wearing shoes decorated as animals, ca. 1880.

**Fig. 102**  Manchu mother in a long gown and waistcoat with her daughter in a robe with a long vest trimmed with a fringe, ca. 1900.

**Fig. 103**  Manchu princesses wearing banner gowns, the young girls flanking them wearing waistcoats on top, ca. 1910.

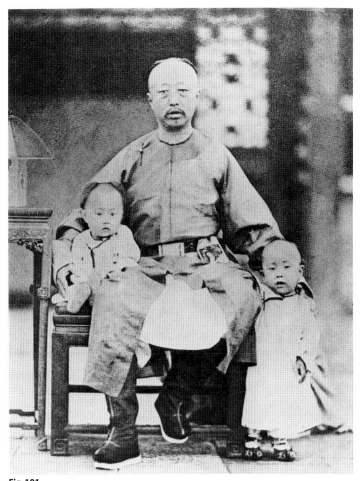

**Fig. 101**

**Fig. 102**

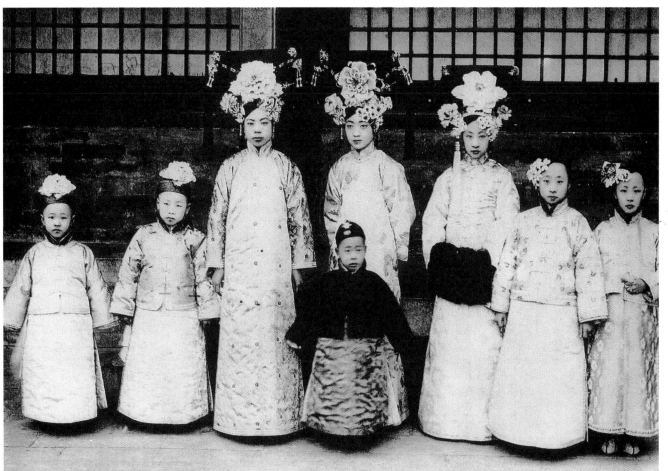

**Fig. 103**

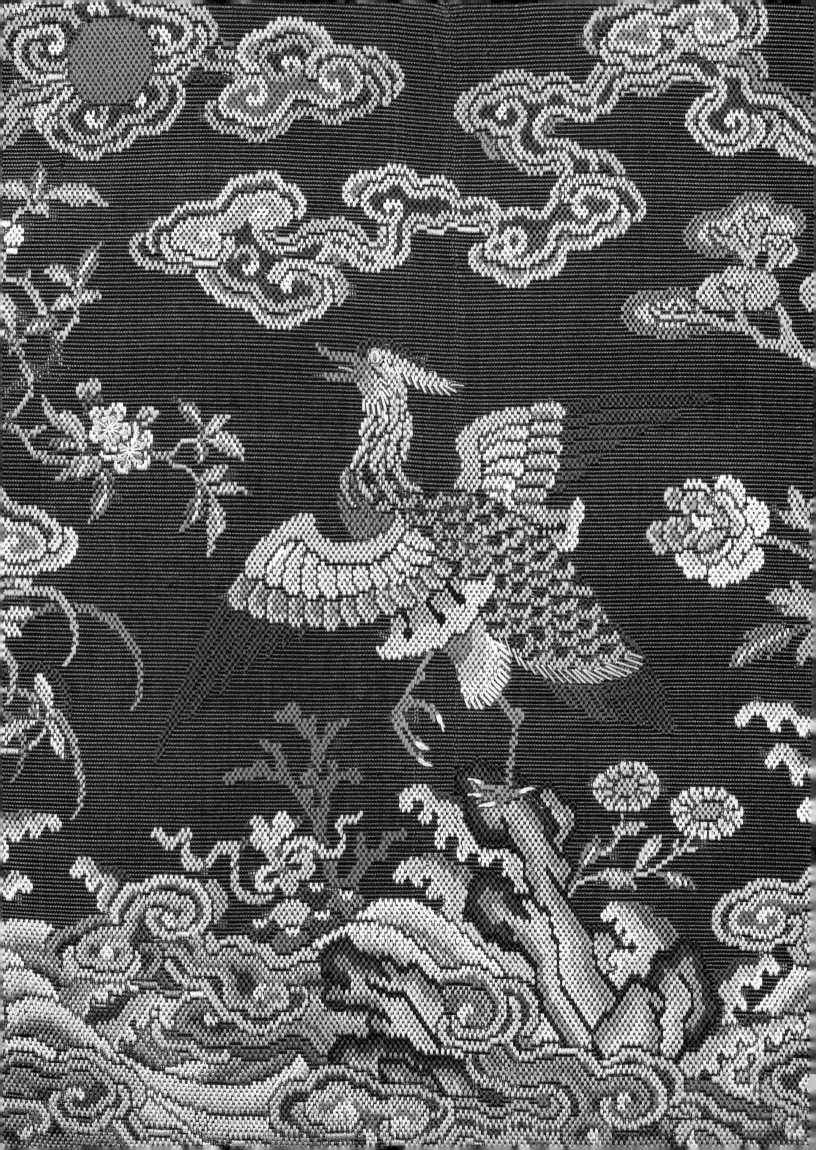

Chapter Three

# THE ATTIRE OF MANDARINS AND MERCHANTS

## Becoming a Mandarin

Once China was under the control of the Manchus, they adopted the system of government already established by the Ming dynasty, but modified it by applying checks to the weaknesses which had resulted in its collapse. Social status continued to be determined by the imperial government, which was run by officials known as mandarins (the word mandarin, *guan* in Chinese, is derived from the Portuguese word *mandar*, meaning "to command"). It was from a highly educated group of Manchu and Chinese men that the mandarins were selected. Although quotas were applied to the number of Manchu and Chinese admitted into the ruling class, from the very beginning the Manchu rulers allowed Chinese to enter both civil and military office at all levels. The Chinese were not only more able scholars than the Manchu, but there were many more of them familiar with an already established system.

There were two orders of mandarin. The first, and more highly respected, were the civil mandarins – scholar officials who administered the government of China – while the second were military officials responsible for internal stability and external defense. Within the two orders were nine ranks, each subdivided into principal and secondary classes. In the administrative hierarchy, civil officials were always placed higher than their military counterparts, since education and refinement, not courage, were considered the most important virtues. Each official was attached to a particular section of the administration, but during his career he could be assigned to judicial, administrative and fiscal duties, and could also be transferred from one post to another with little regard for his previous experience.

The main route to becoming a mandarin, and thus being eligible for appointment to office, was through success in a series of qualifying examinations based on the Chinese classics (Figs. 105, 106). An alternative route was for those with money and little ability to first purchase an academic degree and then an official rank and title. Some form of selection for office based on literary ability had been in place since the Tang dynasty, but it was during the Qing dynasty that the examination system reached its peak, and until its abolition in 1905 was the surest means of social and material advancement. The examinations were open to all males, with the exception of those classified as "mean people": boatman, laborers,

**Fig. 105**

**Fig. 106**

**(Page 62) Fig. 104** Seventh civil rank badge portraying a mandarin duck embroidered in counted stitch on silk gauze, ca. 1800.

**Fig. 105** Examination hall at Nanjing showing the individual stalls, which could accommodate 30,000 candidates, ca. 1900.

**Fig. 106** "Cheat's handkerchief" in silk, both sides inscribed with minute calligraphy in ink of selections from the Chinese Classics, late Qing. Some robes had "cheat's lining" – white silk covered with tiny characters as an aid to passing the examination.

actors and musicians, executioners and torturers. The poorest man could become a distinguished official provided he had the talent and the time to study.

At the age of eighteen, the *jun xiu* ("man of promise") was ready to take his first examination before the magistrate of the district in which he lived. A pass entitled him to be called *tong sheng* or student. The next hurdle was the annual examination for the first degree, which was held in the prefectural city. A pass enabled the scholar to become a *sheng yuan* or government student, colloquially known as *xiu cai* ("budding talent"). Certain privileges accompanied a pass in this examination: the student became a member of the gentry, he was entitled to government aid to enable him to continue his studies, and he was exempt from corporal punishment (Figs. 107, 108).

The examination for the second degree was held in the eighth moon of every third year in the provincial capitals. Strict quotas were imposed nationwide, based on the size of the province. Out of some 10,000–12,000 entrants in each province, barely 300 would obtain their degree and be known as *ju ren* or "promoted men" (Figs. 109, 110). A final examination was held in Beijing for those

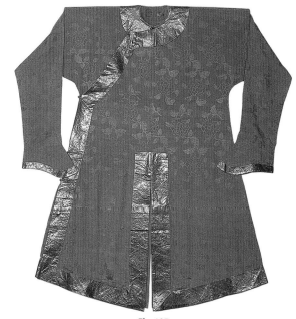

**Fig. 107**

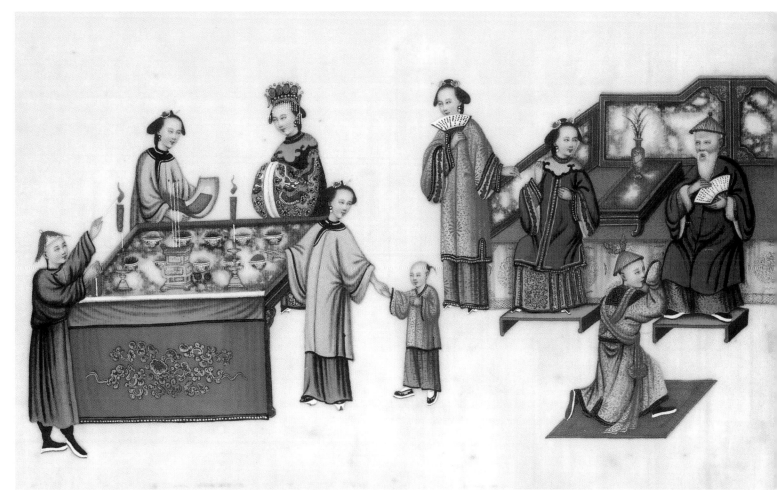

**Fig. 108**

**Fig. 107** Long plain blue silk gown with a black border and horse-hoof cuffs, made for a graduate of the first degree.

**Fig. 108** Painting by Tinqua of a graduate of the first degree at the ceremony to celebrate success after the examination, now entitled to wear a blue silk robe edged with black, a red scarf which crossed the chest twice to form an X, and gold foil hat decorations of branches and leaves, ca. 1854.

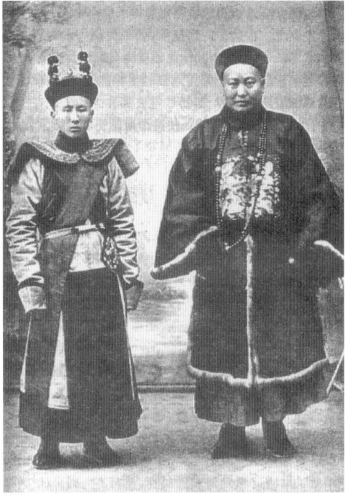

**Fig. 109**

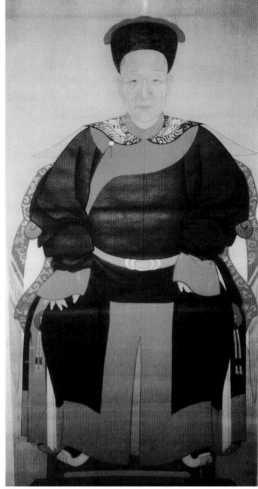

**Fig. 110**

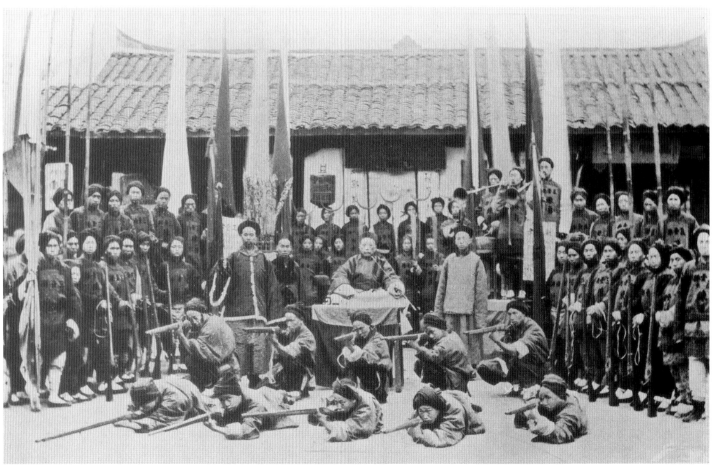

**Fig. 111**

Fig. 112

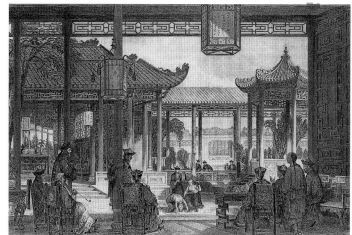

Fig. 113

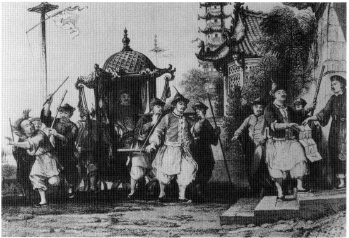

Fig. 114

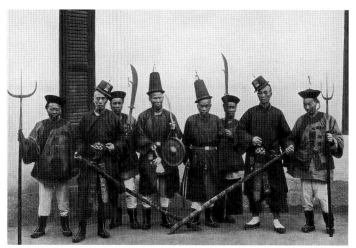

Fig. 115

who reached that high level. At the graduation ceremony, successful candidates were given an audience with the emperor, and were assured of a high position in the government.

Military examinations were based on physical feats rather than literary ability. A military degree was thus never held in high esteem by the intelligentsia, nor was it such an important requirement for military office as was the civil degree for civil office. Very often military promotions and appointments were made on the basis of family connections or financial considerations. Those with some military education could purchase a title as a short cut to military office, while the majority of officers in the Chinese *Lu Ying* or Green Standard Army rose through the ranks and did not obtain a title or degree first.

In addition to a literary test on a short military treatise, the examination for the first military degree tested the candidate's ability in archery, both on the ground and on horseback, and in swordplay (Figs. 111, 112). The emphasis on skill in archery continued throughout the nineteenth century, at a time when other nations of the world had progressed to using modern firearms. The second degree was similar in content to the first. A graduate would then go to Beijing to take the third degree. Success meant immediate employment in the army or navy anywhere in China.

In the provincial administration, the highest rank belonged to the viceroy or governor-general. He could be in charge of one, often two, and sometimes three provinces. In addition to his civil duties, he was also responsible for evaluating military officers and regulating the Chinese Green Standard Army. The position of viceroy was considered to be one of the most important – and desirable – in the land as it involved direct communication with the emperor. Below the viceroy was the governor, a second-rank mandarin with similar powers, who was in charge of the civil and military affairs of a single province. Next came the treasurer of the provincial exchequer, the provincial judge, followed by the salt and grain commissioners, marine inspectors, and other senior officials.

The province was divided into a number of prefectures, subdivided into departments and districts. A prefect or magistrate and

**Fig. 109** Graduate with his father, a mandarin, ca. 1900. The graduate is wearing a blue silk robe edged with black, with a red scarf crossing his chest twice, a *ling tou*, a *pi ling* collar, and a hat with two gold decorations.

**Fig. 110** Ancestor portrait of a graduate of the second degree, wearing a flared collar over a black gown with a wide blue border down the side opening, hem, center back and front splits, and cuffs. His hat has an eagle on top of the finial.

**Fig. 111** Literary official reviewing candidates in West China, ca. 1900.

**Fig. 112** Lifting the "300-catty stone" (ca. 399 lb/180 kg), part of the military examination to test the candidate's strength.

**Fig. 113** Jugglers performing in the courtyard of a mandarin's yamen, ca. 1843.

**Fig. 114** Mandarin in procession in his sedan chair, ca. 1843.

**Fig. 115** An official's retinue, including men with bamboo poles to beat back the crowds and three-pronged forks for catching thieves by their clothes, 1902.

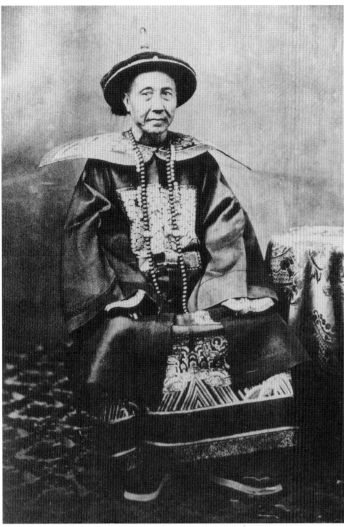

**Fig. 116**

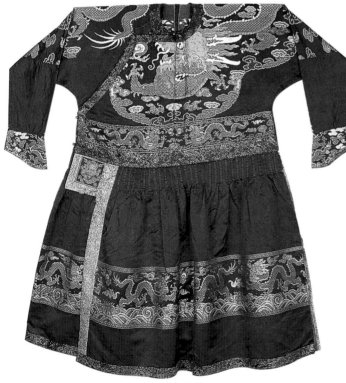

**Fig. 117**

several assistant magistrates administered each division. These lower-ranking mandarins, ranging from the fifth to ninth ranks, had many duties, at the same time acting as judge, tax collector, director of police, and sheriff of the district. They also assumed some military duties and, in an emergency, sometimes took an active part in military affairs (Figs. 113–115).

## Court Dress

In order to establish full control over the Han Chinese, the Manchu emperors decreed that their customs, language, and particularly their style of dress, be adopted by the conquered race. Although Manchu customs and the Manchu language were generally not adopted by the Chinese, the regulations concerning dress did take root a means of unifying the country and of making Han Chinese officials indistinguishable from their Manchu counterparts.

Mandarins from the civil and military orders, both Manchu and Han Chinese, wore Manchu-style robes on formal occasions, such as official government functions, celebrations, and festivals. However, the Chinese were allowed to wear their Han-style robes on informal occasions. As with the dress of the imperial family and their courtiers, clothing was divided into official and non-official attire and subdivided into formal, semiformal, and informal.

High-ranking mandarins wore formal court dress on all important occasions and for court attendances (Fig. 116). First- to third-rank civil and first- and second-rank military mandarins were permitted to wear the first winter style *chao pao* in blue-black, with four *mang* in profile on the upper body and two *mang* on the front and back band of the skirt. The second style of winter and summer *chao pao*, also in blue-black, was worn by the first four ranks of both orders of mandarin. The upper part of the *chao pao* was embellished with four front-facing *mang*, while the lower part of the skirt had four *mang* in profile at the front and back. No roundels, like those worn by the emperor and heir apparent, were allowed on the skirt, although these did make an appearance towards the end of the dynasty when traditions were breaking down (Figs. 117, 118).

Mandarins from the fifth to seventh ranks wore plain blue silk damask *chao pao* with gold and black brocade edging and square badges on the chest and back containing *mang* in profile. The eighth and ninth ranks wore plain *chao pao* with no squares. Robes of this type belonging to lower-ranking officials are very rare today as it was usual for a mandarin to be buried in his court attire. Moreover, such plain items were not considered sufficiently valuable or interesting to early collectors.

The *pi ling* collar was intended for use only with the court robe, but evidence in the form of paintings and photographs reveals that it was also worn with the dragon robe and surcoat bearing a badge of rank when "full dress" was required (Fig. 119). The *pi ling* had either five long or five *mang* dragons, according to the wearer's rank, embroidered on a dark blue ground.

**Fig. 116** Liu Changyu, Governor-General of Guangdong and Guangxi provinces, in official formal court attire comprising a summer hat, court robe, surcoat with a first-rank civil badge on the chest and back, flared collar, and court necklace, 1863.

**Fig. 117** Summer court robe in dark blue satin and brocade, with brocade edging, decorated with two four-clawed dragons in profile on the chest and back, and four on the front and back skirt band, early Qing. No roundels on the skirt.

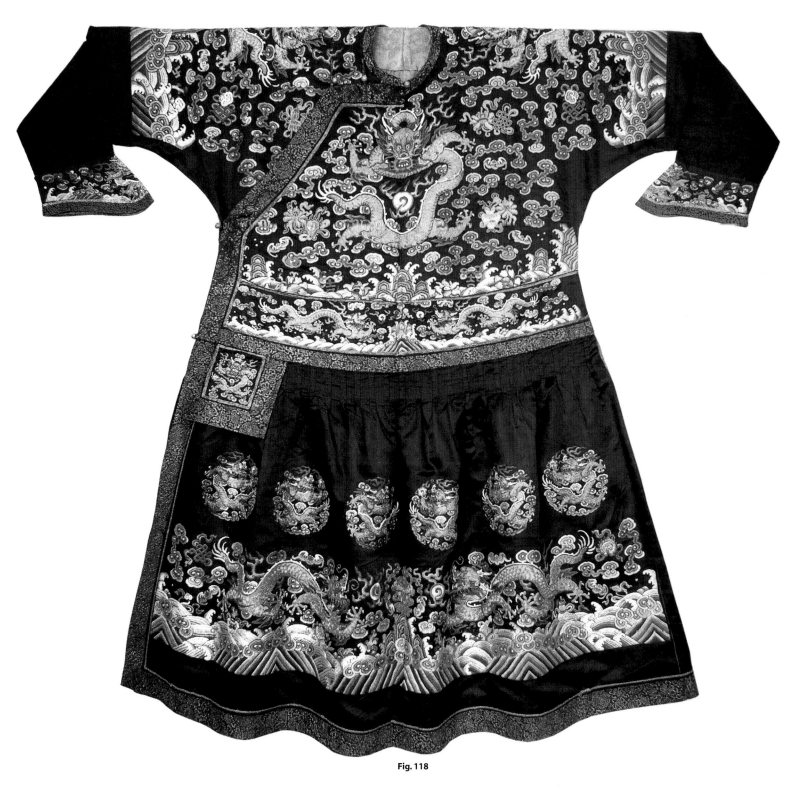

**Fig. 118**

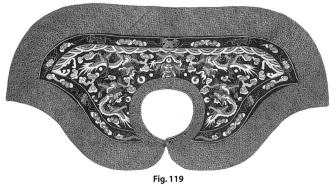

**Fig. 119**

**Fig. 118** Summer court robe belonging to an official, in dark blue satin with brocade edging, embroidered with gold couched dragons, satin stitch clouds, Peking knot Buddhist emblems, and six roundels on the skirt at front and back, mid-19th c.

**Fig. 119** Flared collar with five four-clawed dragons embroidered in satin stitch on dark blue satin, late Qing. The wide gold brocade border indicates it would have been worn with a summer robe.

## Dragon Robes and Informal Dress

For less important court occasions and official or government business, semiformal official clothing was worn. Colloquially known as "full dress," this comprised a dragon robe worn with the *pi ling* collar, stiffened *ling tou* collar, hat, necklace, boots, and a surcoat bearing badges of rank known to the West as "mandarin squares" (Fig. 120).

First-, second-, and third-rank mandarins were distinguished by the nine *mang* on their robes (Fig. 121). Single dragons were placed on the chest and back and the two shoulders, while two were embroidered on the front and back hems. A symbolic ninth dragon was hidden under the front inside flap of the robe. Fourth- to sixth-rank officials wore robes with eight four-clawed dragons (Fig. 122). *Long*, normally restricted to use by the emperor, were also worn by lower ranks if they had been awarded the privilege. Towards the end of the dynasty, many were worn without permission.

Lower officials of the seventh to ninth ranks and unclassified officials were allowed five *mang* on their robes, but this does not seem to have been put into practice as low-ranking officials seldom had occasion to wear such robes. Moreover, those with a low income could not have afforded them, and those with more wealth would have used their money or influence to gain a higher rank. At the end of the dynasty, even the lowest of officials could have openly worn an eight- or even nine-dragon robe if the occasion warranted it.

Off-duty mandarins wore official informal clothing for events not connected with major ceremonies or government matters. Indeed, it was considered bad form to wear formal robes at home, when visiting friends, or on other private occasions. This ordinary dress consisted of a *nei tao* – a plain long gown of silk, usually reddish brown, gray or blue, cut in the same style as the *mang pao* and worn under a surcoat. Low-ranking officials also wore the *nei tao* under a surcoat on semiformal occasions.

## Accessories

A mandarin was seldom seen without his hat, and then only in the private quarters of his home. Hats were worn irrespective of the degree of official formality. A winter hat with a turned-up brim of black satin, mink, sealskin, or velvet, and a padded crown covered in red silk fringing, was worn from the eighth month of the Chinese calendar (Fig. 123). For summer, beginning in the third month of the calendar, the hat was conical and made of split bamboo covered with silk gauze for high officials, and woven straw for lower-ranking public servants. Fringes of red silk cord or dyed horsehair covered the crown from apex to edge. When first introduced in 1646, an official noted that a shortage of materials in southern China meant they had to be cut out of baskets and straw mats (Wilson, 1986: 27). The split bamboo hats worn by high officials were made by villagers in Chengdu in Sichuan province. They took two days or more to weave, and the skill was passed down from generation to generation.

The use of hat finials and spheres meant that the rank of a mandarin could be determined at a glance. They were more conspicuous than badges of rank, especially as the badges were only worn on "full dress" occasions. Officials wore finials on their hats on ceremonial occasions. Above the ornamental base was a spherical shape with a small setting of transparent stone or piece of glass, and then

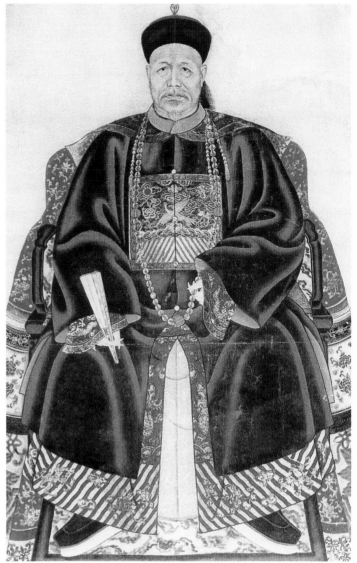

**Fig. 120**

above that the tall jewel depicting rank. The colors of the jewels – red, blue, white, and yellow – were based on Manchu banners. After the conquest of China, when the Manchu took over the Ming system of nine ranks, the small settings were added to depict the principal and the subordinate ranks. Then, in 1730, the Yongzheng Emperor added opaque stones to the transparent ones already in use, to denote subordinate rank. Previously, in 1727, he had introduced hat spheres, sometimes called "mandarin buttons" in the West, for less formal occasions to avoid confusion between ranks when insignia squares were not worn (Fig. 124). The buttons were made of either semiprecious stones or glass in descending order of rank: ruby, coral, sapphire, lapis lazuli, crystal, opaque glass, and gold or brass.

A hat decorated with gold branches and leaves was worn at a ceremony celebrating success in the examinations. Afterwards, for daily attire the man wore a hat with a finial in the shape of an eagle. The eagle, as it soars high, symbolizes a rapid rise in office; as it swoops low, it represents a desire for a long life. For graduates of the first degree, the bird was made of silver, or an alloy known as *bai tong* (white copper), which comprised copper containing a small amount of zinc and nickel, but resembling silver. Graduates of the next examination at provincial level wore the ornament made of silver with a gold bird on top. The *jin shi* or metropolitan graduate wore a gold ornament with three branches bearing nine leaves at the top.

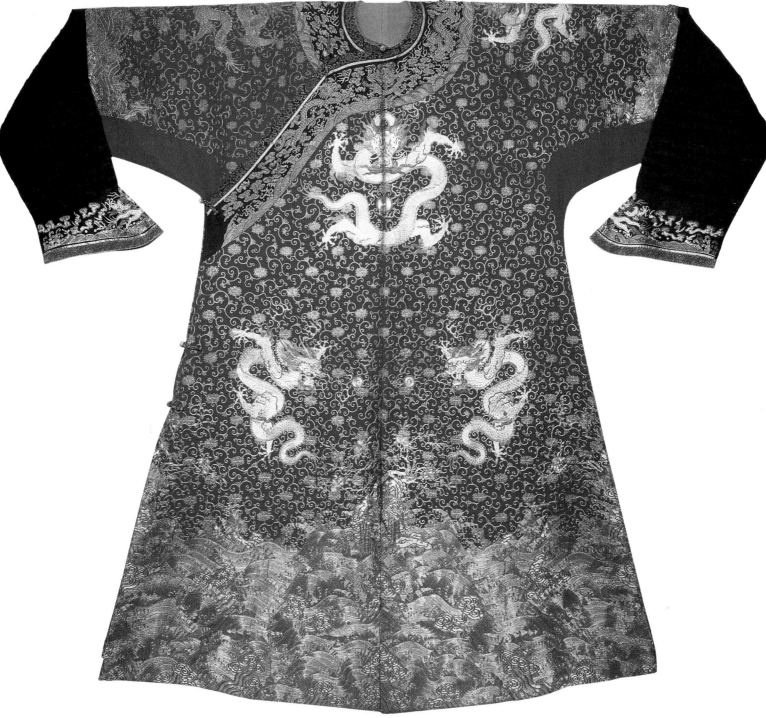

**Fig. 121**

**Fig. 120** Ancestor portrait of a mandarin in "full dress" – dragon robe with a flared collar and a stiffened collar under a surcoat bearing a rank badge, winter hat, necklace, and boots, late 19th c.

**Fig. 121** Dragon robe in blue satin lavishly embroidered with gold thread, five-clawed dragons, Qianlong period, with later replaced collar and cuffs.

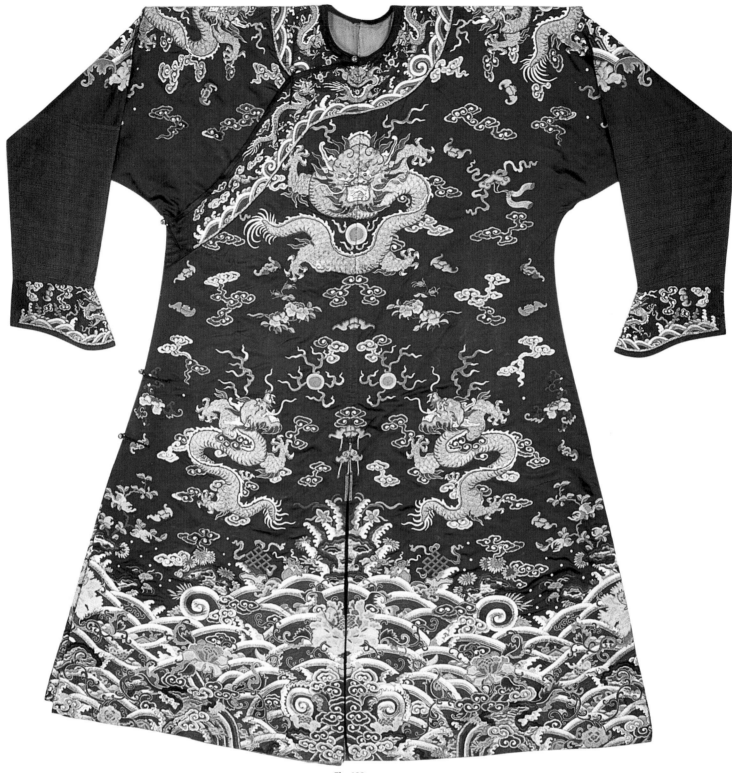

**Fig. 122**

**Fig. 122** Dragon robe for a mandarin of the fourth to sixth rank, in dark blue satin, embroidered with eight gold couched dragons, bats, peonies, and Peking knot Buddhist emblems, satin stitch clouds, and chain stitch *li shui*, with slits at the back and front hem only, and ribbed silk sleeves, Qianlong period.

**Fig. 123** Clockwise from back left: Mandarin's summer hat with fine silk fringing and coral hat button on a blue-and-white ceramic hat stand; stacking hat box for winter and summer hats, 19th c.; ivory hat stand, early 19th c.; Mandarin's winter hat with sealskin brim and crystal hat button; hat stand of wood inlaid with mother of pearl.

**Fig. 123**

On public occasions, mandarins of the fifth rank and above, who had permission, could attach peacock feathers or *hua yu* to their cap button. Peacock feathers were seen as a sign of great honor accorded by the emperor for exemplary services rendered. One, two or three overlapping peacock feathers were worn: the more eyes the greater the honor. However, towards the end of the dynasty, such feathers were openly for sale, with one example in the Victoria & Albert Museum in London still bearing the label from the Wan Sheng Yong Feather Shop in the main street in Beijing. Officials and officers of the sixth rank and below were allowed the use of black quills (*lan yu*) from the crow's tail (Fig. 125).

Mandarins also wore the *chao zhu*, the necklace of 108 semiprecious stones worn by the emperor and his court. Civil officials of the fifth rank and above, and military officials of the fourth rank and above, were required to wear the necklace, which could be made of any semiprecious stones other than pearls. The chain shown here is made of wooden and green and blue glass beads (Fig. 126).

Part of the Manchu traditional costume was a tightly woven girdle or belt in blue or blue-black silk, tied closely around the waist. The buckle of the belt and three similarly designed plaques were a further means of denoting rank. Materials for the plaques ranged from jade mounted in gold for the first rank, through gold, tortoiseshell, silver, and horn, although other materials could also be used (Fig. 129).

**Fig. 124**

**Fig. 124** Center back: Gold hat finial with a crystal and small blue stone setting. Right: Gilt hat finial topped with a bird for a provincial graduate. Top left: Plain gilt hat knob denoting seventh rank. Bottom left: Blue glass hat knob denoting third rank.

**Fig. 125** From left: Flat wooden box for holding the adjacent crow's tail quill; lacquered cylindrical plume case made for a military officer for holding the adjacent double-eyed peacock feather, bearing the inscription: "The merit of a good officer: yield when required to yield, be stern when necessary," dated 1876.

**Fig. 125**

**Fig. 126**

**Fig. 127**

The possession of a pair of boots was a demonstration of wealth and superiority. Boots could only be worn by officials and men with some position in society, as shown in this proverb of the day: "A man in boots will not speak to a man in shoes" (Sirr, 1849; reprint 1979, Vol. 1: 309). A mandarin's black satin knee-high boots were reinforced along the front and back seams with leather piping. The white soles were 3 inches (7 cm) thick (Fig. 127). Boots were expensive: a pair could cost as much as a servant's wages for the year (Wilson, 1986: 29). Blue padded and quilted cotton covers were made to button neatly over the boots for protection when not being worn.

Socks were worn inside the boots. For the cooler months, socks were knee length and made of silk, cotton, or linen, lined and padded with rows of stitching. Socks for warmer weather were shorter. Either embroidered or plain in blue or white silk or cotton, they could be worn over the hem of trousers when wearing shoes (Fig. 128).

**Fig. 128**

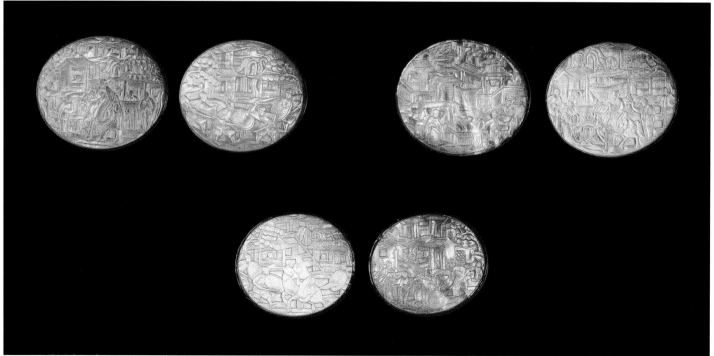

**Fig. 129**

## Surcoats and Civil Rank Badges

After 1759, a calf-length, center-fastening surcoat was mandatory for formal occasions. All who appeared at court were required to wear it, regardless of their background or income. Made from blue or purple-black satin, the surcoat was called a *pu fu* or "garment with a patch" when a badge of rank was applied, or a *wai dao*, meaning "outer covering," when worn without a badge. For winter, the surcoat was often lined or edged with white fur (sable was reserved for mandarins of the third rank and above). For spring and autumn, the lining was cotton, and for summer the garment itself was made of silk gauze with no lining (Fig. 130).

The surcoat was loose fitting, opening down the center front, with side and back vents. The three-quarter length sleeves and the fact that the coat reached mid-calf enabled the wearer to show off the sleeves and the embroidered hem of the court or dragon robe under it. In addition, the simple shape of the coat made it an ideal "canvas" for the badges of rank attached to the front and back.

A fur surcoat of the same style, called a *duan zhao*, was worn for extra warmth with winter dragon robes. However, its use was restricted to the imperial family, imperial guardsmen, and the first three ranks of mandarins (Fig. 131).

Although the Manchu, on assuming power, made a break with Chinese traditions and retained their own national costume, in 1652, eight years after the conquest, they brought back the Ming custom of indicating rank by insignia squares. With slight modifications, they continued the system of demarcating the nine ranks of civil officials by birds embroidered on the squares and the military mandarins by animals. The ability of birds to fly high to heaven indicated the superiority of the civil mandarins over their military counterparts whose animals were earth-bound.

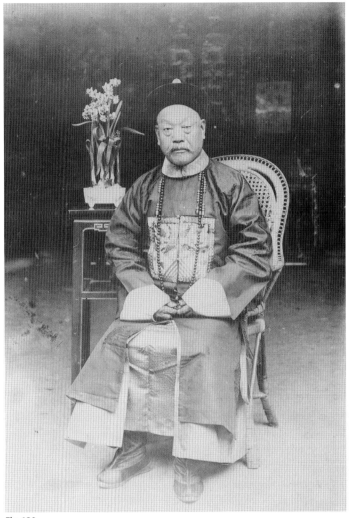

**Fig. 130**

**Fig. 126** Woven rattan box containing a necklace of 108 carved wooden beads interspersed with four "jade" beads, the counting strings and counterweight of blue glass.

**Fig. 127** Black satin boots with thick white soles, an inscription on the lining indicating they were made for a military official.

**Fig. 128** Men's socks, one pair in white cotton, the other in blue silk, both with cotton soles, 19th c.

**Fig. 129** Set of girdle plaques inlaid with mother-of-pearl and mounted in silver.

**Fig. 130** Fourth-rank civil mandarin in official informal dress comprising a calf-length, center-fastening surcoat with a rank badge and stiffened collar, over a long plain gown, ca.1900.

**Fig. 131** High-ranking mandarins wearing fur surcoats over their winter dragon robes, and winter hats with peacock feathers, 1906.

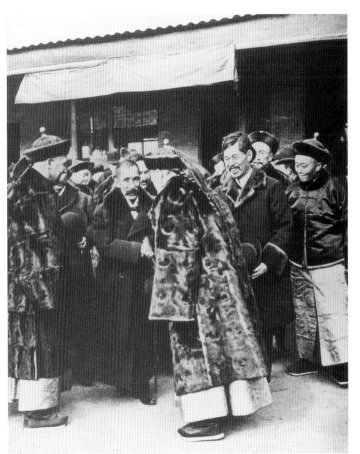

**Fig. 131**

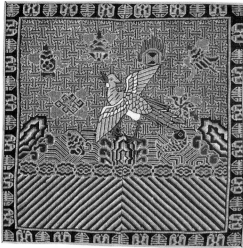

**Fig. 132**

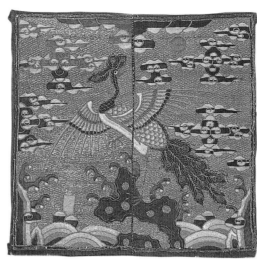

**Fig. 133**

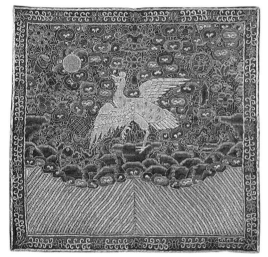

**Fig. 134**

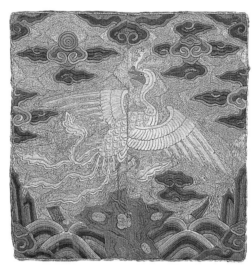

**Fig. 135**

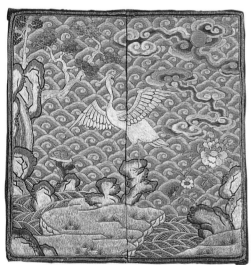

**Fig. 136**

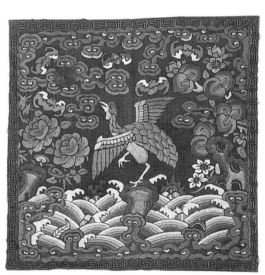

**Fig. 137**

**Fig. 132** Second civil rank badge showing a golden pheasant surrounded by the Eight Buddhist Emblems embroidered in tent stitch on silk gauze, late 19th c.

**Fig. 133** Badge for the wife of a third-rank civil mandarin showing the peacock and peacock feather embroidery on the rock. The gold background filled with clouds and white striations is typical of the transitional Yongzheng/early Qianlong period.

**Fig. 134** Fourth civil rank badge portraying a wild goose embroidered in white against a background of blue brick stitched clouds and Buddhist emblems outlined in gold, the *li shui* below couched in gold thread, ca. 1875.

**Fig. 135** Fifth civil rank badge showing a silver pheasant embroidered in white silk against a background of elongated clouds and swirling couched gold thread, peacock feather embroidery partly missing on the rock, Kangxi reign.

**Fig. 136** Badge for the wife of a sixth-civil rank mandarin showing an egret in a natural setting, Qianlong period, mid-18th c. Badges from this period were often smaller than before; this one measures 8 inches (20.5 cm) square.

**Fig. 137** Eighth civil rank badge showing a quail embroidered in satin stitch against a cloud filled sky, first half 19th c.

**Fig. 138** First civil rank badge in *kesi* depicting a crane against a cloud-filled sky, surrounded by five bats, first half of 19th c.

**Fig. 139** Badge for the wife of a ninth-rank civil mandarin depicting a paradise flycatcher with three tail plumes, unlike later in the dynasty when two became the norm, ca. 18th c.

**Fig. 140** Censor's badge depicting the *xie zhai* in couched gold and silver thread, mid-19th c.

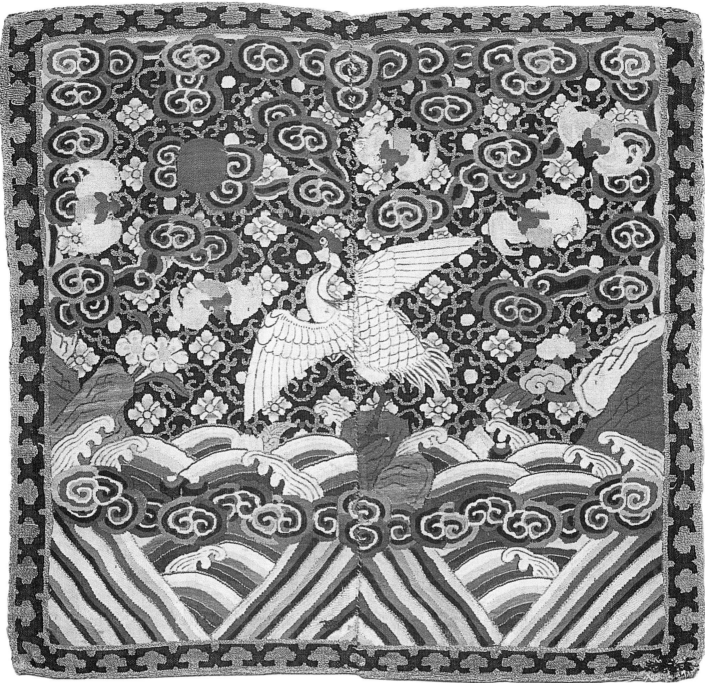

**Fig. 138**

**Fig. 139**

**Fig. 140**

Even though it had always been possible for a man to purchase a degree and, consequently a rank, this practice increased rapidly towards the end of the dynasty as the Qing government began selling ranks as a means of generating revenue. Ranks without office were sold even to merchants and tradesmen. This led to the practice of wearing appliquéd birds and animals, instead of those worked into the square, as the speed with which officials rose through the ranks meant that the base could be retained and the bird or animal simply changed.

For a civil official, the bird's head faced the wearer's right; for his wife, the badge was identical except the bird faced left. For a military official, the animal's head faced the wearer's left, and for his wife it faced right. Both birds and animals were depicted looking up to the sun disk placed in the top corner of the badge, which was a kind of rebus for "Point at the sun and rise high" (*zhi ri sheng rao*) (Cammann, 1953: 11).

The first civil rank was represented by the Manchurian crane, while ranks two to nine, in descending order, were represented by the golden pheasant, peacock, wild goose, silver pheasant, egret, mandarin duck, quail, and paradise flycatcher (Figs. 104, 132–139). It is sometimes difficult to distinguish between the different birds. Often the embroiderer had never seen the subject matter live, and would have to rely on doubtful representations for guidance. Unscrupulous officials would also try to have their rank symbol looking as much as possible like the one above it, even though emperors repeatedly issued edicts to stop this deceitful practice. In addition, towards the end of the dynasty the birds were also depicted in gold and silver threads, thus rendering color useless as a means of identification.

One further badge worn by officials with civil responsibilities was that of the Censor, whose role it was to report on the honesty and integrity of the other mandarins. The Censor was depicted as a mythical animal called a *xie zhai*, which symbolized justice (Fig. 140). It had a horn to gore wrongdoers and roared when it encountered unlawful behavior.

There were also badges worn which related more to occasion than rank. Elderly men who had continually tried to pass the examinations, and failed, and who held no official rank could wear what was known as a Four Character square. Such squares were of similar size to insignia rank badges, but in place of a bird there were four characters on the front square, *huang en qin zi*, or similar, implying they were "conferred by imperial grace." The back square bore a large *shou* character.

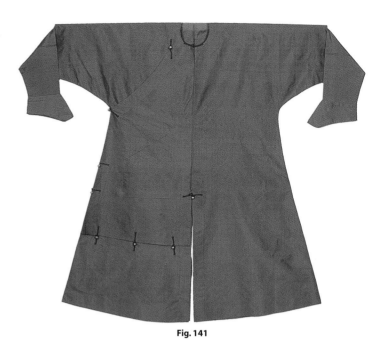

**Fig. 141**

## Military Officials and Rank Badges

In addition to the Manchu banner divisions, a second regular army, the Green Standard Army or *Lu Ying*, was established by the Manchu as a form of provincial constabulary within the Qing administration. Made up entirely of Chinese, its name derived from the army's large triangular standard, which was made of green satin with a scalloped red satin border representing flames and a gold dragon embroidered in the center. The Green Standard Army was divided into army and navy and was responsible for the defense and internal security of the country. It was made up of two kinds of soldiers: those permanently employed, and those, named *yung* or "braves," who were called up to fight when required.

Manchu officers shared responsibility with Chinese officers for the Green Standard Army units. This regular army was organized by province, with a commander-in-chief stationed in the provincial capital or prefectural city. Below him were the brigadier-generals, colonels, majors and captains, sergeants, and corporals who were stationed in the smaller cities and towns, and who cooperated with the civil mandarins and village headmen in maintaining order.

There were nine ranks of military officials, both principal and subordinate (Figs. 142, 143). The lower ranks of military mandarins

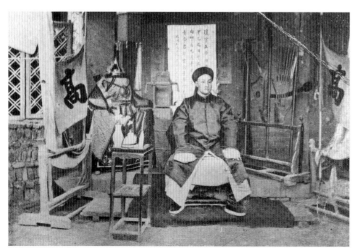

**Fig. 142**

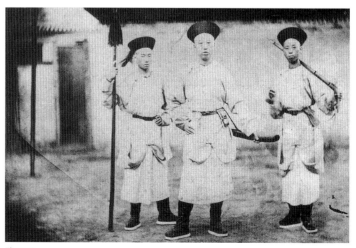

**Fig. 143**

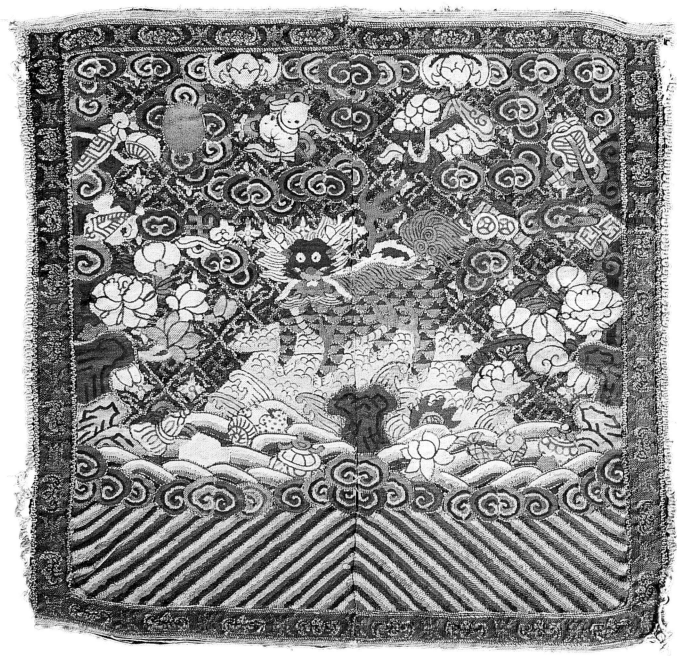

**Fig. 144**

did not enjoy the same status as the equivalent civil ones and had to ride on horseback rather than be carried in sedan chairs, though this was not always observed towards the end of the dynasty. High-ranking military mandarins wore the same hats and robes as civil mandarins, distinguished only by an animal rather than a bird on the rank badge. Red horsehair or yak hair replaced silk fringing on summer hats of soldiers and guards. The hair extended beyond the brim to keep flies out of the eyes when on sentry duty. Lower ranks such as clerks and attendants wore shorter black velvet or satin boots made more flexible with thin leather or cotton soles.

The plain long gown (*nei tao*) worn by military mandarins had a section at the lower right-hand side above the hem, which fastened with loops and ball buttons and could be removed when riding on horseback (Fig. 141). Two kinds of hip-length jackets (*ma gua*) – originally a military garment that was later adopted for traveling – were worn with the *nei tao*. The first type fastened over to the right with the lower part cut away from the right-hand corner. The second type, also with a detachable lower section, fastened down the front, and was eventually worn by all officials up to the twentieth century.

**Fig. 141** Military gown in blue jacquard silk gauze.

**Fig. 142** Military official at home, his uniform and weapons displayed in the background, ca. 1900.

**Fig. 143** Lower-ranking officers wearing the military version of the *nei tao* gown, and satin boots, 1863.

**Fig. 144** First military rank badge in *kesi* showing a *qilin* surrounded by clouds, bats, and the Eight Daoist Emblems, ca. 1850.

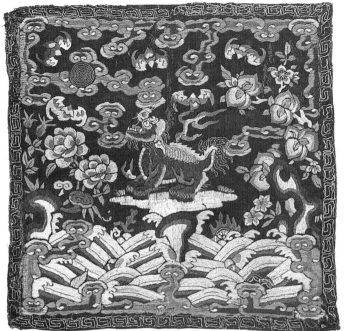

**Fig. 145**

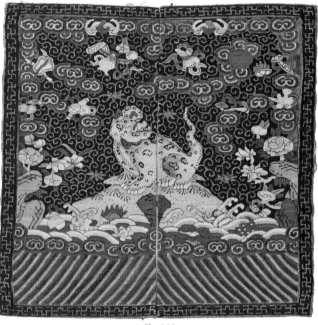

**Fig. 146**

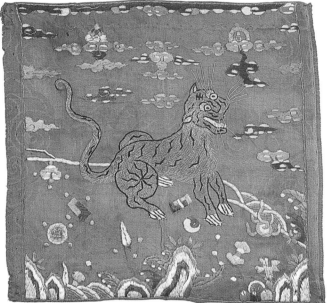

**Fig. 147**

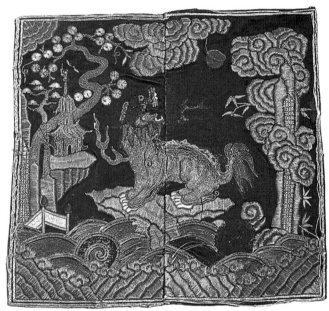

**Fig. 148**

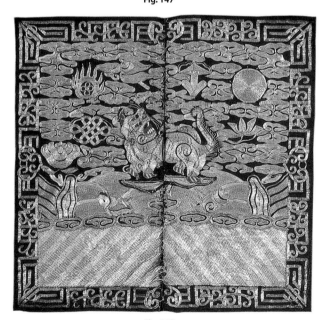

**Fig. 149**

**Fig. 145** Second military rank badge with a lion embroidered in satin stitch on a dark blue ground amidst clouds, flowers and bats, *li shui* below, early 19th c.

**Fig. 146** Third military rank badge in *kesi* showing a leopard standing on a rock in a natural setting surrounded by bats and the emblems of the Eight Immortals, late 19th c.

**Fig. 147** Fourth military rank badge for a provincial officer depicting a tiger embroidered in couched gold thread on a green satin ground. The striated clouds and absence of a sun disk indicate a first half 18th c. date.

**Fig. 148** Fifth military rank badge showing a bear surrounded by Turkish-style embroidery of padded gold couched threads of trees and a pagoda on black satin, ca. 1750–80.

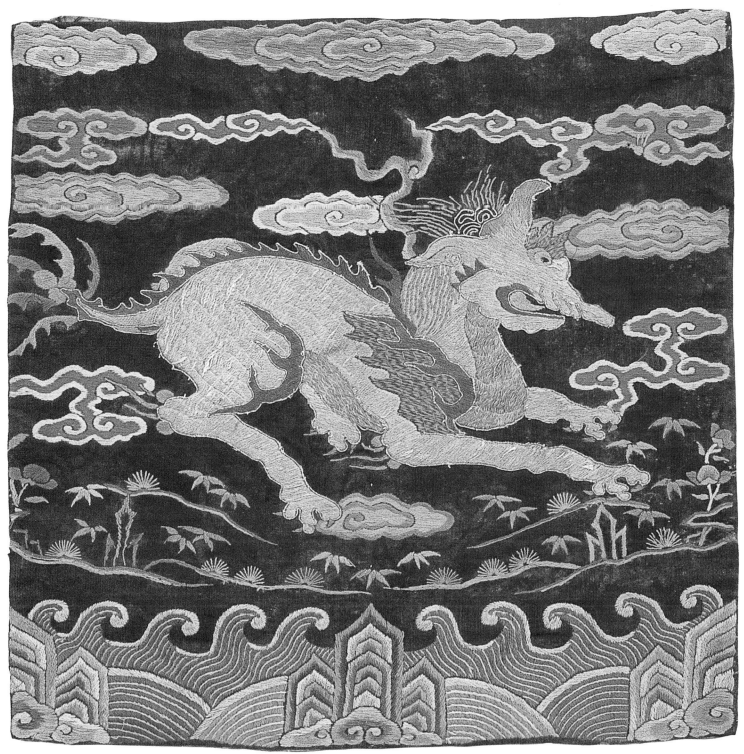

**Fig. 150**

**Fig. 149** Sixth and/or seventh military rank badge bearing a panther embroidered in couched gold and silver thread and appliquéd onto the badge, late 19th c. Birds and animals were appliquéd to the badges in the late nineteenth century when it became more common to buy one's way up the ladder. This made it easier to remove the lower-ranking bird or animal and replace it with a higher one.

**Fig. 150** Very rare example of what is possibly the eighth military rank, the rhinoceros, a horned animal running over land, embroidered in white and tan on a blue damask ground, Ming dynasty (1368–1644). Since there are no other known existing examples of this rank, it has been identified by comparing it with the woodblock illustrations in the Ming and Qing encyclopedias. Badges from this period were larger than those in the Qing: this one is 13.8 inches (35 cm) high and 14 inches (36 cm) wide.

Animals were often embroidered without any attempt to obtain a true likeness. The animal representing the highest military rank was the *qilin*, a composite beast with a dragon's head, a pair of horns, hooves, the body of a stag covered with large blue or green scales, and a bushy lion's tail (Fig. 144). It was believed to have great wisdom. Below the *qilin* were the lion, leopard, tiger, bear, panther (for the sixth and/or seventh rank), rhinoceros and sea horse (Figs. 145–150). Examples of the rhinoceros and sea horse are extremely rare, as they belonged to provincial soldiers who would have had to destroy them when the dynasty fell in 1911.

In the nineteenth century, the Manchu rulers were forced to recruit Chinese volunteer forces to assist in dealing with both foreign invasions and internal revolts. With official permission, many Chinese landowners raised units to fight the Taiping and other rebels. These were known as *yung* or "braves" from the character written in the circular badge on the front and back of the jacket. As these uniforms and weaponry were used infrequently, they were often pawned by the commanding officer (also a fairly common practice for special civilian dress among the general population). This occurred, for example, when the defeated military leader Li Hong-Zhang arrived in Shanghai after the Sino-Japanese war in 1894–5. The guard of honor was made up of two battalions of braves carrying weapons more appropriate for an armorer's museum than a military unit; attached to each was a pawnbroker's ticket (Cunningham, 1902: 75).

The traveler and writer Isabella Bird writes similarly on seeing Chinese troops on their way to the same war: "The uniform is easy, but unfit for hard wear, and very stagey – a short, loose, sleeved red cloak, bordered with black velvet, loose blue, black or apricot trousers, and long boots of black cotton cloth with thick soles of quilted rag. The discipline may be inferred from the fact that some regiments of fine physique straggled through Mukden [Shenyang] for the seat of war carrying rusty muskets in one hand, and in the other poles with perches, on which singing birds were loosely tethered.… Yet they made a goodly scenic display in their brilliant coloring, with their countless long banners of crimson silk undulating in the breezy sunshine, and their officers with sable-tailed hats and yellow jackets riding beside them" (Bird, 1898; reprint 1970: 209–10).

## Clothing for Children of Mandarins

Sons who still lived at home or who had not taken public office, and daughters who had not yet married, could wear the dress of their father, except for his insignia of hat jewel, girdle plaques, and rank badge (Figs. 152, 153). Despite this ruling, children's rank badges surface from time to time, proving that traditional laws were often disregarded (Figs. 154–156). These badges all seem to be of the higher ranks since only the highest officials could have afforded to dress their children in official robes or would have had any need to.

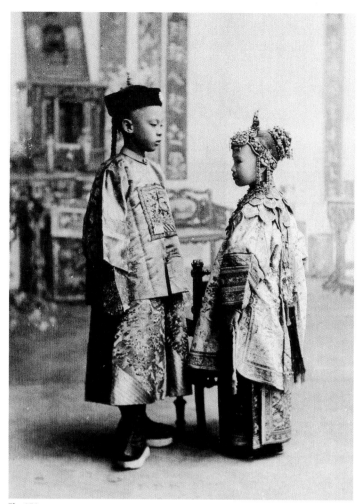

**Fig. 151**

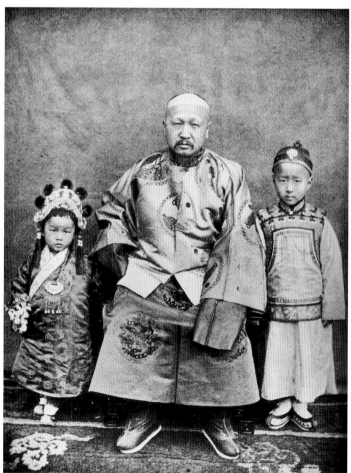

**Fig. 152**

**Fig. 151** Children of a Chinese mandarin, the boy wearing a jacket with a rank badge over a dragon robe and boots; the girl in an *ao* upper garment and wedding collar over a skirt, ca. 1900. Since a girl was not entitled to wear a skirt until she married, this is probably a betrothal picture.

**Fig. 152** The Governor of Shanxi with two of his sons, the one on the right in informal dress of a long, side-fastening gown and a red sleeveless waistcoat (*bei xin*), 1902.

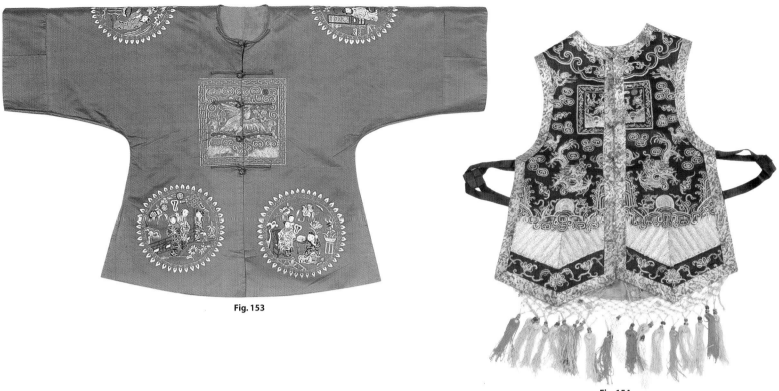

**Fig. 153**

**Fig. 154**

**Fig. 155**

**Fig. 156**

**Fig. 153** Girl's orange/red satin surcoat with six embroidered roundels showing scenes of scholars and ladies in a garden surrounded by peaches for longevity and other auspicious symbols, the center front and back rank badges depicting the crane and bats embroidered in couched gold thread, ca. 1870–1900.

**Fig. 154** Young girl's *xia pei* official vest, with fifth-rank civil badges at chest and back showing the silver pheasant. The vest is made of black satin, couched with gold and silver thread depicting dragons, cranes, bats and clouds above a *li shui* hem edged with multicolored tassels, late 19th c.

**Fig. 155** Boy's black satin surcoat with a first-rank civil badge over a blue *nei tao* gown, mid-19th c.

**Fig. 156** Young boy's fifth-rank badge with a silver pheasant embroidered in white floss silk on a black satin background, Yongzheng (r. 1723–35).

## The Chinese Merchant Class

Many Chinese merchants and landowners were exceedingly wealthy and their lifestyles superior to that of a mandarin, especially as the latter's salary was not high and he had many expenses. The homes of these rich merchants were often located in the suburbs of a city and were concealed from the eyes of onlookers by high walls. A large garden usually surrounded the house, with small lakes stocked with fish and lotus flowers, bridges, willow trees, pavilions, and winding paths (Fig. 158). Gardens were very important to the Chinese gentry, who viewed them as a retreat, a refuge from business affairs, and a place in which to revive the spirits.

Chinese mansions were renowned for their ornate architecture and collections of rare books, paintings, and calligraphy. Inside was a series of courtyards, large and small, and adjacent parallel halls of various sizes. The main rooms were graced with massive columns, paneling, latticework, and woodcarvings, and were replete with carved furniture, scroll paintings, and calligraphic couplets: "… in the houses of the wealthy there is no little elegance. The stiff-backed chairs and tables are of carved ebony or inlaid with mother-of-pearl or marble. The divan is supplied with mats and cushions on which the guests may recline and smoke their opium, while they may sip their tea and take their refreshments from choice China on the little marble-topped tea trays or tables arranged around the room" (Graves, 1895: 28).

During the Qing dynasty, the Han Chinese had slimmed down the voluminous Ming robes. After their conquest by the Manchu, they also incorporated some features from Manchu garments in

**Fig. 157**

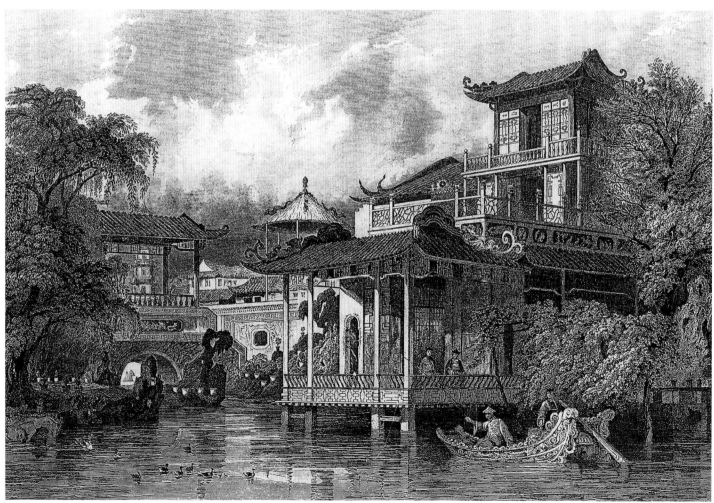

**Fig. 158**

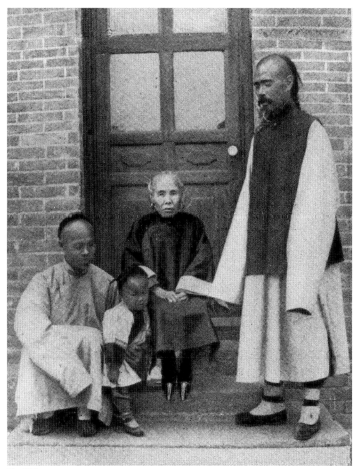

**Fig. 159**

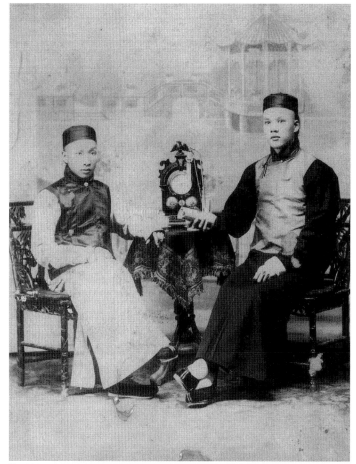

**Fig. 160**

their *chang shan* gowns, including the curved front opening, which echoed animal skin origins, and the fastening of loops and buttons, again of nomadic derivation. The Chinese gown was adapted to suit a more sedentary way of life than the *nei tao*: the center back and front slits were closed and the sleeves became long and tapering without the horse-hoof cuffs. A hip-length *ma gua* jacket with wider sleeves was worn over the *chang shan*, while a sleeveless jacket was worn on less formal occasions (Figs. 157, 159–163).

Silk was used to make the garments, often gauze for summer and satin for winter, while the lower classes wore cotton. Black gummed silk (*hei jiao chou*) was popular for its durability and coolness in hot weather (Fig. 164). In winter, gowns were wadded with silk or lined with cat or dog fur, as well as goatskin and sheepskin, for extra warmth. These fur-lined gowns would pass from father to son as part of his inheritance, since the styles changed little over the years. It was also the custom for rich and poor alike to pawn their fur-lined garments during the summer months, as they would be stored better.

Wearing pawned clothing was a common habit, as this description of the celebrations to mark the start of Lunar New Year reveals: "Everyone will appear, if possible, in long robes and jackets of silk

and satin, with their red-buttoned and tasselled skull caps on…. These fine clothes can be hired, the price being gradually lowered as the hours of the first six days pass by. We complained once of the very late arrival of a caller, who should have been among the first to salute us. He replied that money was scarce and he was obliged to wait for the cheapest day to secure a fine robe already donned and doffed by a dozen others" (Moule, 1914: 201).

No special clothing was worn for sleeping or for under outer garments, and nightwear or underwear was often an older or thinner version of the top garment. The bamboo vest or jacket was one exception, and worn up to the beginning of the twentieth century. "Bamboo clothing is made from the finest branches of the tree, worn in summer next to the skin to keep the light cotton shirt or inner jacket from irritating the skin when moist from perspiration…" (Dudgeon, 1884) (Fig. 165).

On informal occasions, men wore a close-fitting skullcap made up of six segments; this was also worn as everyday wear by the lower classes. Called a *guan pimao* or melon cap, as it resembled a half melon, or else *xiao mao*, meaning "small hat," the cap was made of black satin or gauze and topped with a red or black knotted silk cord knob, which was changed to blue if the wearer was in mourning.

**Fig. 157** Merchant wearing a long side-fastening gown (*chang shan*) with long tapering sleeves, belted round the waist, with boots. He is holding a fan.

**Fig. 158** Home and garden of a wealthy salt merchant in the Western suburbs of Guangzhou, 1792.

**Fig. 159** Chinese merchants, with elderly woman and child, wearing gowns with long tapering sleeves, ca. 1890.

**Fig. 160** Merchant and son, both wearing the long gown and waistcoat, with a melon cap and black cloth shoes.

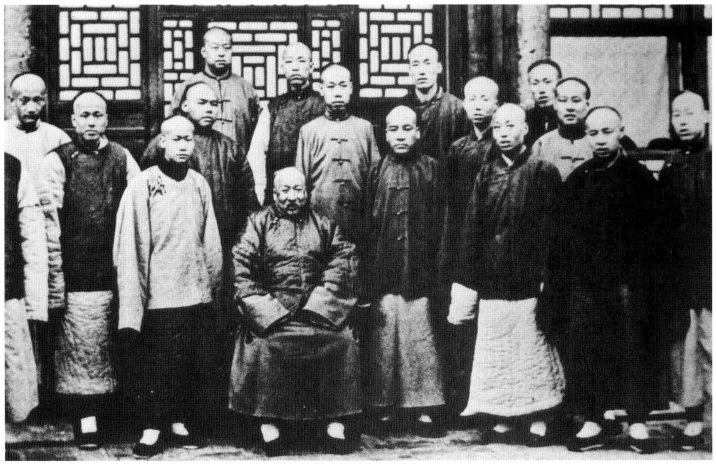

**Fig. 161**

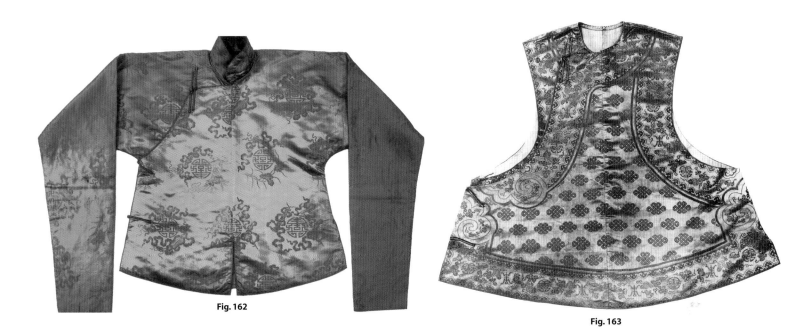

**Fig. 162**

**Fig. 163**

**Fig. 161** Group of Chinese mathematicians wearing the *chang shan* below the hip-length jacket, Beijing, ca. 1870.

**Fig. 162** Dark cream silk damask padded jacket with long tapering sleeves and *shou* characters surrounded by emblems of the Eight Immortals, ca. 1870.

**Fig. 163** Rust silk damask waistcoat with the Endless Knot design, mid-19th c.

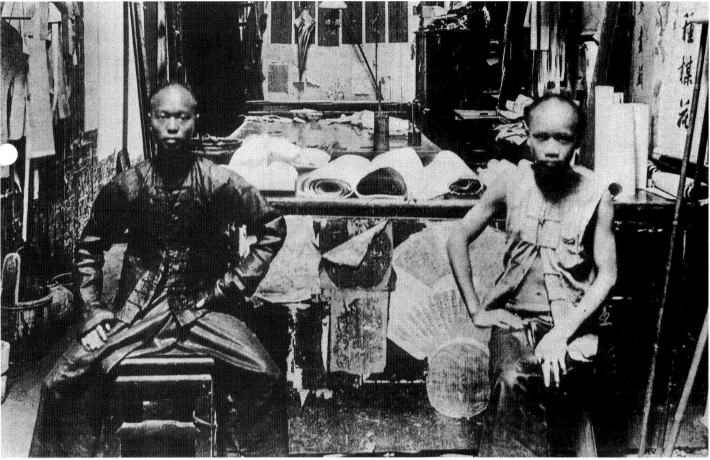

**Fig. 164**

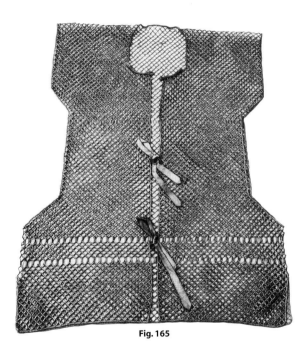

**Fig. 165**

For summer, the hat was often lined with rattan for ventilation. Some hats were stiffened and sold in circular cardboard boxes, while others were soft and folded into six for easy storage in triangular boxes or paper pouches. The skullcap continued to be worn well into the middle of the twentieth century, but the shape changed from the earlier flatter crown to a more rounded one. Hoods, buttoned under the chin, developed from the skullcap for wear in the bitterly cold weather of northern China (Fig. 166).

Some skullcaps had an attached queue or pigtail. As a sign of subjugation, all Chinese males had to shave the front of their head and wear their hair in a single plait in the style of the Manchu rulers. The plait resembled a horse's tail, the animal whose speed and stamina had helped in the conquest of China. At first, this ruling was bitterly resented, but was later accepted and became most respectable. As a punishment, the queue could be cut off, and to be called *wu bian* ("tailless") was a great insult. At the end of the nineteenth century, when men went to study or travel overseas, they removed the queue, and on their return wore a cap with a false one attached. In practice, however, most queues were lengthened by the addition of some false hair. Wearing the queue was forbidden after the dynasty fell in 1911 and the practice soon died out.

**Fig. 164** Two shop assistants, the one on the left wearing a jacket and trousers in black gummed silk, the one on the right in cotton waistcoat and black gummed silk trousers, ca. 1900.

**Fig. 165** Bamboo vest constructed from tiny pieces of hollow bamboo sewn together in a diagonal pattern, the edges of the neck, sleeves, and underarms trimmed with cotton binding, the neck fastened with a ball button and loop, the front pieces held together with ties, 19th c. Some garments had sleeves and others were sleeveless.

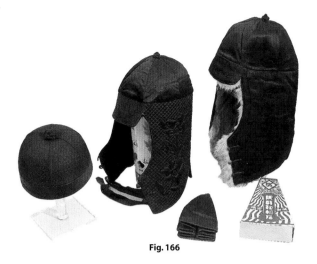

**Fig. 166**

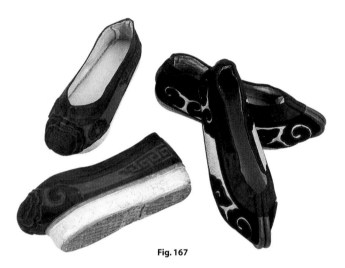

**Fig. 167**

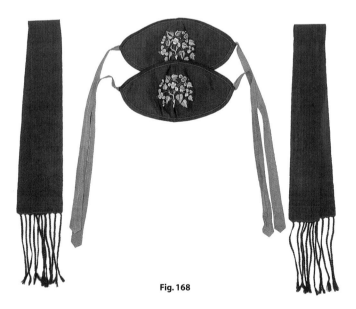

**Fig. 168**

Shoes were worn by the gentry for informal wear in the private quarters of their homes, and were also in regular use by the lower ranks. Like the boots, some shoes had a stiff sole several inches thick, made of layers of paper, to raise the vamp and keep it dryer in wet weather. The vamps were made of black satin, cotton, or velvet, plain or appliquéd; leather was used only for the trimming or binding. There were two main styles for men, one with a rounded toe curving back to the sole, the other with a wide toe the same width as the heel (Fig. 167). Like the boots, the inflexible sole was made shorter than the uppers in order to give sufficient spring for walking.

Lengths of tightly woven silk with silken fringes at each end were used as puttees and wound spirally round the leg, over the trousers and socks from ankle to knee, for protection and support. Thickly padded kneepads were useful for cushioning the knees when required to perform the full kowtow whereby the person knelt three times, one after another, each time knocking the head three times on the ground (Fig. 168).

## Purses and Their Contents

Since robes lacked pockets, small items were often tucked into the sleeves. "Sleeve editions" (small books concealed by candidates in the examinations) and even "sleeve dogs" (Pekinese or lap dogs) were carried there. Generally, however, daily necessities were suspended from the girdle.

The absence of pockets was cause for comment among many nineteenth-century writers: "One of the most annoying characteristics of Chinese costume, as seen from the foreign standpoint, is the absence of pockets.... If he has a paper of some importance, he carefully unties the strap which confines his trousers to his ankle, inserts the paper, and goes on his way. If he wears outside drawers, he simply tucks in the paper without untying anything. In either case, if the band loosens without his knowledge, the paper is lost – a constant occurrence. Other depositories of such articles are the folds of the long sleeves when turned back, the crown of a turned-up hat, or the space between the cap and the head. Many Chinese make a practice of ensuring a convenient, although somewhat exiguous, supply of ready money, by always sticking a cash in one ear. The main dependence for security of articles carried, is the girdle, to which a small purse, the tobacco pouch and pipe, and similar objects are attached" (Smith, 1894: 128).

Purses were popular and acceptable gifts to mark special occasions and some original yellow and red boxed sets still survive. Certain shops specialized in their manufacture; as with many other trades, there was a street in Beijing devoted to their sale. Women also spent many hours producing exquisite purses for their loved ones, and it was the custom for the emperor to reward his courtiers and officials, especially at the Lunar New Year, with purses containing jeweled charms.

**Fig. 166** Clockwise from left: Man's silk gauze skullcap; quilted hood; silk hood lined with fur; folded "Horse" brand skullcap made in Shanghai with its original box.

**Fig. 167** Left: Pair of shoes in blue satin trimmed with black satin with the *shou* character on the toe. Right: Pair of shoes with an appliquéd design of clouds of black velvet on beige silk.

**Fig. 168** Kneepads in black silk flanked by a pair of black woven silk puttees with a damask design at the ends.

**Fig. 169** Official set of five purses made for presentation to a high official. Clockwise from top left: Rectangular *da lian* purse for valuables; fan case; spectacle case; and pair of drawstring purses.

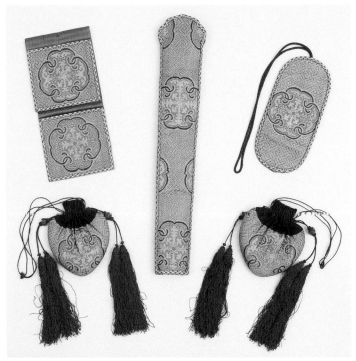

**Fig. 169**

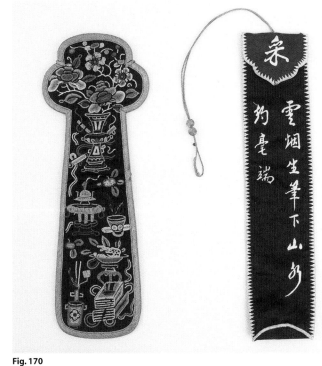

**Fig. 170**

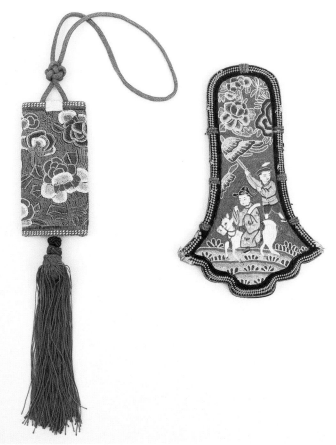

**Fig. 171**

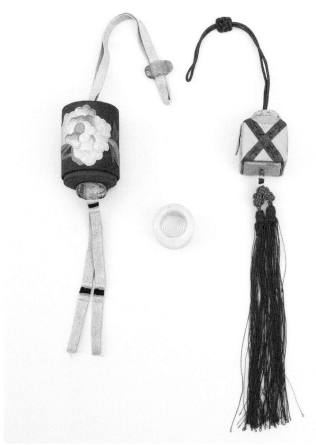

**Fig. 172**

**Fig. 170** Left: Paintbrush holder embroidered in Peking knot with peonies, vases, ritual vessels, and books. Right: Paintbrush holder resembling a fan holder but with a cord passing through the center to create divisions for brushes. Made of black satin reversing to blue, and a poetic embroidered inscription on the front stating its purpose.

**Fig. 171** Left: Rectangular key holder, suspended from a cord (the key was attached and hidden inside the holder), embroidered in Peking knot with peonies. Right: Bell-shaped key holder with the design in Peking knot and satin stitch of a successful scholar shielded by a servant carrying an umbrella. Only persons of high rank were entitled to have an official umbrella.

**Fig. 172** Left: Red silk case with peonies painted and appliquéd in silk made to contain a pair of thumb rings like the jade one shown here. Right: Seal box in yellow silk with a red silk cross bearing characters in black ink

hyperbolically stating that the owner has gained first place in the examinations. The yellow silk and the shape of the box are a miniature version of imperial seals and it would have been presented as a symbolic gesture.

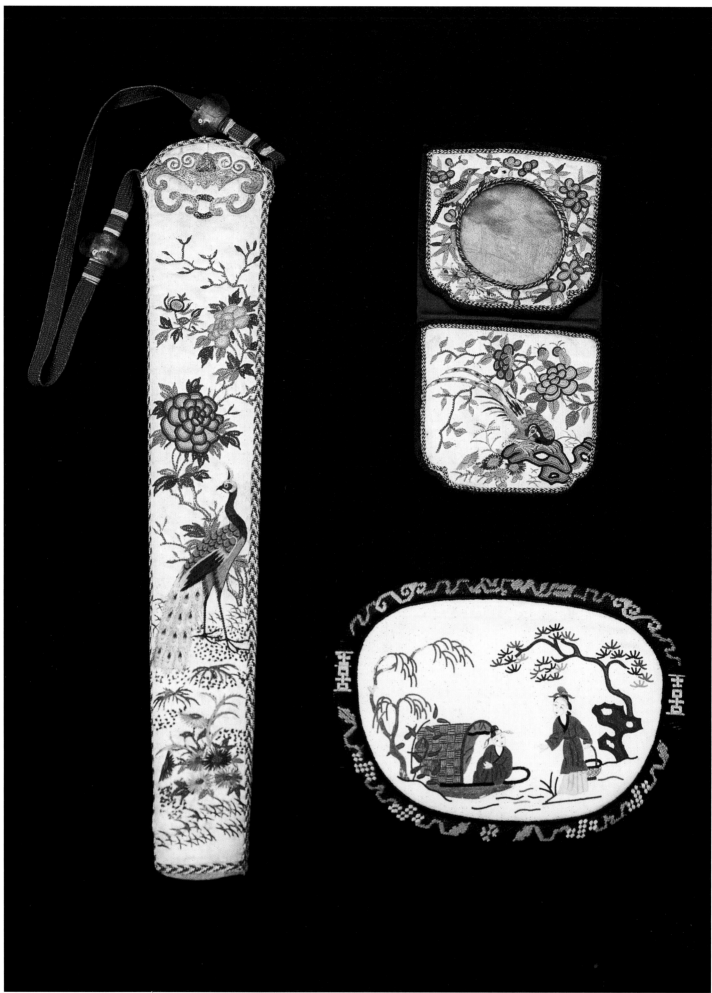

**Fig. 173**

By the end of the nineteenth century, more purses were added to the original ones mentioned earlier, which made it necessary to hang them over the girdle as well as from the rings (Fig. 169). These were known as the "Official Nine" and consisted of most of the following: a pair of drawstring purses, a *da lian* purse (a flat rectangular purse used to carry money), a watch purse (Fig. 173), an oval purse, a spectacle case, a fan case, a thumb ring box, a tobacco pouch, a holder for brushes and ink (Fig. 170), a case for carrying visiting cards (Fig. 174), and a key holder (Fig. 171).

The thumb ring was originally a leather band worn by archers to assist in drawing the bow (Fig. 172). Later, the ring became an ornament worn by the literati, first on the right thumb and then on both thumbs. Such was the importance of the thumb ring that on his birthday, when the emperor gave presents to invited guests at a feast, among the gifts of vases and scroll paintings would be archers' rings.

Seals or chops were carried and used as personal signatures, as well as signs of possession in a country where many people were illiterate and unable to write their name. Seals were carved from a variety of materials, such as jade, ivory, and soapstone, and carried in specially made little boxes.

Calligraphy and painting were two of several gentlemanly accomplishments. Chinese men needed a purse to carry their bamboo-handled brushes and sticks of solid ink, which were ground with water to produce ink.

Snuff made from ground tobacco spiced with aromatic herbs was introduced to China by Europeans during the Ming dynasty as a remedy for nasal congestion. But because the Chinese literati grew their fingernails long, it was not easy for them to take snuff from boxes, as was the custom in the West. Moreover, the humid climate, especially in South China, meant that snuff kept in boxes deteriorated quickly. Thus, tiny bottles with a small spoon fixed to the stopper were used to hold the snuff. The snuff was transferred by the spoon to the back of the left thumb and then inhaled. The bottles were easy to carry, either tucked into the sleeves of robes or suspended in a small purse (Fig. 175).

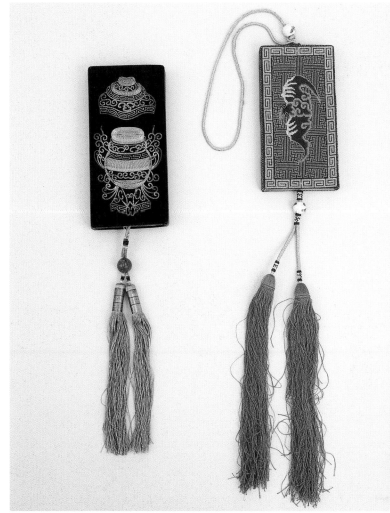

**Fig. 174**

**Fig. 173** Having a pocket watch was a sign of wealth and was flaunted by those who could afford one. Left: Fan case with a third civil rank peacock and peonies. Top right: Watch purse with a design of a second civil rank golden pheasant and peonies. Bottom right Oval purse with a scene of a river and figures.

**Fig. 174** Visiting cards were carried in a rectangular holder with a pull out drawer. Left: Holder made of black silk over stiff card, embroidered with couched gold thread in a design of ritual vessels. Right: Holder made of counted stitch on silk gauze over a card base, with the design of a bat against a key fret background.

**Fig. 175** Snuff bottle holder in red silk over stiffened card, with a design in raised Peking knot of a crane in a garden.

**Fig. 175**

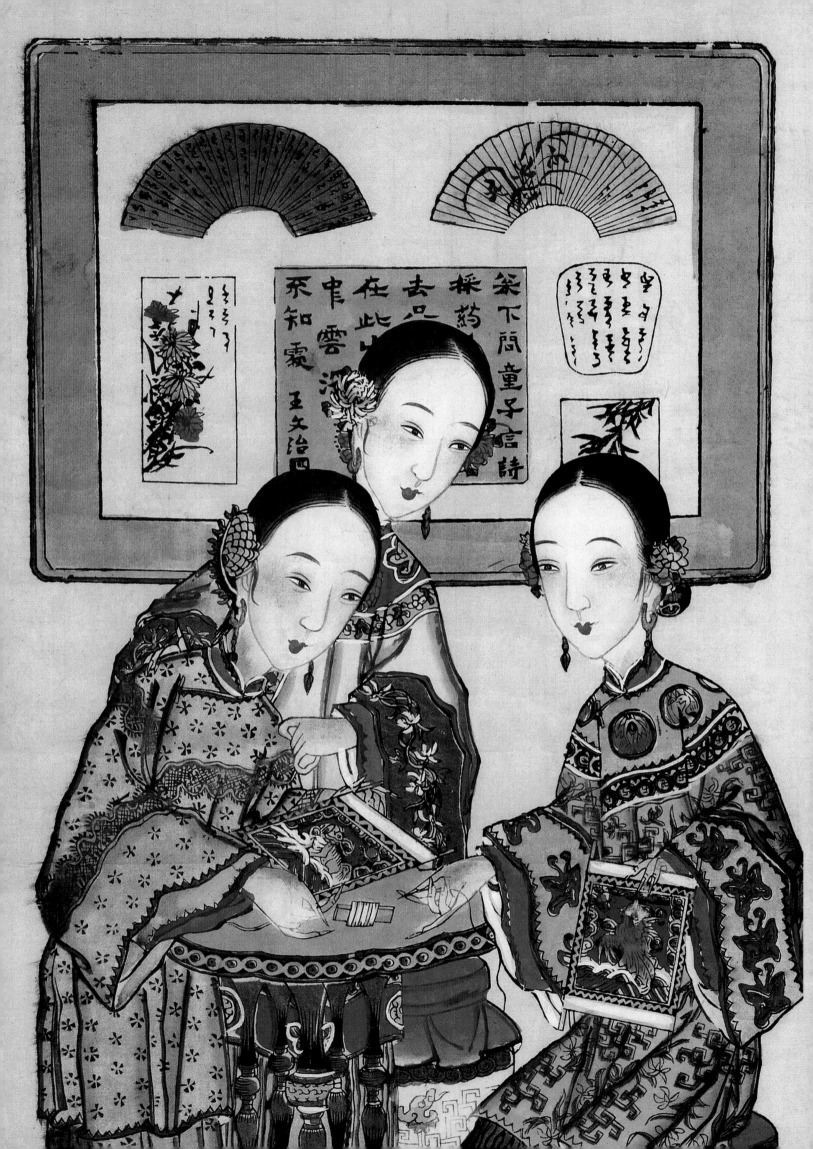

Chapter Four

# THE ATTIRE OF CHINESE WOMEN

## At Home

It was the custom in Chinese families that on marriage a bride went to live with her husband's family. These extended families, in which many daughters-in-law served a powerful matriarch, meant that three or more generations might live under one roof, not always harmoniously. The most important role for the new wife was to produce a son or, more importantly, many sons. If she did not, she would be vilified by her mother-in-law, cast off by her husband in favor of other women, and pitied by all she met. Indeed, such was the low status of women and girls that if a father had only daughters he was considered to be childless.

The women and younger members of the family were cloistered in the domestic apartments and the schoolroom located behind the offices of the mandarin or merchant (Fig. 179). Here, women spent their time gossiping, looking after children, attending their mother-in-law, and helping in the kitchen (Figs. 177, 178). An extensive garden was a feature of many wealthy homes, and a place where women could walk freely. Within the high walls, artificial landscapes were created, with pleasure houses, gazebos, and zigzag bridges (Figs. 180, 183; see also Fig. 158).

One of the main diversions for women was embroidery (Fig. 176). Almost every garment worn by a middle- and upper-class

Chinese was embellished with embroidery, as were all the soft furnishings for the home: door curtains to keep out drafts, table cloths, bed hangings, bed covers, and pillows. From the time she was young, a girl was taught to embroider as a feminine accomplishment, and prior to marriage was required to prove her skills to her prospective husband and mother-in-law. Preparing these embroidered articles could take as long as two years to produce before the wedding could take place. In the Qing dynasty, the designs and application of embroidery reached a peak during the relatively stable and peaceful reigns of the Kangxi, Yongzheng, and Qianlong emperors, especially the latter who did much to foster the arts. Embroidery became an industry in itself.

Up to the end of the nineteenth century, wealthy households employed servants to sew the many articles of clothing and household furnishings the family required (Fig. 184). The task was given to wives and daughters of tradesmen and artisans, while in poorer families, men and children also embroidered to supplement the household income. Clothing made by workers in the small cottage industries that abounded could also be bought from itinerant pedlars or shops (Fig. 182). In the cities there were streets specializing in one particular item, such as ladies' jackets, men's shoes, and so on (Fig. 181). Sewing machines were introduced into China at the end of the nineteenth century, making production much faster.

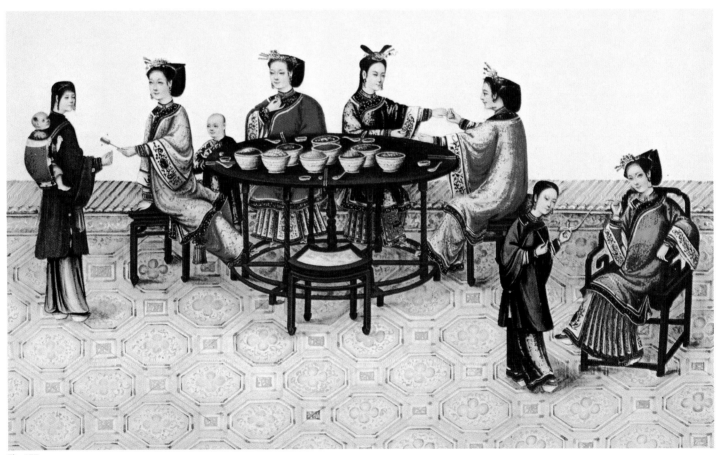

**Fig. 177**

**(Page 92) Fig. 176** Detail of a painting of three Chinese ladies embroidering rank badges.

**Fig. 177** Painting by the Guangzhou artist Tinqua of Chinese women seated at the dining table, while a servant carries a baby on her back, ca. 1854.

**Fig. 178** Women in northern China preparing food while sitting on a heated brick bed (kang), ca. 1894.

**Fig. 179** Home of a rich official in Beijing named Yang, seated, with his son standing. Upstairs are his wives and concubines and the younger children of his household, ca. 1870.

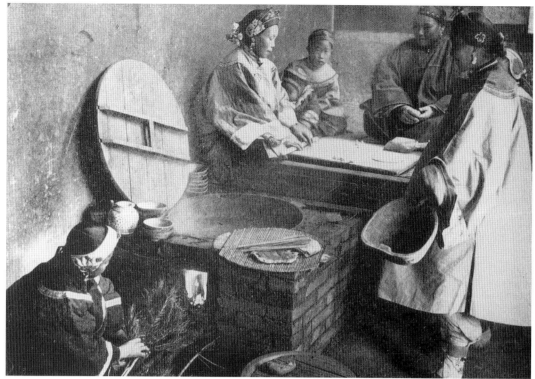

**Fig. 178**

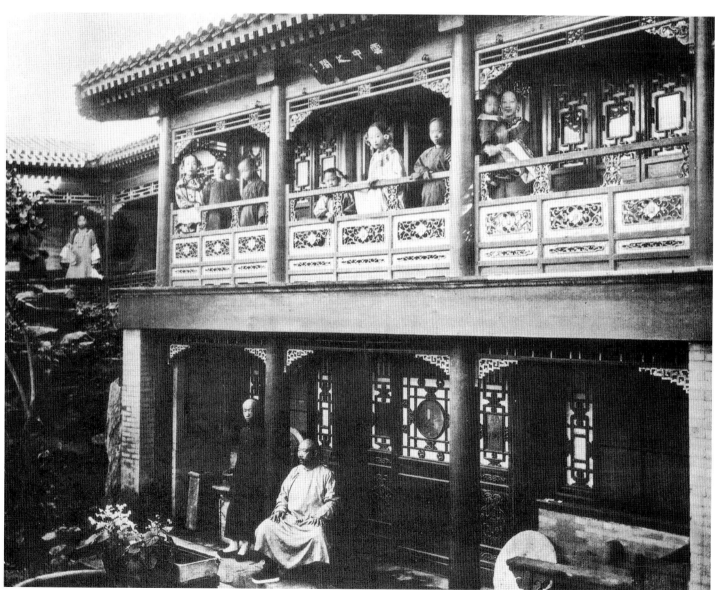

**Fig. 179**

**Fig. 180**

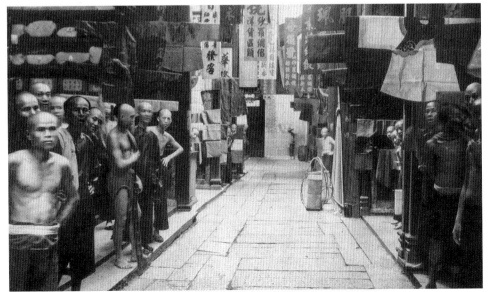

**Fig. 181**

**Fig. 180** Chinese women strolling
in the garden of a wealthy merchant,
Howqua, in Guangzhou, ca. 1850.

**Fig. 181** The Street of Tailors in
Guangzhou, ca. 1900.

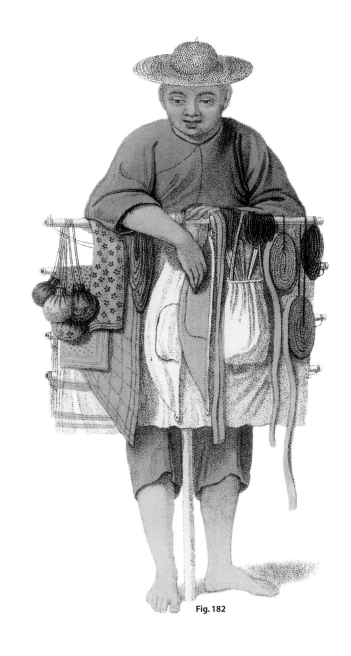

Fig. 182

**Fig. 182** "A Chinese pedlar carries handkerchiefs, garters, fans, pockets, tobacco-pouches, &c. for sale, upon a bamboo frame…. He thus can easily carry the whole upon his shoulder…." He also sells silks and other items for embroidery.

**Fig. 183** Chinese women by a pavilion in the garden of a wealthy salt merchant in Guangzhou, ca. 1840.

**Fig. 184** Young girl working at an embroidery frame, Suzhou, early 20th c.

Fig. 183

Fig. 184

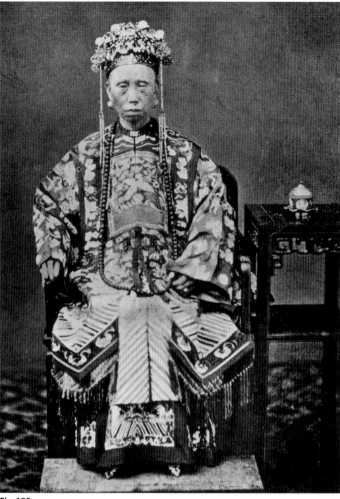

**Fig. 185**

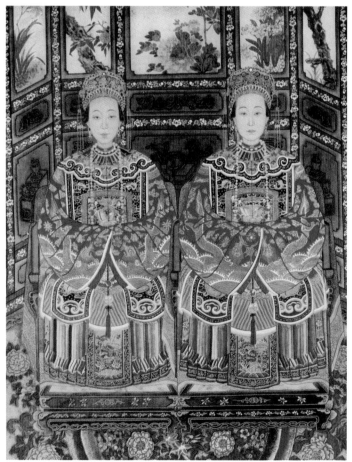

**Fig. 186**

## The Mandarin's Wife

Han Chinese women were persons of little consequence within the Manchu regime, except those whose families were connected with the court in Beijing. However, within the family itself senior women had status and were well respected, particularly by the younger daughters-in-law, and were accorded a position of honor at important domestic events and festivals. They were not required to wear official attire. Most, in fact, were keen to retain their pure Chinese identity and took care not to wear Manchu-style clothing. At the beginning of the Qing dynasty, wives of Chinese officials were expected to continue wearing Ming costume, but gradually Ming conventions were forgotten and aberrations crept in.

The dynastic laws made no reference to the dress to be worn by Han Chinese women, but it appears from written accounts of the period that there was an accepted code based on class and occasion. The wives of Chinese noblemen or high-ranking officials were expected to wear quasi-official formal dress on ceremonial occasions when their husbands wore the court robe (Fig. 185). This consisted of a dragon jacket or *mang ao*, a stole called a *xia pei*, a dragon skirt, and a coronet (Fig. 186).

The *mang ao* was a loose-fitting jacket with wide sleeves, a plain round neck, and a side opening from neck to underarm, similar to Ming robes. It sometimes had side extensions to give greater bulk. This considerable use of silk fabric indicated the wealth and importance of the family. A man's principal wife wore red, the dynastic color of the Ming, and therefore considered auspicious, while the second wife wore blue and the third wife green.

Originally, the jacket was undecorated, but portraits from the eighteenth century show that it began to be decorated with dragons. From the late eighteenth and early nineteenth centuries, between two and ten *mang* were embroidered according to the status of the wearer (Fig. 187). Lower-ranking officials' wives also wore the *mang ao* as part of their bridal dress. A rigid hooped belt called a *jiao dai* was worn around the *mang ao* and held in place by loops at the sides of the jacket. It was made of bamboo and covered with red silk with ornamental plaques, akin to those worn by men in the Ming dynasty to denote rank.

The *mang ao* was worn over a *mang chu* or dragon skirt, in red or green silk, with dragons and phoenixes embroidered on the front and back panels. The skirt was first worn on a woman's wedding day and thereafter on formal occasions, always over trousers or leggings. Wearing a skirt was seen as a symbol of maturity, and was reserved for married women.

The skirt comprised a pair of pleated or gored aprons with panels back and front. They wrapped around the body, and were attached to a wide waistband, which was secured with ties or loops and buttons. The waistband was made of cotton or hemp to prevent the skirt from slipping down, while the skirt was of silk. Because the skirt was worn with a knee-length jacket, the panels

**Fig. 185** Wife of the Han Chinese official Huang Cantang, Governor of Guangdong, in full court dress comprising a dragon jacket, *xia pei* or stole, dragon skirt, and "phoenix crown," ca. 1862.

**Fig. 186** Painting of two wives of a mandarin, the bird on the rank badges on their stoles artfully concealed by the sleeves of their jackets to imply a higher rank, 19th c.

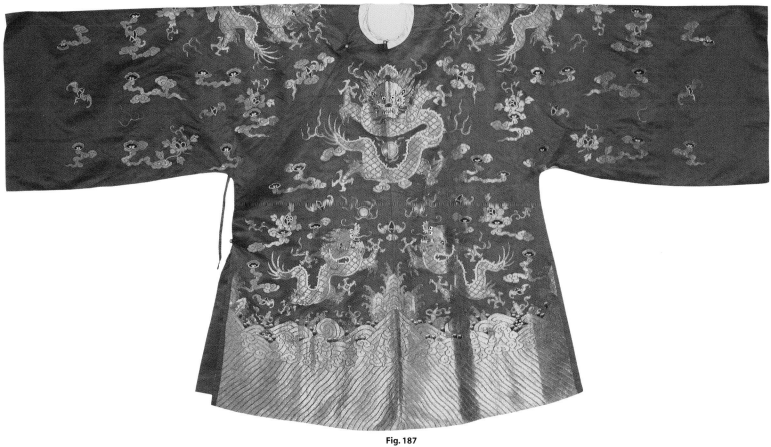

**Fig. 187**

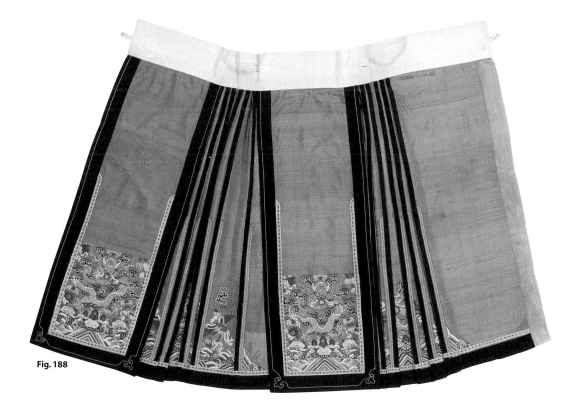

**Fig. 188**

**Fig. 187** Dragon jacket in red satin with ten four-clawed dragons and clouds embroidered in couched gold thread, ca. 1800.

**Fig. 188** Green dragon skirt in *kesi*, the front and back panels embroidered with five-clawed dragons surrounded by bats and the Eight Buddhist symbols, the godets embroidered with standing and descending phoenixes, possibly made for a wedding, mid-19th c.

were only embroidered up to the point where the jacket met the skirt. The back and front panels were often identical and edged in braid. The skirt allowed ease of movement because of the many narrow pleats caught down in a honeycomb or fish-scale pattern, or godets to the left side of the panels, widening towards the hem (Fig. 188), swinging gracefully as the wearer walked

The stole or *xia pei* worn over the *mang ao* was also first worn on a woman's wedding day and later at events of special importance connected with her husband's status. It developed from a Ming stole into a wider, sleeveless stole held together with ties at the sides, reaching to below the knees and finishing with a fringe at the pointed hem. The *xia pei* was made of *kesi* or satin and decorated with dragons in profile and *li shui*, and there was a space on the front and back for a badge of rank corresponding to that of the husband (Fig. 190).

To offset the plain neckline of the *mang ao* and *xia pei*, and also to add status, a detachable collar with four lobed corners, known as a cloud collar or *yun jian*, was worn over the jacket and stole. The lobes at the four corners were positioned over the chest and back and at each shoulder, often in three widening layers. The lobes indicated the cardinal points, with the wearer's head the cosmic center. Some multi-lobed collars were highly decorated, with numerous petals radiating from the neckband over the shoulder (Figs. 189, 192). Others were embellished with elaborate tassels.

A coronet, called a "phoenix crown," modeled on those worn by empresses in earlier Chinese-ruled dynasties, especially the Ming, was worn on formal occasions. This headdress is formed over a copper wire base, and covered with kingfisher feather inlay flowers, butterflies, phoenixes with pearls, and tiny mirrors to deflect bad spirits (Fig. 191).

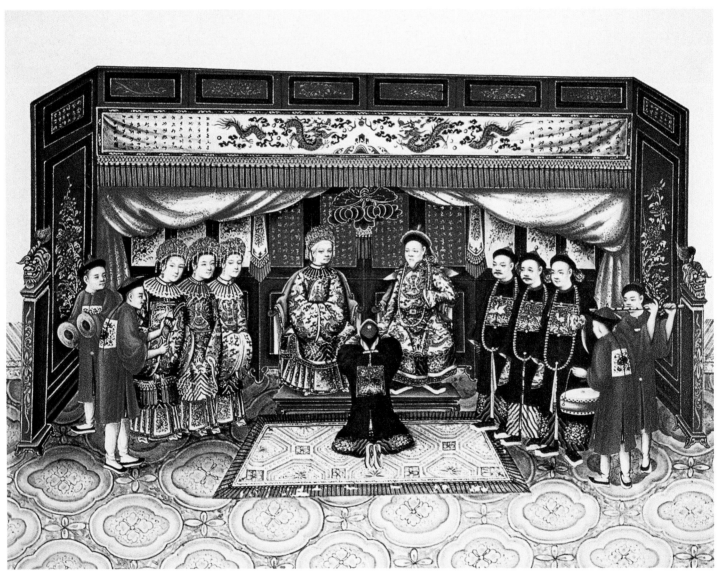

**Fig. 189**

**Fig. 189** Painting by the Guangzhou artist Tinqua of a newly proclaimed mandarin kowtowing to his parents as other family members look on, all wearing official dress, including the women, who wear surcoats with rank badges, collars, and stoles, ca. 1850.

**Fig. 190** *Xia pei* stole in dark blue silk with ties at the side, embroidered with gold couched dragons, satin stitch clouds and bats, Peking knot birds of the first, third, and fourth ranks on the front and the fifth, seventh, and ninth on the back, and a fourth-rank civil badge of couched gold thread, 19th c.

**Fig. 191** Coronet or "phoenix crown," worn for formal occasions, made of copper wire covered with kingfisher feather inlay flowers, butterflies, phoenixes with pearls, and tiny mirrors to deflect bad spirits.

**Fig. 192** Detachable "cloud collar" with four lobed corners worn by an older woman, 18th c. The design on the lobes, in counted stitch on silk gauze, is of the *shou* character surrounded by the Eight Buddhist emblems. In the four corners round the neck is the double *dorje*, a very powerful Buddhist emblem implying invincibility and impregnability against demons.

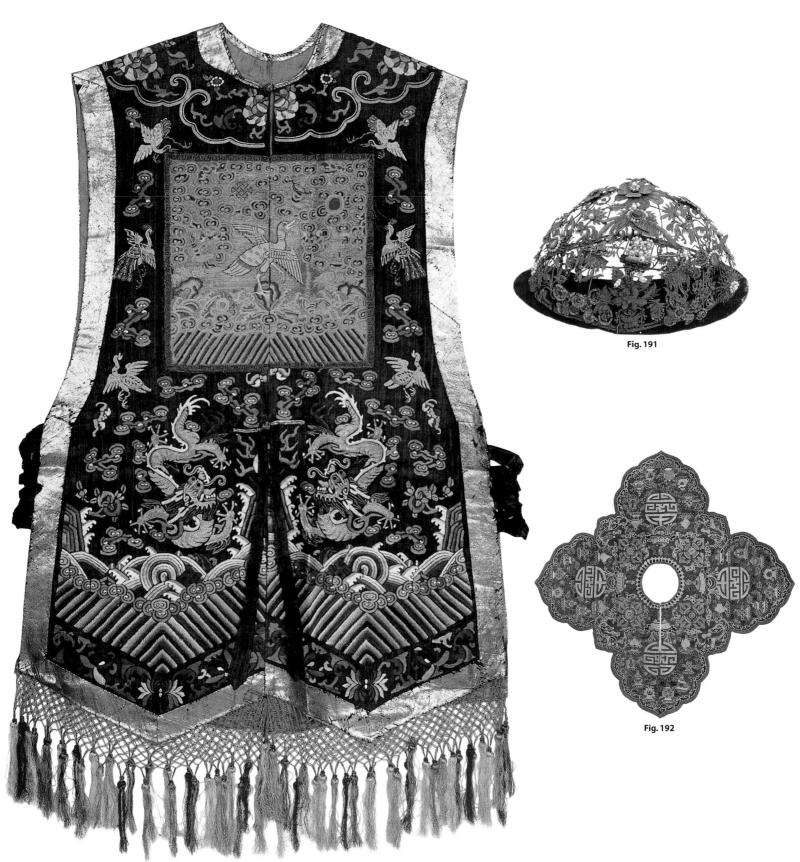

Fig. 190

Fig. 191

Fig. 192

## Formal Wear

On occasions when a mandarin wore a dragon robe and his wife accompanied him, she would wear a surcoat and a highly decorated skirt. Although the surcoat was cut like the man's and opened down the front, towards the end of the dynasty it became more elaborate, with wide bands of embroidered satin forming deep cuffs. For "full dress" occasions, rank badges were attached to the front and back. Two short lappets hung down each side at the center front, echoing the *zai shui* pointed kerchief worn by Manchu women, but with less adornment (Figs. 193, 194). Completing the outfit, a *chao zhu* or mandarin chain, similar to the husband's, was worn with the surcoat and a more formal *xia pei* stole, but with the position of the three counting strings reversed.

Wives and unmarried daughters of Qing officials took the same rank as that of their husband or father. At first the badges were identical, but around the middle of the eighteenth century the custom began of depicting the wife's bird or animal facing in the opposite direction to that of her husband. In this way, when

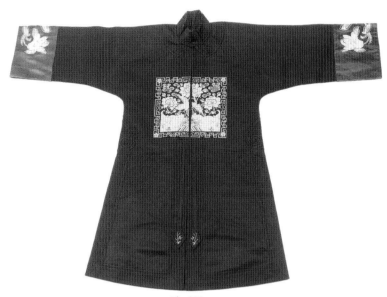

**Fig. 193**

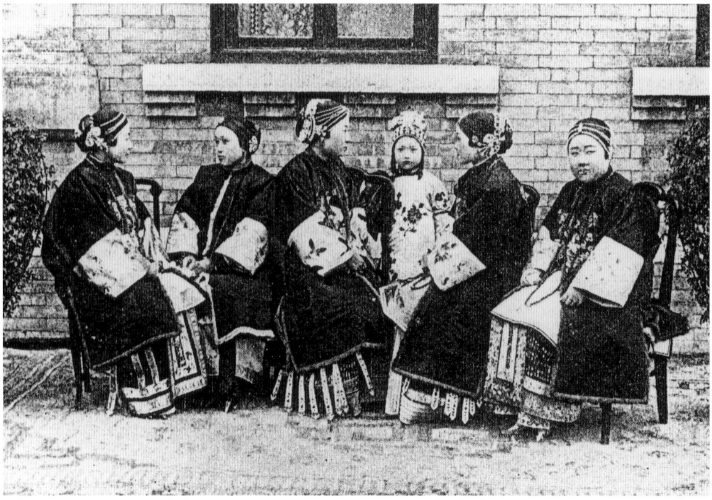

**Fig. 194**

**Fig. 193** Black silk damask surcoat with a sixth-rank civil badge on the chest and back, couched gold and silver embroidery on the blue satin sleeve bands, with lappets representing a form of pointed kerchief, ca. 1900.

**Fig. 194** Wives of high-ranking Chinese officials wearing surcoats bearing rank badges, headbands, and elaborate skirts with streamers, late 19th c.

**Fig. 195** Insignia badge belonging to the wife of a second-rank civil mandarin depicting a golden pheasant embroidered in brightly colored satin stitch, ca. 1900.

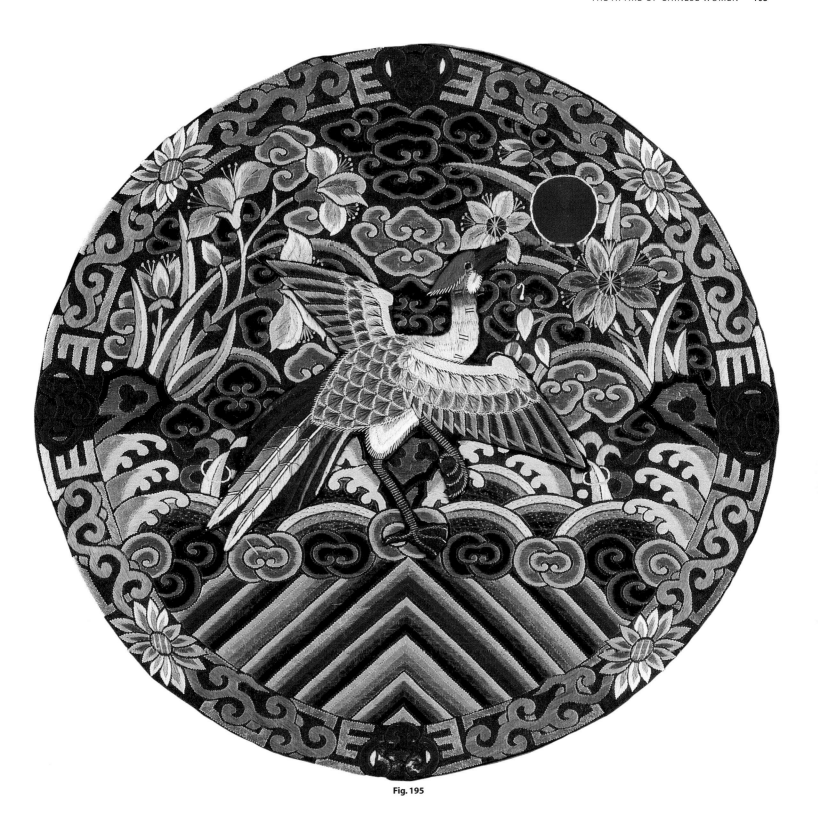

**Fig. 195**

the husband and wife sat together in state, with the wife on the left of her husband, the animal or bird on their rank badges would face each other. Later on, at the end of the nineteenth century, the badges were made even more distinct when the embroidery formed a circle inside the square, or else became a complete roundel (Figs. 195, 196).

Birthday badges were worn by both men and women, and presented by family members to be worn on major birthdays, such as the sixtieth, seventieth, etc, on formal clothing. Auspicious motifs, such as the bat, phoenix, coins, and peaches, were embroidered in satin stitch around the edges or in the center (Figs. 198, 199).

Prior to her marriage, a woman would have the hairs on her forehead removed by a "fortunate" woman with many sons, using two red threads, to give a more open-faced look. This process was known as *kai mian*, literally "opening the face." (The practice, which dates back to the Shang dynasty (ca. 1600–ca. 1050 BCE), continued to be performed in Hong Kong in the 1990s.) The hair was then put up into a bun. A shaped, embroidered band was worn across the forehead for warmth, as pulling the hair back caused the hairline to eventually recede with this style. Only married women wore these bands and they were made or bought as part of the wedding dowry (Fig. 197).

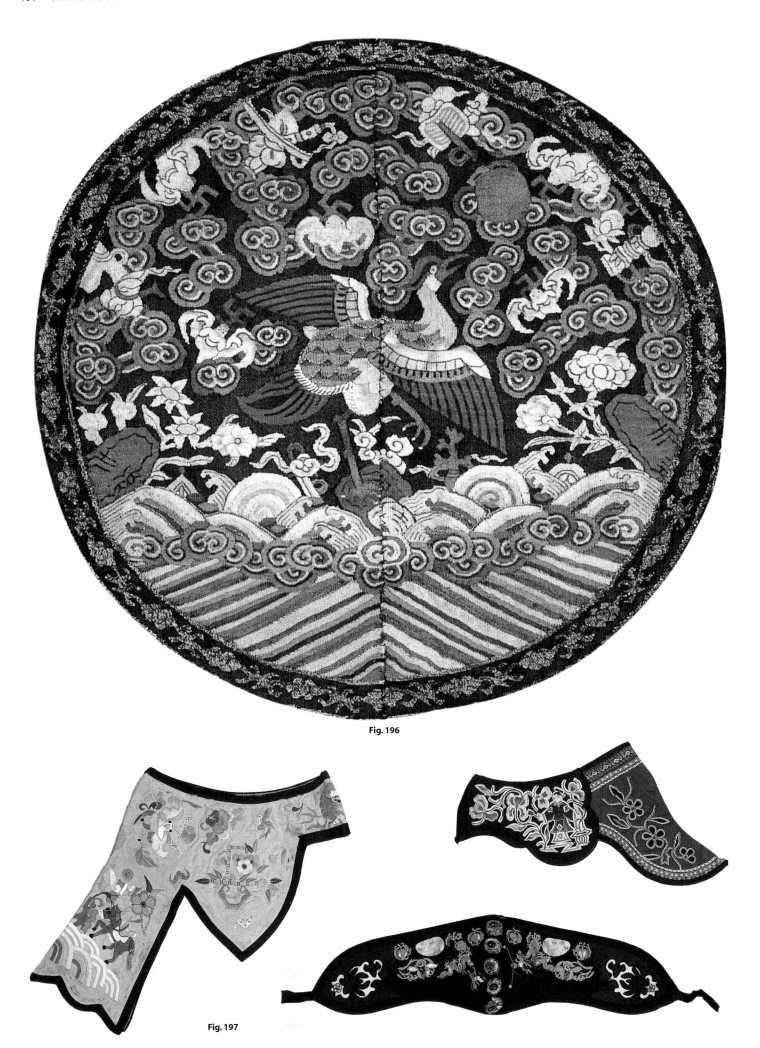

**Fig. 196**

**Fig. 197**

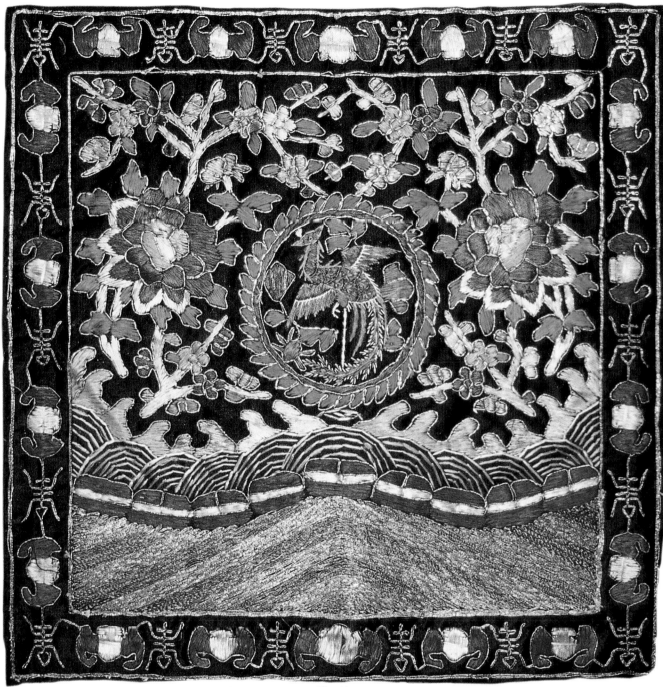

**Fig. 198**

**Fig. 196** Rank badge in *kesi* belonging to the wife of a seventh-rank civil mandarin, showing a mandarin duck surrounded by bats and four of the emblems of the Eight Immortals, ca. 1900.

**Fig. 197** Left: Headband of yellow silk with an extended back flap, with a lion, butterflies, bats, flowers, and two horses over a *li shui* border embroidered in satin stitch. Right: Headband with a short flap embroidered with plum blossoms, the front depicting a scholar and horse successfully returning from an examination being greeted by his wife embroidered over a gold paper cut. Below: Headband of black satin with a reverse appliqué design at the sides and decorated with kingfisher feather dragons, jewels, and pieces of jade.

**Fig. 198** Birthday badge embroidered with designs of flowers above *li shui*, a phoenix in the center, a border of bats and longevity characters, probably made for a woman, early 20th c.

**Fig. 199** Birthday badge depicting bats for happiness, peaches for longevity, and coins for wealth above *li shui* embroidered in satin stitch, late 19th c.

**Fig. 199**

## Semiformal and Informal Dress

For semiformal public occasions, the mandarin's wife wore the surcoat without a rank badge, corresponding to the "half dress" worn by her husband. At other times, such as private functions, the wife of a mandarin wore the *ao*, an elaborately decorated upper garment made from self-patterned silk damask, with broad plain or embroidered bands at the sleeves, neck, hem, and curved opening (*tou jin*). The curved front overlap of the *ao*, fastened with toggles on the right-hand side, was based on the Manchu tradition of using animal skins. While such skins required no reinforcement, after the mid-eighteenth century contrasting bias-cut borders outlined the edges of the *ao* to neaten and strengthen it and, later, to decorate it.

From the middle to the end of the nineteenth century, the woman's *ao* was cut very large, reaching the calf, and with wide sleeves. Bulky garments were a sign of wealth and dignity. Large quantities of silk fabric, which took a long time to produce, also reflected the status of the wearer. At this time, too, elaborate borders of contrasting colors edged with braid, and sometimes

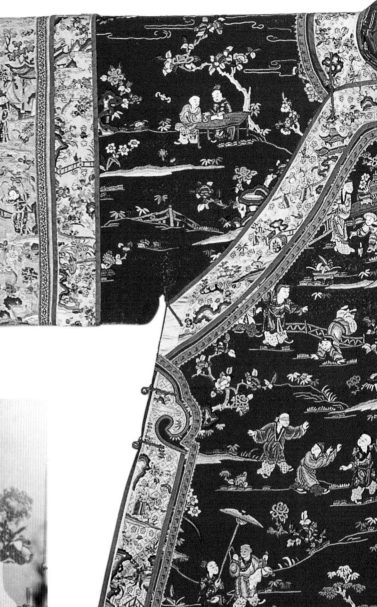

**Fig. 201**

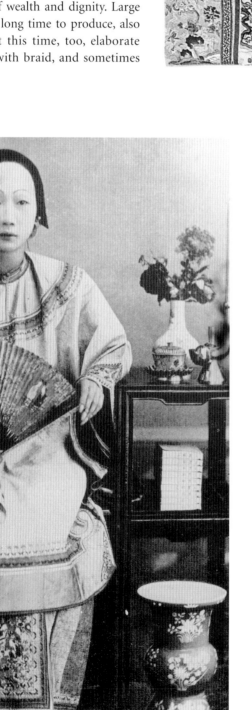

**Fig. 200**

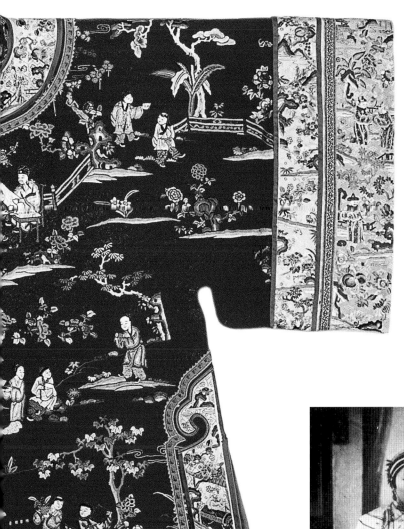

lace, following fashion influences from the West, outlined the curved edge, sleeves, and hem (Figs. 200–203a, b, 204).

The *ao* was worn with a skirt or *gun*, which was often very colorful and decorative (Figs. 205–208). Certain colors indicated marital status. For example, older women wore black, while widows wore white as it is a color the Chinese associate with death. "Marrying the wearer of a white skirt" meant marrying a widow (Doolittle, 1895, Vol. 1: 100).

Informal dress for unmarried women consisted of the *ao* worn over loose trousers or *ku*. The *ao* had narrower, plainer borders at the neck and curved opening, and was also often made of cotton (Fig. 209). For warmth, a sleeveless side-fastening waistcoat edged with braid could be worn over it. The trousers were cut as straight tubes of fabric, with gussets to form the crotch, and were attached to a cotton or hemp waistband. The hems of the trousers were decorated with bands of silk or embroidery, which sometimes, but not always, matched the *ao* worn with them (Fig. 210). Leggings were also worn under the skirt in place of trousers (see Fig. 210). These were made separately for each leg and were fastened with a button or ties to a band round the waist.

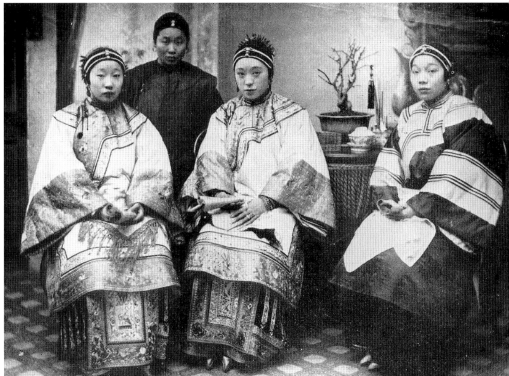

**Fig. 202**

---

**Fig. 200** Woman wearing a semiformal jacket and skirt and holding a fan.

**Fig. 201** Woman's jacket in red silk damask, embroidered all over with figures in a garden setting, the children playing, the adults enjoying a variety of leisure pursuits, the deep cuffs of the jacket edged with embroidered bands, mid-19th c.

**Fig. 202** Three ladies, with their servant, wearing semiformal dress comprising a bulky, elaborately embroidered upper garment (*ao*) and skirt (*gun*), late 19th c.

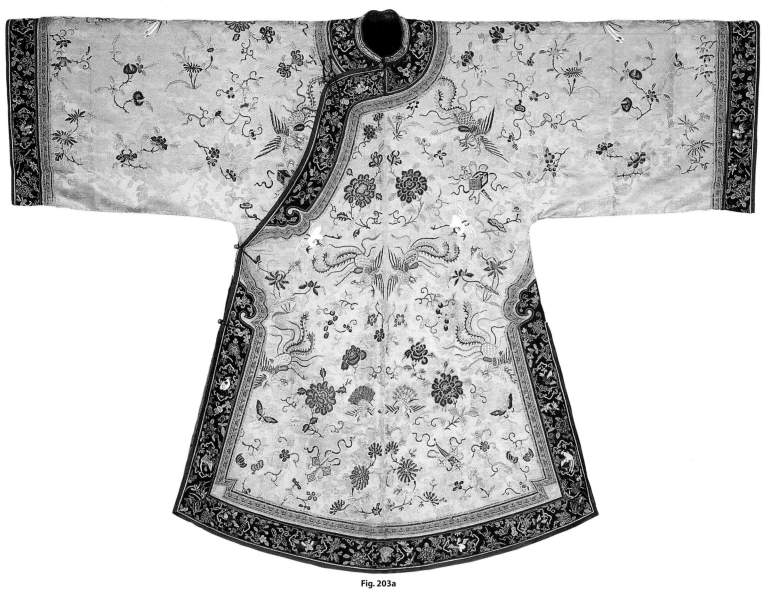

**Fig. 203a**

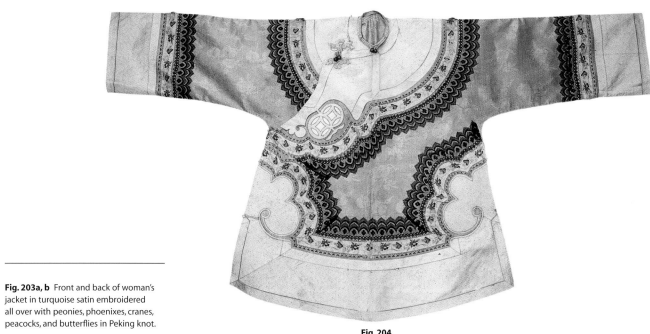

**Fig. 203a, b** Front and back of woman's jacket in turquoise satin embroidered all over with peonies, phoenixes, cranes, peacocks, and butterflies in Peking knot.

**Fig. 204** Turquoise silk *ao* with a wide three-type border of plain bias-cut silk in pale pink, braid, and black lace, late 19th c.

**Fig. 204**

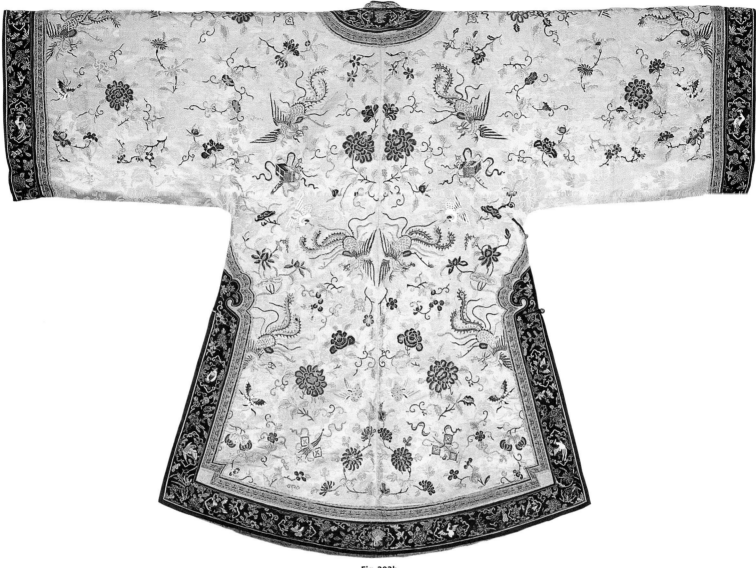

**Fig. 203b**

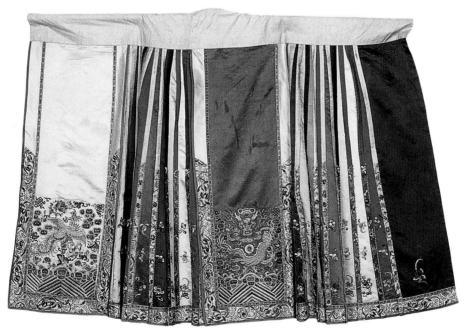

**Fig. 205**

**Fig. 205** Skirt with multicolored embroidered dragons and phoenixes on the godets and panels at the back and front.

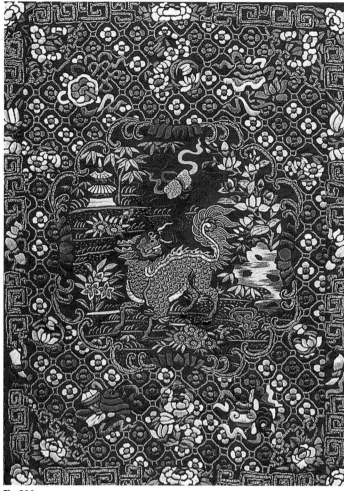

**Fig. 206**

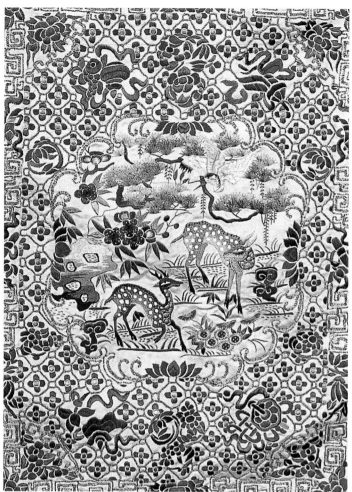

**Fig. 207**

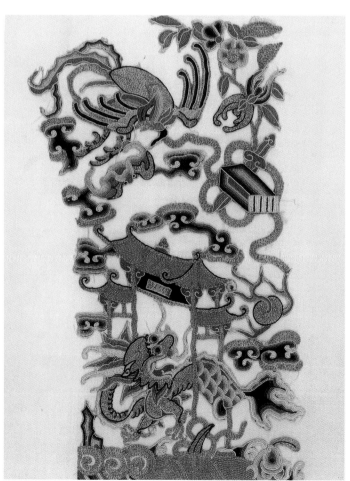

**Fig. 208**

**Fig. 206** Detail of a panel from an older woman's skirt featuring the *qilin*, a symbol of great wisdom, surrounded by Buddhist emblems, flowers, and *lingzhi*, the sacred fungus said to give immortality, all embroidered with couched gold thread and satin stitch, late 19th c.

**Fig. 207** Detail of the other panel from the skirt showing deer, a symbol of an official's salary, hence high status and wealth, surrounded by cypress trees and *lingzhi*, both symbols of longevity, late 19th c.

**Fig. 208** Panel of Peking knot and couched gold thread embroidery to be used for a skirt. The design of a carp leaping through a gate and emerging as a dragon denotes a man passing the imperial examinations. Above the gate is a phoenix, symbolizing high achievement, a bat for happiness, and a set of books.

**Fig. 209** Matching jacket and skirt in cream silk damask edged with pink bias-cut satin and braid, coins, and bats, outlined with piping; hemp waistband.

**Fig. 210** From left: Trousers in lilac silk with an embroidered band and braid at the hem; leggings in blue silk jacquard embroidered with flowers at the hem in the "three blues" (light, medium, and dark blue), a color combination worn only by married women; leggings in blue satin tapering to the ankle, decorated with chrysanthemums in couched gold and silver thread.

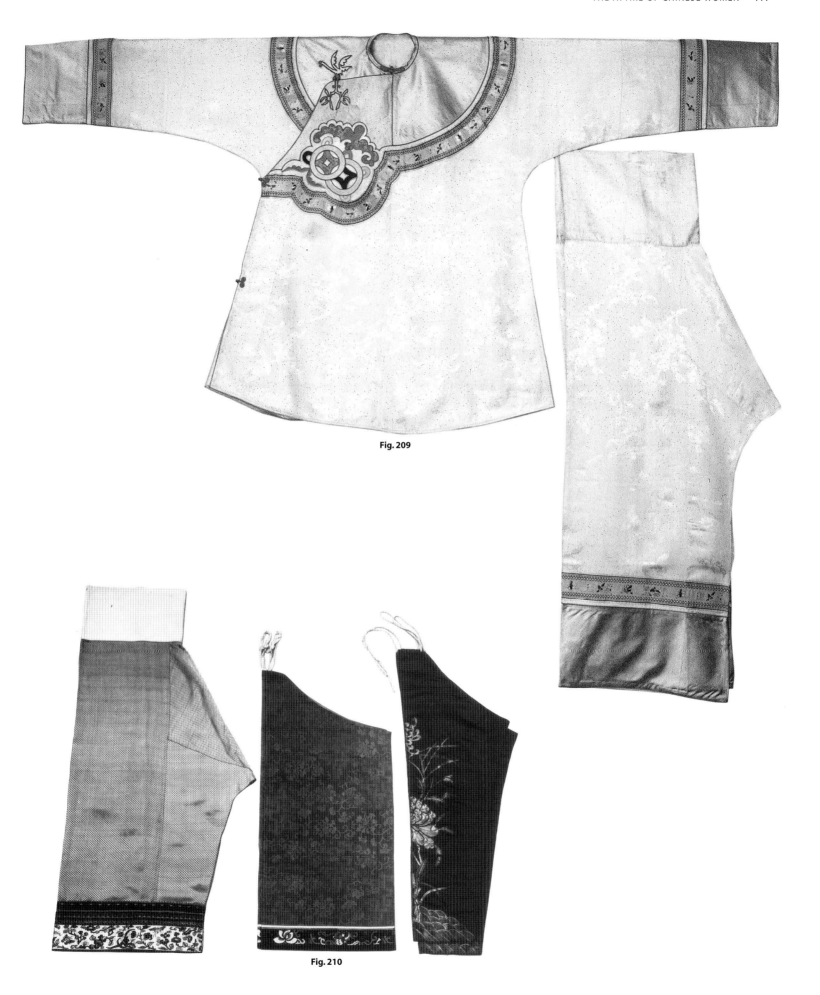

**Fig. 209**

**Fig. 210**

**Fig. 211**

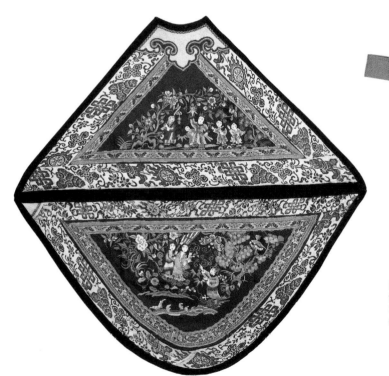

**Fig. 212**

**Fig. 211** Bamboo jacket made of fine tubes of hollow bamboo sewn together in a diagonal pattern and edged with cotton, 19th c.

**Fig. 212** Woman's diamond-shaped *dou dou* (chest apron) worn as underwear, embroidered with figures in a garden, the edges trimmed with braid depicting the Eight Buddhist emblems.

**Fig. 213** Money belt, the embroidery depicting a child wearing a *dou dou* sitting in a lotus flower, 19th c.

**Fig. 213**

A bamboo jacket or vest was worn over a cotton under-jacket to aid air circulation and protect the outer jacket from being stained with perspiration in the hot weather. The one shown here was made of fine tubes of hollow bamboo sewn together in a diagonal pattern and edged with cotton (Fig. 211).

Chinese women wore a small apron or *dou dou* next to their skin to cover their breasts and stomach (Fig. 212). Made of cotton or silk and richly embroidered with auspicious symbols, the *dou dou* had developed from a bodice worn during the Ming dynasty, and continued to be worn up until the early years of the twentieth century by both women and children. The apron was narrow at the neck and had a wider curved base, and was held close to the body by a silver chain or tape around the neck and waist. The bottom half of the apron often comprised a pocket stretching the full width of the garment. Another type of apron, sometimes called a money belt, consisted of a shallow embroidered pouch for daily necessities (Fig. 213). It was worn around the waist and over the stomach and was fastened with tapes at the back.

## Accessories

In addition to a liberal application of cosmetics, women spent many hours dressing their hair in the style of the time and the region. One writer describes how his sister would "make freshly the jelly-like liquid with which she polished her hair. For this she used very thin shavings of a wood called *wu-mo* or *pau-hua-mo*, which, after being steeped in water for a short time, formed a jelly-like liquid. After combing her hair out straight, my sister would brush it with this liquid and comb it again. She then dressed her hair according to the fashion of the time" (Chiang Yee, 1940: 52) (Fig. 214). Many ornaments or artificial flowers were added depending on the style of the region (Fig. 215).

A large number of hairpins made of gold, enamel, silver, or semiprecious stones, such as jade or coral, and fashioned into the shape of insects, birds, or butterflies were inserted into this stiff arrangement (Fig. 216). Those inlaid with kingfisher feathers in the form of bats, butterflies, and flowers were particularly popular (Fig. 218).

Han Chinese women pierced their ears and wore earrings made from a variety of materials, such as gold, jade, silver, coral, pearls, with kingfisher feather inlay to form auspicious emblems (Fig. 218). Equally elaborate rings were made of enamel, jade, semiprecious stones, and gold, inlaid with many different stones (Fig. 219). They also wore bracelets, anklets, nail extenders, and other items of jewelry made of jade, gold, silver, gilded silver, or enamel. (Women from poorer families wore jewelry made of *bai tong* as it resembled silver but was much cheaper.) Bracelets and anklets, generally worn in pairs, were made of gold, silver, enamel, horn, ivory, fragrant woods, jade, and other semiprecious stones decorated and inlaid with similar materials in the design of flowers and auspiciousemblems. Pendant charms made of jade, amber, or gold were also hung from the top button on the side of the *ao*. Other pendants were made of filigree metal in the shape of a potpourri container, and held fragrant herbs to sweeten the air.

Needle cases were made of silver or *bai tong*, often enameled, and pinned to the gown or attached to the top button. Originally, needles were made of ivory, bone, bamboo or porcupine quills. Later, in the nineteenth century, when steel needles were imported from Germany, they were expensive and needed to be kept in a safe place (Fig. 220).

Elaborately carved silver or *bai tong* chatelaines were also fastened to the top button on the upper garment. They comprised sets of three or five chains hanging from a central plaque, ending with a selection of tongue scraper, toothpick, nail cleaner, ear pick, and tweezers (which were also useful when making knotted fabric ball buttons and decorative loops used to fasten clothing) (Fig. 221). Long silver pendants with small silver charms filled with little bells, which tinkled as the wearer moved to scare away evil spirits, were another popular item (Fig. 221).

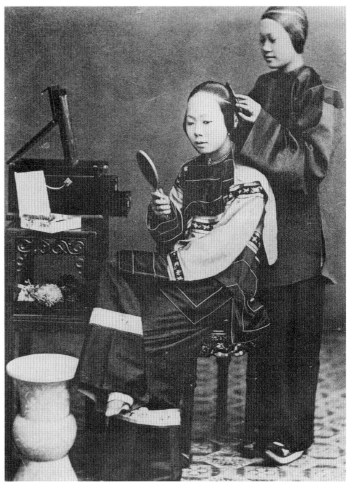

**Fig. 214**

**Fig. 214** Young woman having her hair combed by a servant. The woman, from southern China, has tiny bound feet while her servant has natural feet and is wearing boat-shaped shoes with thick soles, 1868.

**Fig. 215** Young woman, her hair decked out with jade and coral hair ornaments, wearing earrings and bracelets, ca. 1850.

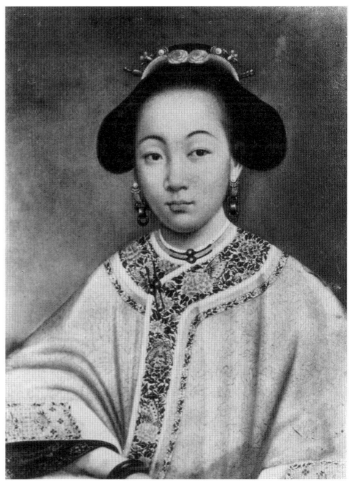

**Fig. 215**

**Fig. 216**

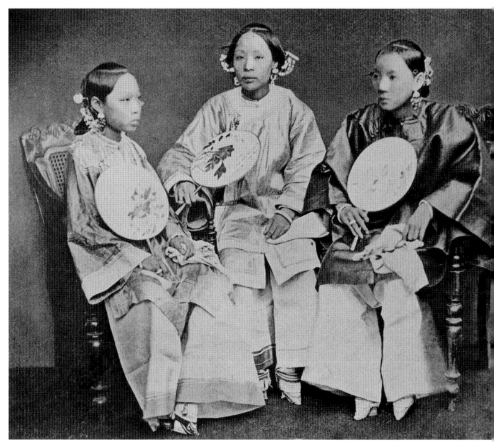

**Fig. 217**

**Fig. 216** Young woman from Shantou in southeast China with her hair swept up and studded with hairpins in the style of butterflies and other auspicious symbols, ca. 1870.

**Fig. 217** Chinese women holding *pien mien* fans, ca. 1905.

**Fig. 218** Hairpins inlaid with kingfisher feathers. Above: Pair of hairpins incorporating bats. Center: Hairpin in the shape of a butterfly. Bottom left: Hairpin with bats and five strings of pearls and coral beads. Bottom right: Oval hairpin composed of flowers and butterflies.

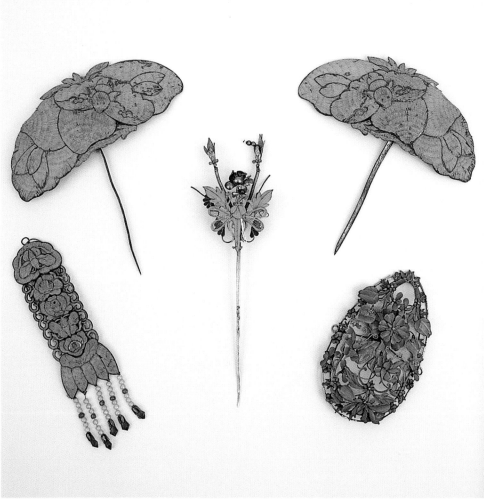

**Fig. 218**

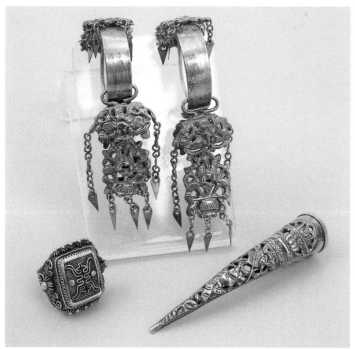

**Fig. 219**

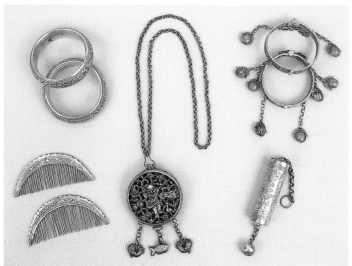

**Fig. 220**

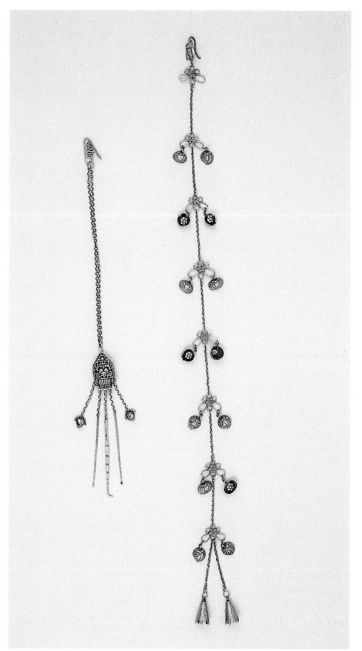

**Fig. 221**

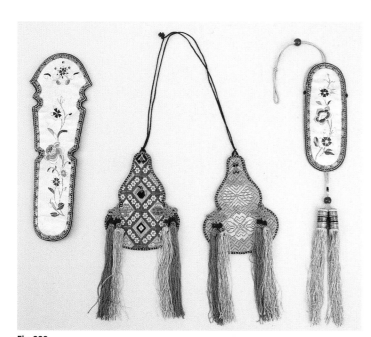

**Fig. 222**

**Fig. 219** Above: Pair of hooped silver earrings in the design of bats and flowers, ca. 1900. Left: Silver ring with the *shou* character for long life in the center. Right: Silver nail guard engraved with Daoist emblems.

**Fig. 220** Clockwise from top left: Pair of silver bracelets carved with designs of birds and flowers; silver pendant for holding potpourri, with an openwork design on the front of a laughing child, coins, bats, and flowers, and hanging charms of two cockerels flanking a fish; pair of silver anklets with hanging peach stone charms filled with bells; silver needle case decorated with figures in a procession of a successful graduate; two silver combs.

**Fig. 221** Left: Chatelaine in silver comprising an earpick, nail cleaner, toothpick, and two peach stone charms hung from a floral plaque. Right: Silver pendant with small bell charms.

**Fig. 222** Four women's purses made in Shanghai, early 20th c. Left and right: Matching fan case and spectacle case in cream silk with pink silk on the reverse, and edged with gold couching. Center: Pair of tobacco pouches made of voided satin stitch with a geometric design on one side and a floral one on the reverse, with decorative tassels at each side.

Unlike men, women did not wear a girdle around the waist, so purses were often hung from the top button of the *ao*. Both men and women smoked tobacco as it was thought to have medicinal properties. Gourd-shaped purses, often suspended from the stem of the pipe by a cord, were filled with tobacco, opening at one side only so that the long-stemmed pipe could be inserted (Fig. 222).

Rigid round or oval fans called *pien mien* had been popular since the Tang dynasty. They were made of bamboo or ivory with silk stretched across the frame and embroidered or painted. This type of fan continued to be carried through to the end of the nineteenth century (Fig. 217).

## Bound Feet

The Han Chinese tradition of binding women's feet to make the feet appear as small as a lotus bud was thought to have started between the end of the Tang dynasty and the beginning of the Song. Legend has it that a favorite consort of the emperor danced for him having bound her feet to represent a new moon. The style was quickly adopted by women at court, and gradually spread outside court circles until it was almost universal in China. Bound feet restricted women's movements and made them subservient to men. Further-

more, the smell and size of the small foot, together with the woman's teetering gait, produced erotic associations for men, and few mothers would risk their daughters being unable to marry if allowed to have natural feet.

The Manchu, on taking power, tried unsuccessfully to ban the custom, but most Chinese women continued to bow to pressure and bind their daughters' feet. It was not until the end of the nineteenth century that the practice started to decline. Various anti-footbinding societies were formed by Westerners to promote its demise. Mrs Archibald Little, the wife of a Yangtze River merchant and scholar, was a leading exponent of the Natural Feet Society and very active in the fight at the turn of the century to denounce footbinding. It was banned by the new Republic in 1912, and gradually died out, although there was resistance to having natural feet in much of the country for some decades after that.

Footbinding began at any time when the girl was between the ages of three and twelve. The feet were usually bound to a length of 5 inches (13 cm); the "3 inch (7 cm) lotus" was quite rare, and only for those women who had servants to support them while walking (Fig. 223). In some cases, a woman was carried on a servant's back. "The appearance of the deformed member when uncovered is shocking, crushed out of all proportion and beauty, and covered

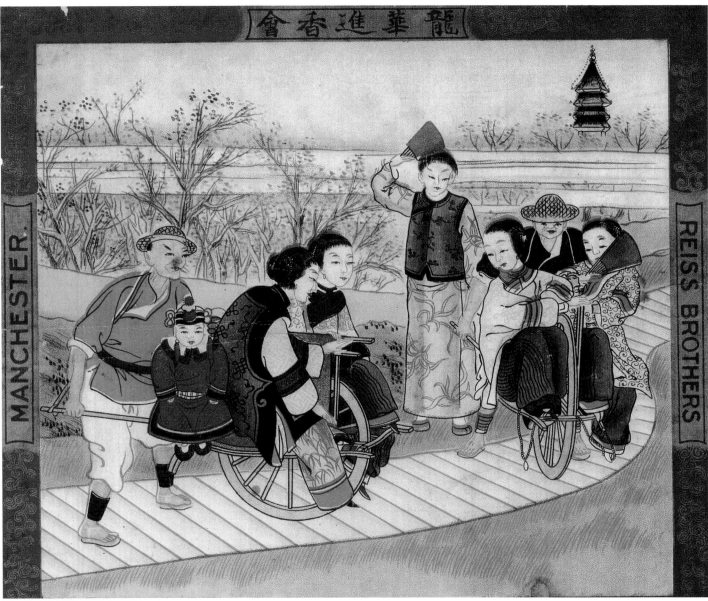

**Fig. 223**

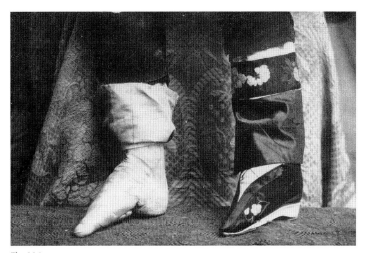

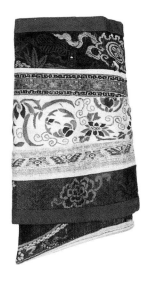

Fig. 224

with a wrinkled and lifeless skin like that of a washwoman's hands daily immersed in soapsuds" (Wells William, 1883; reprint 1966, Vol. 1: 768) (Fig. 224). A binding cloth about 4 inches (10 cm) wide and around 100 inches (250 cm) long, of woven silk or cotton, either natural or dyed indigo blue, was tightly wrapped around the foot, starting at the toes which were forced in towards the sole. The bandage was wrapped around the heel to further force the toes and heel in towards each other (Fig. 225).

The method of binding varied from region to region. Sometimes, a wet cloth was used so that as it dried it tightened to give greater support. At other times, a small block of wood was inserted under the heel for support and the bandages wrapped over. Following a visit to Shantou, a treaty port in Guangdong province, Mrs Little wrote that girls' feet were not bound until they were almost thirteen so they could do more work, at which time "the foot is already too much formed for it to be possible to do more than narrow it by binding all the toes but the big one underneath the foot. An abnormally high heel is however worn, and this gives to the foot,

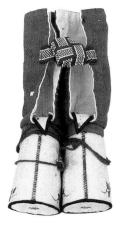

Fig. 226

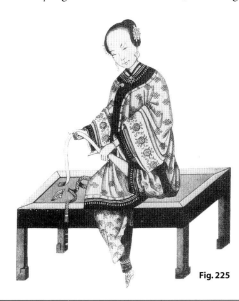

Fig. 225

---

**Fig. 223** Advertisement of manufacturer Reiss Brothers of Manchester, depicting a group going to a temple, the women with bound feet being pushed in Shanghai wheelbarrows.

**Fig. 224** Close-up of the bound feet of a woman showing one foot naked and the other in a shoe and ankle cover.

**Fig. 225** Painting of a lady in the process of binding her feet.

**Fig. 226** Boots are worn with ankle covers decorated with braid and embroidery. Top: Pair of boots with hidden inner heel supports (one shown center right), with attached ankle covers made of coarse blue cotton with metal stays (one shown center left). Bottom left: Rare pair of

unused supports, with the blue and white woven cotton tapes still tied together, from the Shantou region referred to by Mrs Little. Bottom right: Small pair of supports with yellow embroidered heels with attached heel tongues.

placed slanting upon it, the appearance of being short. There is often a little round hole at the tip of the shoe through which the great toe can be seen" (Little, 1902: 339–40).

As well as making the foot appear even smaller, raising the heel made walking easier. Supports for bound feet came in several guises. A woman could cheat by putting a support shaped like an embroidered cotton reel inside her boot. The heel of the foot was raised by placing it on the support, which was then secured with tapes around the lower leg. Boots with rigid ankle covers had metal stays inside to support the leg and conceal the bandages (Fig. 226).

As part of her dowry, a woman would make several pairs of shoes as proof of her needlework ability as well as her small feet (Figs. 227, 228). First, she would make the vamp of silk or cotton and embroider it. Then, she would make the heel and sole from densely layered and stitched white cotton. Finally, she would join the vamp to the sole. A heel tongue and loops at the sides enabled the shoes to be pulled onto the foot more easily. After her wedding, a bride gave each of her main female in-laws a pair of shoes at a special ceremony known as "dividing the shoes."

There were some regional differences in shoes. In general, those from the north, especially Beijing, had a "bow" shape – an exaggerated curved sole and heel in one piece – often with leather reinforcements at the toe and heel. In the late nineteenth century and early twentieth century, style-conscious women from Shanghai, then becoming the fashion capital of China, preferred a multiple heel, while those from the southern provinces, such as Guangdong, wore shoes often made of black cotton or silk, with a fairly flat heel (Fig. 229).

Some shoes had embroidered soles for wearing indoors, while those made for burial had soles embroidered in blue or white, the traditional colors of mourning.

Leggings or tube-like ankle covers were worn to cover the bandages used for binding the feet. Leggings were made of silk with an embroidered hem, which hung over the shoe. They were fastened with ties or puttees around the calf, and the under-trouser legs tucked inside the leggings (Figs. 230, 232). The tops of the socks were wide enough to be pulled over the foot, where they were held in place with ribbons. Bandages were changed after bathing, but the shoes and leggings or ankle covers were the last items of clothing to be removed inside the curtained bedchamber, the small feet and their smell being a strong aphrodisiac.

Not all women bound their feet. In southern China, especially in Guangdong, and in Hong Kong, women from the Hakka ethnic group had natural feet and wore normal sized shoes, like those women who had been persuaded to give up foot binding. "At Canton [Guangzhou] the women with natural feet wear what is called the boat shoe, being shaped like the bottom of a boat, on which they can balance backwards and forwards. Boatwomen and working women do not bind there, which has given the foreigner, who so often gets his idea of a Chinese city from Canton, the impression

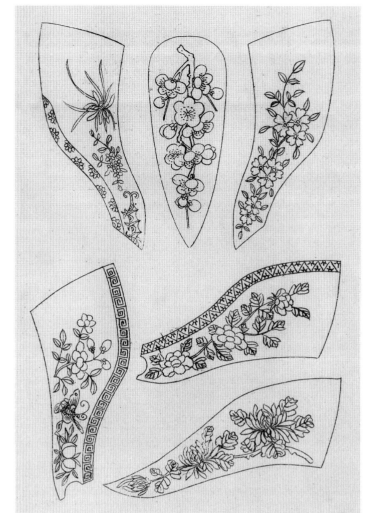

**Fig. 227**

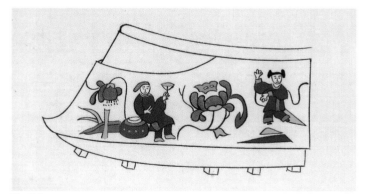

**Fig. 228**

that this is the case all through China. Alas! in the West [of China] women even track boats with bound, hoof-like feet, besides carrying water, whilst in the north the unfortunate working women do field work, often kneeling on the heavy clay soil, because they are incapable of standing…" (Little, 1902: 343) (Fig. 231).

**Fig. 227** Pattern designs for bound feet shoes from a woodblock printed pattern book, 3rd year of the Republic, 1914.

**Fig. 228** Pattern for bound feet shoes from a woodblock pattern book, showing a design of flowers and children playing. The metal cleats under the shoe are designed to raise and protect the silk embroidery from the dirt of the streets.

**Fig. 229** Left: Boots for the bedchamber in red silk embroidered with lotus flowers and bats, symbols of purity, fruitfulness, and happiness. Top center: Shanghai-style shoes with multiple heels, the red satin embroidered with satin stitch and couched gold thread, 4 inches (11 cm) from heel to toe, made for a bride on her wedding day. Below center: Shoes for the bedchamber in red satin, the color contrasting with the white of the limbs, with bells inside the heels to fuel erotic associations. Right: Flat shoes in pink satin, embroidered with butterflies and the phoenix, 7 inches (18 cm) from heel to toe, made for women who had had their feet bound too long for them to regain their natural size, early 20th c.

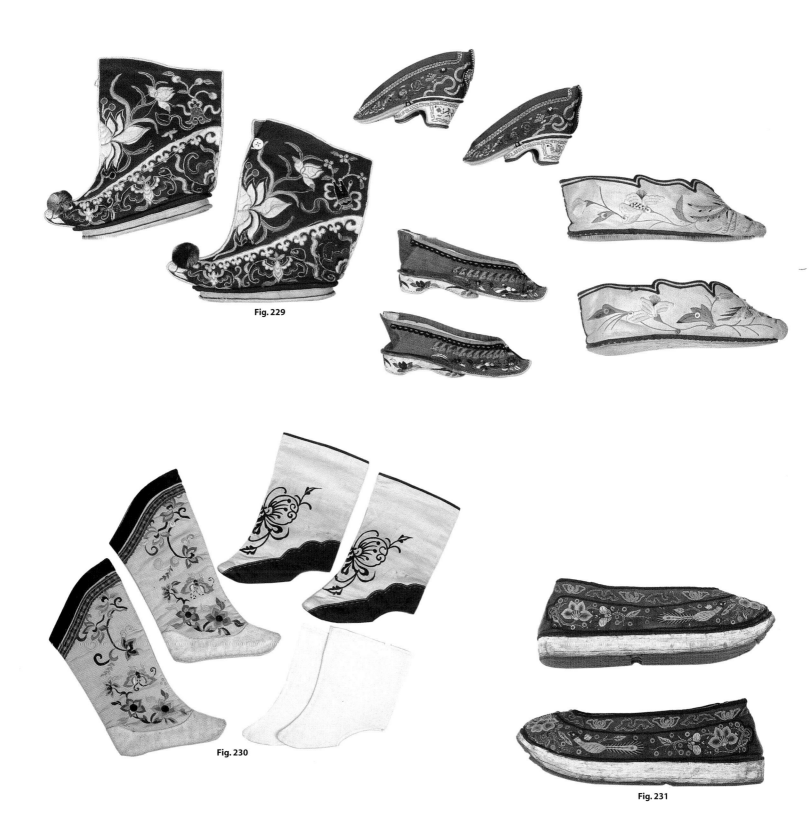

Fig. 229

Fig. 230

Fig. 231

**Fig. 230** Left: Pair of padded socks in peach silk, lined with cotton and embroidered with flowers and butterflies in the "three blues," with cotton soles and heels. Top right: Pair of socks in pale green silk embroidered with black, with deep blue soles and a cutaway heel. Bottom right: Pair of socks made of fine white cotton with cutaway heels. All are worn over binding cloths.

**Fig. 231** Boat-style shoes for natural feet, the vamp of purple silk embroidered in Peking knot with flowers and the phoenix, the sole made of several layers of paper, and the outer layer made of leather.

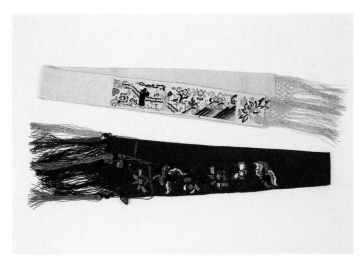

**Fig. 232**

## Wedding Attire for Men and Women

The marriage ceremony in China has always been of great significance. This was true, not only for the bride and groom, but also for their immediate families and for the community in which they lived. The union was seen as a means of maintaining good ties and of establishing a firm bond between another family or village. The marriage was always an arranged one, with a matchmaker being called upon to consult horoscopes in an effort to find a son a suitable mate, and it was likely that the couple had not seen each other before the actual wedding day. This custom still continues in some rural areas.

The ceremony was the subject of elaborate preparations. An auspicious day was chosen according to the Chinese almanac, and the question of dowry and other gifts settled. The day before the wedding, the bride would undergo the *kai mian* custom to give a more open-faced look (see page 103). Her hair was then styled in the manner of the married women of her class.

A custom in some areas entailed the bridegroom's family sending to the bride "a girdle, a headdress, a silken covering for the head and face, and several articles of ready made clothing, which are usually borrowed or rented for the occasion. These are to be worn by the bride on entering the bridal sedan to be carried to the home of her husband on the morning of her marriage" (Doolittle, 1895, Vol. 1: 72). Wearing a veil to conceal the bride's face is known to have taken place as early as the Song dynasty.

The number of clothes worn by the bride and groom was important and conformed to the *yin* and *yang* principle, with an even number (*yin*) of garments for the female and an odd number (*yang*) for the male. The wedding attire worn by the groom was based on Manchu official dress. If the man was an official, a center-opening surcoat with badges of rank fixed to front and back was worn over a dragon robe. A plain surcoat and long blue gown were worn if he was not. A red sash or two, symbols of a graduate of the civil service examinations, were draped over the shoulder and tied at the waist. A winter or summer hat was worn with the insignia showing his rank as a mandarin, if he had such status. Fixed at each side of the hat were the two gilt sprays of leaves, which were part of the graduation dress.

The bride would be dressed in a red embroidered dragon jacket or *mang ao* around which was a hooped belt (*jiao dai*). Not every bride wore the *mang ao*. Some who were less wealthy wore a plain red silk or cotton *ao* (Fig. 233), sometimes with a detachable

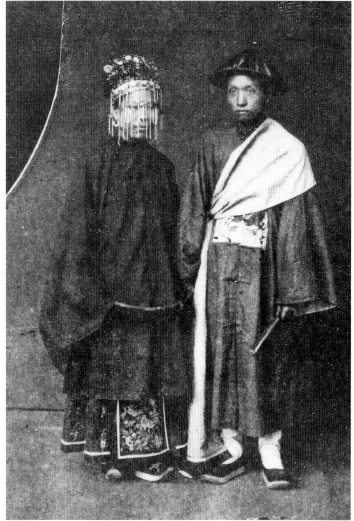

**Fig. 233**

four-pointed "cloud collar" (*yun jian*) to compensate for the plain neck of the *mang ao* (Fig. 234). The jacket was worn over a dragon skirt or *mang chu*, a pleated skirt with panels at the front and back decorated with dragons and phoenixes. The symbolism of dragon and phoenix, which represented the emperor and empress of China, was meant to emphasize the relationship between the imperial family and their subjects, and indicated the couple were "emperor and empress" for the day. The color of the skirt varied according to personal taste, although red or green were the most common. In order to raise the status of the skirt, it often had streamers attached to the pleated parts. In some instances, an over-skirt was worn, consisting of two elongated pointed embroidered panels at front and back, and loose streamers at the sides attached to a cotton waistband (Fig. 235). This ensured that the skirt itself could be worn on other, less important occasions after the wedding. If the couple were of sufficiently high rank, the bride wore a stole (*xia pei*) over this outfit. After the wedding day, this would be worn on formal occasions.

On the appointed day, the bride left her home in a richly decorated sedan chair, closed and hidden from view (Fig. 238). When the wedding procession arrived at the groom's home, he would knock on the door of the chair with his fan; the bride then stepped out and the groom raised the red veil over the bride's head (Fig. 237). Even so, her face remained obscured by her heavy decorative headdress, which had many strings of pearls covering her features (Fig. 236).

**Fig. 232** Above: Pair of puttees in tightly woven pale green silk with fringing at each end, and embroidered at one end with a design of flowers and figures in a garden. Below: Pair of puttees in red silk with blue embroidered flowers and butterflies, and bells and fringing at the ends.

**Fig. 233** Cantonese bride wearing a plain cotton *ao* with a rigid hooped belt and a "phoenix crown," the groom wearing a surcoat with rank badges and a red sash, ca. 1870.

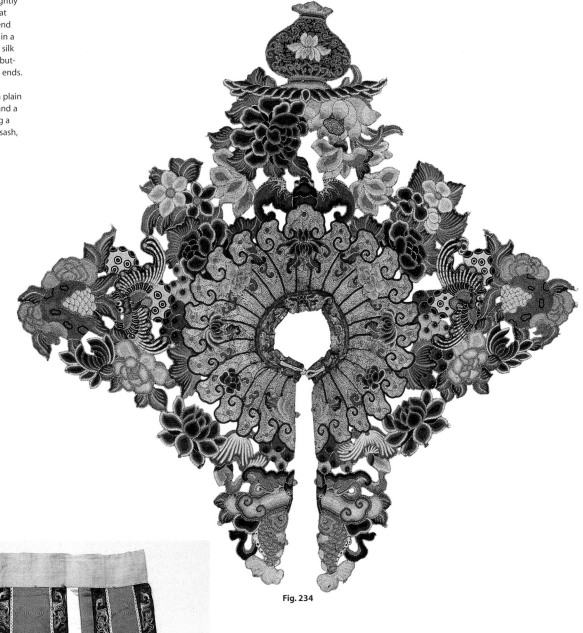

**Fig. 234**

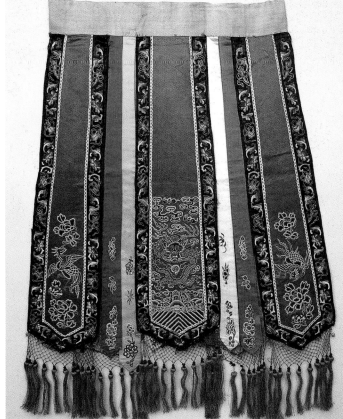

**Fig. 235**

**Fig. 234** Detachable wedding collar covered completely with Peking knot outlined with couched gold thread, ca. 1800. The design is of peonies in a vase at the center back, two fish at the center front opening, four bats around the neck, and pomegranates over each shoulder. The radiating lobes round the neck are all embroidered in couched gold thread.

**Fig. 235** Overskirt with red silk pointed panels, streamers and fringing, embroidered Peking knot phoenixes standing and descending, and dragons, mid-19th c.

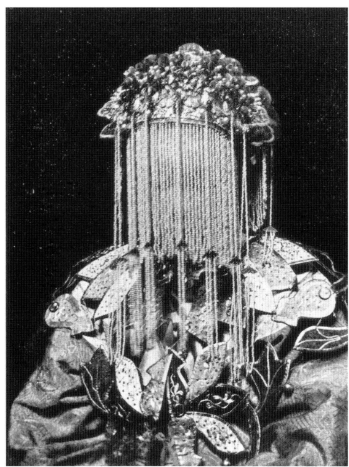

**Fig. 236**

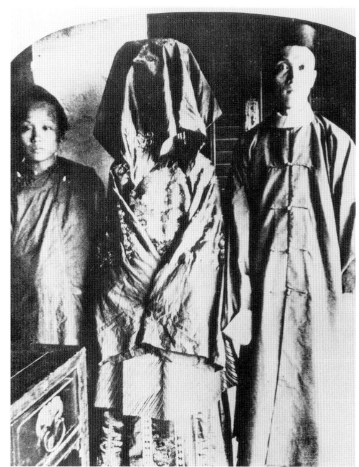

**Fig. 237**

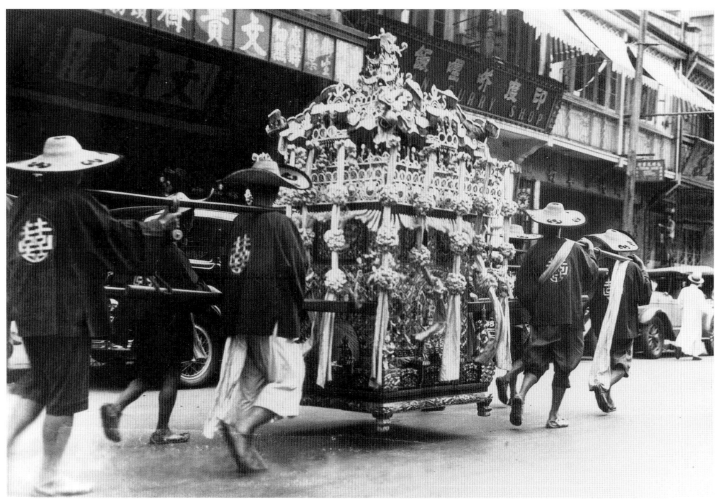

**Fig. 238**

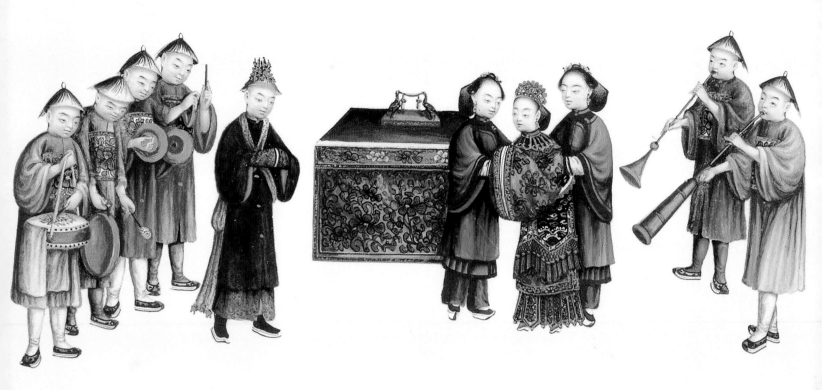

**Fig. 239**

After prostrating themselves before the altar, the couple was escorted to the bridal chamber. "The bride tries hard at this time to get a piece of her husband's gown under her when she sits down, for, if she does, it will ensure her having the upper hand of him, while he tries to prevent her and to do the same himself with her dress. The strings of pearls on her coronet are now drawn aside by the maids in attendance, in order that the bridegroom may have an opportunity of seeing the features of his bride" (Ball, 1900; reprint 1982: 370).

If at this point the groom was not happy with the appearance of his prospective bride, he was quite at liberty to send the girl back. However, if he was satisfied with her looks, the bride then kowtowed to her new in-laws and the pair offered them tea, thus establishing the bride as a member of the family (Fig. 239). Following a feast, friends and relatives made personal remarks at the bride's expense, often late into the night.

On the third day, the ancestors were worshipped again, and the couple paid a visit to the bride's parents. After this there was little communication between the bride and her family, as she was now considered to belong to her husband's family, and it was quite likely she would not see them again.

## Funeral Attire for Men and Women

The Qing court and wealthy families continued the Ming dynasty tradition of having lavish funeral processions, and of being buried in great finery with many treasures. Those men who had held a position of power and authority wished to arrive in the next world with ample proof of their status (Fig. 240).

Preparations for burial, particularly with regard to the outfit in which a person would be buried, would start when he or she reached their sixtieth birthday, the end of the natural cycle of twelve times five. (This was actually the sixty-first birthday according to the Western calendar, since the Chinese system of numbering years means a baby is one year old at the moment of birth.) Inevitably, elderly men's birthdays were celebrated more grandly than those of elderly women. The most splendid celebrations marked a new decade – the sixtieth, seventieth, and so on.

Burial clothing for the wealthy was either made to measure or purchased ready-made from specialist shops. There were certain superstitions attached to the choice of clothing. Brass buttons were never used for fastening as they would weight the body to the earth, and, in general, buttons were avoided as the Chinese phrase for

---

**Fig. 236** Bride wearing a jeweled head-dress, the numerous strings of pearls concealing her features, which were not parted until the last moment of the wedding ceremony. The coronet is decorated with artificial flowers, ca. 1900.

**Fig. 237** Bride, her head covered with a silk square, and groom, with a servant, 1905.

**Fig. 238** Bride being carried in an elaborately decorated wedding sedan chair, the bearers having the character for "double happiness" on the back of their jackets.

**Fig. 239** Painting by the Guangzhou artist Tinqua of a bride and groom during the tea ceremony, 1850s.

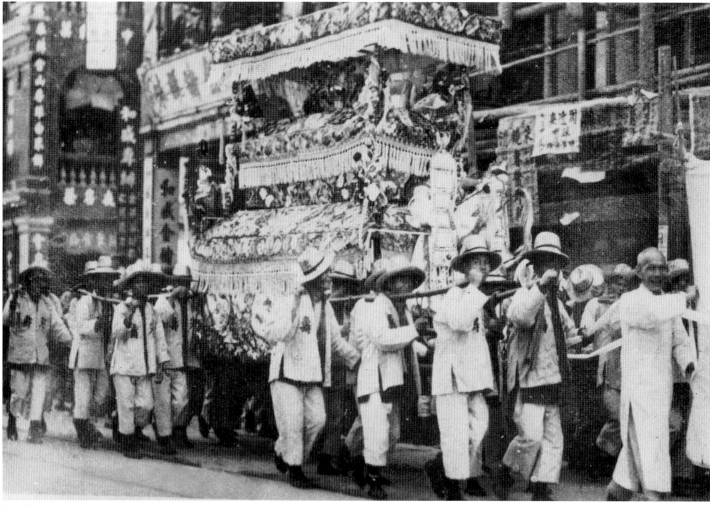

**Fig. 240**

buttoning a gown, *kou niu*, is similar to that meaning to detain somebody against their will. No fur was used on the clothing in case the deceased be reborn into the body of an animal. As it is considered more fortuitous, burial clothing is called *shou yi* (long-life garment) rather than a more literal expression.

The number of clothes worn for a burial was very important: "It is an established custom that, if three garments are put on the lower part of the person, five must be put on the upper part. The rule is that there must be two more upon the upper than upon the lower part of the corpse. Oftentimes there are nine upon the upper and seven upon the lower. Sometimes rich families provide as high as twenty-one pieces for the upper part of the corpse, and nineteen for the lower part" (Doolittle, 1895, Vol. 1: 175). For women, as a rule, there were six pieces on the upper part and four on the lower.

Next to the skin was a bleached cotton or ramie under-*shan* (upper garment fastening to the right) and under-*ku* (trousers), which would have been first worn for marriage, then put aside for burial. Two or three *shan* were placed over these garments, followed by the finest attire worn in life. High officials wore the *chao pao* court robe, lower ranks the *nei tao* long plain gown, as well as a surcoat, winter hat, and satin boots. Badges of rank were attached to the surcoat. Summer official dress was never worn, as winter apparel was considered to be more in keeping with death. Men without official rank wore the black *ma gua*, with the blue gown worn for ancestor worship or specially made for the occasion, plus a skullcap, shoes, and stockings.

For burial, the wives of mandarins were dressed in their bridal clothes, which had also been their official dress. These would consist of a *mang ao* dragon jacket, *mang chu* dragon skirt, *jiao dai* hooped belt, and *xia pei* stole. A phoenix crown was placed on the head and boots of red silk pulled over the bound feet. The deceased would also be adorned with many hairpins, rings, and bangles decorated with deer, tortoise, peach and crane – all symbols of longevity, good fortune and happiness.

Wealthy men without official rank were buried in a *shen yi* or "deep garment." This was made of deep blue silk, edged with a band of bright blue or white, and tied at the underarm. This large, enveloping garment with bell-shaped sleeves, similar to Ming robes, fastened over to the right or down the center front. It was worn with a long cowl hood and black satin boots.

A variation of the *shen yi* was the longevity jacket or *bai shou yi*, literally "one hundred longevity character garment" (Fig. 241). Made from deep blue or black silk edged with bright blue or white, it had *shou* longevity characters embroidered all over in gold, which were thought to have the power to extend the wearer's life. It either fastened over to the right like the "deep garment" or had a center front opening. It was only worn by the wealthy and was prepared in advance, sometimes being given to a parent by affectionate offspring. As most men with power and authority preferred to be buried in their official attire, longevity garments were usually presented to women. The longevity jacket was worn with a white pleated skirt edged in blue satin and decorated with many *shou* characters embroidered in blue (Fig. 242).

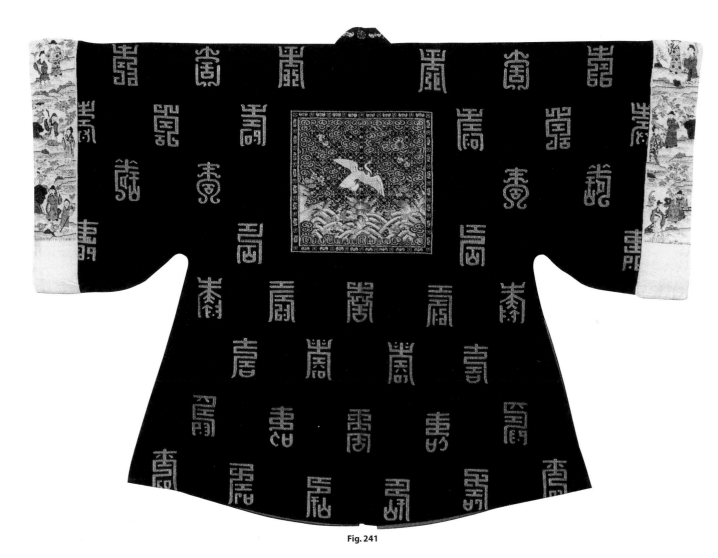

**Fig. 241**

There were five grades of mourning costume or *wu fu*. The first, and most important, was for parents or husband. A dress of undyed, unhemmed coarse hemp was worn with a headdress of hemp, grass sandals, and bamboo mourning staff. This grade of mourning lasted twenty-seven months. Wearing hemp in this unfinished state symbolized the greatest manifestation of poverty by the son, and represented the traditional idea of giving all one's possessions to the deceased to ensure a comfortable life in the next world. This sacrifice was also demonstrated by the dead person's rich finery. The second grade was for wife, grandparents, and great-grandparents, for whom the mourning period was one year. They were accorded a dress of undyed, hemmed coarse hemp, with a hemp headdress, shoes, and bamboo mourning staff. The third grade was for brothers, sisters, and other close relatives, and a dress of coarse hemp was worn during the nine months of mourning. A fourth grade, lasting for five months, was for aunts and uncles and consisted of a dress of medium coarse hemp. The final grade was for distant relatives and lasted for three months; here finished hemp was worn.

**Fig. 242**

**Fig. 240** Chinese catafalque being carried by professional mourners, early 20th c.

**Fig. 241** Back view of a longevity jacket (*bai shou yi*) for the wife of a first-rank mandarin, made in black satin with gold couched *shou* characters and embroidered sleeve bands, with a first-rank civil badge at the front and back, mid 19th c.

**Fig. 242** Longevity skirt in white satin with *shou* characters embroidered in blue, 19th c.

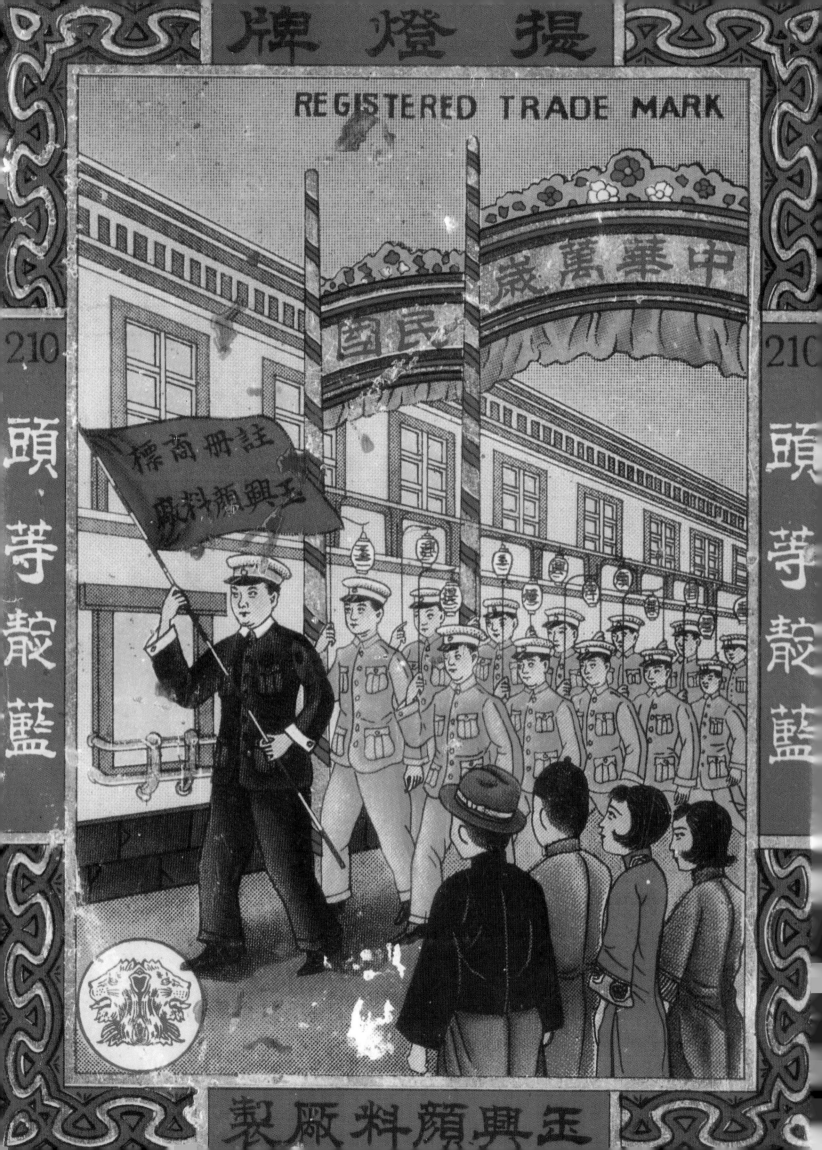

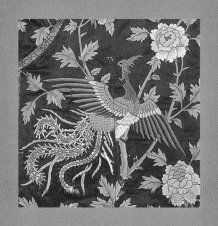

# Chapter Five

# REPUBLICAN DRESS
# 1912–1949

## The New Republic

By the early twentieth century, the Qing dynasty was crumbling, brought on by rebellions, economic disasters, and foreign imperialism. In 1911, the Revolutionary Alliance Party or *Tung Men Hui*, led by a Western-educated medical doctor more interested in politics than helping the sick, brought about the downfall of the Manchu government. The last emperor, the infant Puyi, abdicated in 1912, and Dr Sun Yatsen from Guangdong province became the first President of modern China. He held office for just six weeks before standing down in favor of a powerful northern general, Yuan Shikai, whose ambition was to continue the empire under his rule.

In 1914, as President of the Republic, Yuan Shikai revived an important ceremony, the Sacrifice at the Temple of Heaven, formerly carried out only by emperors, and proclaimed the beginning of a new dynasty. A robe and hat specially designed for him to wear

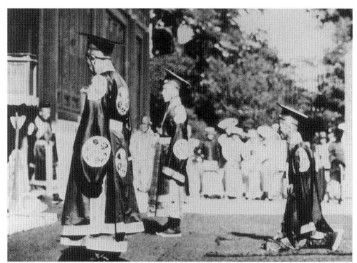

**Fig. 244**

**Fig. 245**

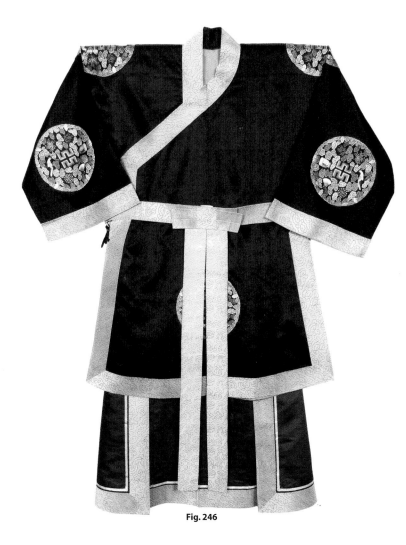

**Fig. 246**

---

**(Page 126) Fig. 243** Picture on a can of dye produced for a manufacturing company in Shanghai showing young men marching through the streets in the Zhongshan-style uniform.

**Fig. 244** Zhang Zuolin, a first-rank official in Yuan Shikai's government, wearing a

hat and black satin robe edged with brocade and modeled on the old Chinese ceremonial attire, the robe having nine roundels containing nine of the Twelve Symbols – one on each shoulder, two on the lower front skirt, one on each lower sleeve, two on the lower back skirt, and one on the upper back.

**Fig. 245** Third-rank official in Yuan Shikai's government wearing a robe with five roundels at the sacrificial ceremony at the Temple of Heaven in Beijing.

**Fig. 246** Gown of black satin edged with blue/gold brocade, tied under the arm and lower down at the side and with seven roundels with seven symbols, made

for a second-rank official. Worn over a purple satin gored skirt edged with blue/gold brocade and narrow gold braid. The skirt is composed of two parts, the wider for the back overlapping the narrower front section, and tied at the waist. Belt and sash/bow made of blue/gold brocade. Belt fastens with a heavy brass buckle and sash/bow hooks over the top.

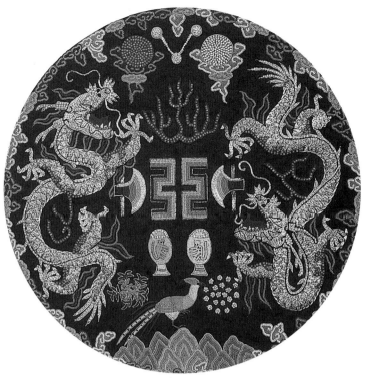

**Fig. 247**

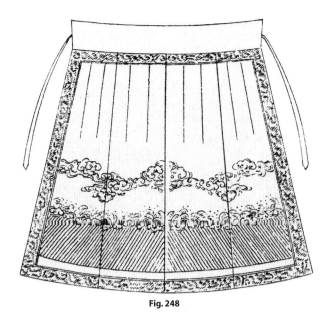

**Fig. 248**

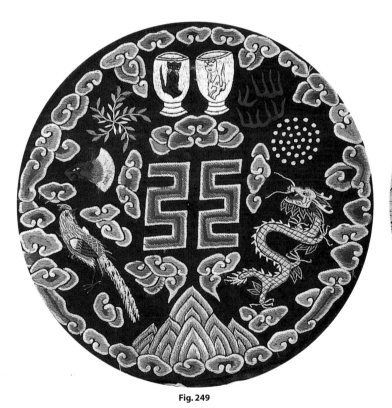

**Fig. 249**

**Fig. 250**

**Fig. 247** Roundel from a set of twelve, each containing all Twelve Imperial Symbols, made for President Yuan Shikai, 1914. Seed pearls form the constellation of three stars, the moon, millet, and edge of the gold dragons. Coral beads form the sun and flame motif. Other symbols – the axe, *fu*, cups, phoenix, waterweed, and mountain are embroidered in Peking knot.

**Fig. 248** Woodblock print from the Republican Regulations of the back apron skirt for the President, composed of four gored panels embroidered with clouds and *li shui* and edged with brocade; the separate front apron skirt has three panels. The apron skirt for first- to fourth-class officials was plain with a brocade border. The fifth-rank skirt was plain with edges outlined with a narrow braid.

**Fig. 249** Roundel in black satin made for a first-rank official with nine symbols. Roundels for officials in descending ranks had to be progressively less colorful, without the use of gold thread, which was only permitted on roundels for the President.

**Fig. 250** Roundel in black satin for a third-rank official containing five of the Twelve Symbols embroidered in blue and white. The robe would have had five roundels – one on each shoulder, one on each lower sleeve, and one in the center back.

at the Temple of Heaven were based on the regalia worn by the Han and Ming emperors at sacrificial ceremonies. The robe, made of black satin with a border of gold brocade, fastened over to the right, and was emblazoned with twelve roundels containing the full Twelve Imperial Symbols (Fig. 247).

Officials who participated in the ceremony also wore gowns of black satin but theirs were edged with bands of blue brocade. The laws laid down for Republican dress decreed that first-rank officials should wear nine roundels with nine symbols on their robes (Figs. 244, 249); second rank, seven roundels with seven symbols (Fig 246); third rank, five roundels with five symbols (Figs. 245, 250); fourth rank, three roundels with three symbols; the fifth, and lowest, rank wore a robe with neither border nor roundels.

The gown was worn over an apron skirt of purple satin edged with blue/gold brocade (Figs. 245, 246, 248). Around the waist was a belt of matching brocade with a separate bow and long ties. A flat hat made of black satin with couched gold thread embroidery completed the outfit. Some hats had strings of pearls that hung over the face similar to the hats of the earlier Chinese emperors.

## Formal Dress for Men

Yuan Shikai's reign was short-lived for he died in 1916. Dispute over the control of Beijing intensified, and another turbulent period in China's history followed. With the collapse of imperial rule, and after failed attempts to restore the monarchy, dragon robes and their attendant regalia were gradually phased out, although Puyi, the deposed Xuantong Emperor, continued to live in the northern section of the Forbidden City until November 1924.

After the establishment of the Republic in 1912, government ministers were required to wear Western-style dress. From the end

**Fig. 251**

of the nineteenth century, Western influences had begun to affect the clothing traditions of men involved in commerce and industry. Now, more and more foreign businesses entered the country and a mixture of Western and Chinese dress was common, especially in the main ports and cities. People began to travel and work overseas and their "home remittances" affected the lifestyle of those left behind, while many returning students adopted Western dress.

Regulations published in government gazettes laid down the correct official attire for both men and women (Figs. 252, 253). Women were expected to wear an embroidered Chinese-style

**Fig. 252**

**Fig. 253**

**Fig. 251** Dr Sun Yatsen and other luminaries wearing Western evening dress, discussing the formation of a provisional government in Shanghai, 1911.

**Fig. 252** Page from a woodblock printed book showing hats and clothes, 1913.

**Fig. 253** Pages from a compendium first published in 1920 showing a mixture of Chinese and Western clothes for men and

women prescribed as official dress in the early Republican era, Shanghai; reprinted 70th impression, 1929.

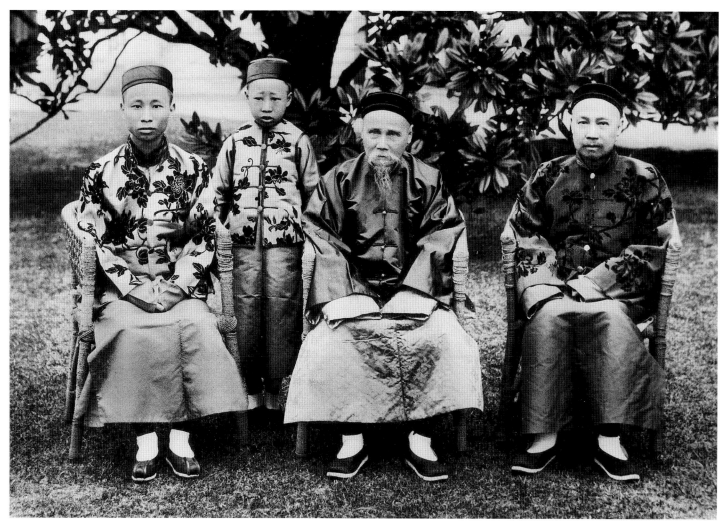

**Fig. 254**

jacket with a skirt based on the Qing style, but made in one piece, not two. For formal day wear, men had to wear a black jacket and trousers in the Western style with a bowler hat, and for evening, a Western-style dinner suit and top hat (Figs. 251, 252). At other times, a Western suit or a long, side-fastening Chinese gown with a hip-length jacket on top (*chang shan ma gua*) could be worn (Fig. 255). It was stipulated that the various forms of male and female dress were to be made from Chinese or "national," as opposed to foreign, materials. It is clear that despite its foreign origins and appearance, the new dress, designated for all ceremonial occasions, great and small, was to be utilized as an instrument of the newly re-established national pride in China, and of being Chinese.

The *chang shan ma gua* was worn with either a black skullcap or a Western-style felt trilby (Figs. 254, 256). Since the overthrow of the Manchu, Han Chinese men were no longer required to wear the queue, but many continued to shave their heads, often completely. To keep out the winter cold in the north, a black satin hat, lined with fur, was worn with earflaps and a back flap attached to

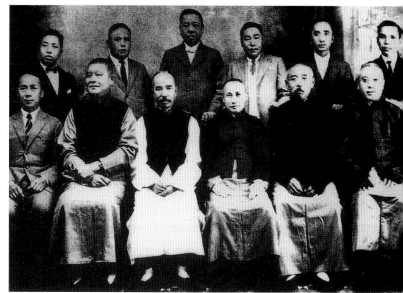

**Fig. 255**

**Fig. 254** Four generations of a merchant family, aged between thirteen and eighty-five. The men are wearing the *ma gua* hip-length jacket with the long gown, while the young boy wears a sleeveless *bei xin* waistcoat over his gown, 1913.

**Fig. 255** Staff of the Sincere department store which opened in Shanghai in 1917, some wearing Western dress, others Chinese dress.

**Fig. 256**

**Fig. 257**

the hat. Black cloth shoes, often made of felt, with thin leather soles, replaced the high black satin boots.

When the capital moved south to Nanjing in 1927, the traditional *ma gua* and *chang shan* were established as formal, official wear for men, and were worn for important ceremonial occasions such as weddings and when worshipping in temples and ancestral halls. When worn as formal wear with the *ma gua*, the long gown was usually blue, but when the gown alone was worn it could be gray, brown, or black. A stand-up collar replaced the narrow collar binding at the beginning of the twentieth century. For less formal occasions, a sleeveless center- or side-fastening waistcoat was worn over the gown.

By the mid-1930s, men in China's major cities had adopted many aspects of Western dress, including plus fours, patterned socks, knitted sweaters, and straw boaters (Figs. 257, 258). At the same time, although life went on as normal, defense forces began mustering as war loomed, with the Japanese occupying some parts of China. The Sino-Japanese War, which lasted from 1937 to 1945, brought about many changes in society, not least the way people dressed. Many more men wore Western suits and ties to work, while

a more traditional two-piece outfit of jacket and trousers was worn for informal occasions. The jacket was cut like the long gown, but without the inside flap on the right-hand side, and it opened down the center with seven buttons. Patch pockets were added to the front. The sleeves were cut longer and wider, and the cuffs of the under-garment were sometimes turned over the top jacket or coat. Detachable white cuffs turned back were worn for an added touch of elegance. The jacket and trousers were often made in matching silk or wool mixtures.

## The Sun Yatsen Suit

During the first half of the twentieth century, military uniforms also underwent great change, becoming more Westernized with elements from many nations. What later became China's national dress is credited to Dr Sun Yatsen, often referred to as the Father of Modern China. Sun Yatsen is reputed to have brought a Japanese student uniform to Rongchangxiang, a clothes shop on Nanjing Road in Shanghai, and asked the Western-trained tailor to design a suit based on the style, with a fitted jacket, closed stand-up collar,

**Fig. 256** Three men in a park wearing *chang shan ma gua*, two with trilby hats, one with a skullcap, 1920s.

**Fig. 257** The last emperor, Puyi, playing golf after giving up the throne. He is wearing a flat cap, plus fours, and a Fair Isle sweater.

**Fig. 258** Man in a Shanghai department store wearing a straw boater and Western suit and shirt.

**Fig. 259** Dr Sun Yatsen wearing the Zhongshan-style uniform, 1924.

**Fig. 260** Mao Zedong in a Zhongshan suit, later becoming known as the Mao suit, 1936.

**Fig. 261** In the late Qing and early Republican era, many young people studied abroad, and new schools and new Western-style student uniforms appeared.

Fig. 258

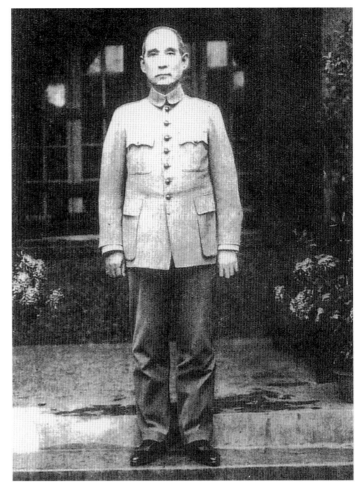

Fig. 259

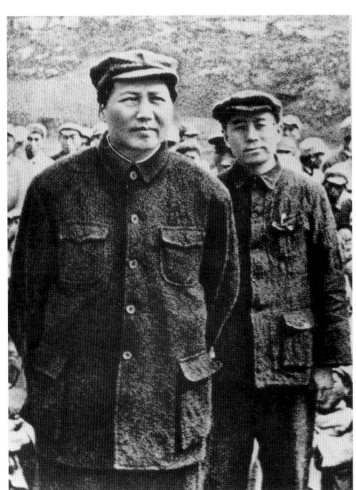

Fig. 260

Fig. 261

and center front opening (Fig. 259). It became known as the Yatsen suit, or *Zhongshan zhuang*, Zhongshan being the county of his birth in Guangdong province. Another school of thought believes it was based on existing Chinese student uniforms in Hong Kong, which were "very similar to that worn by British soldiers…. It was but a short step from the high collared tunic with breast pockets worn by these Hong Kong students to the Sun Yatsen suit of the Republic…" (Scott, 1958: 65–6).

The new Republic adopted the Yatsen style for its officers, worn with a hard flat peaked cap and trousers pushed into knee-high boots. In the early 1920s, the outfit was redesigned with a high turn-down collar, four gusseted patch pockets on the front of the jacket, and a fastening of five or seven buttons (Fig. 261; see also Fig. 243). The four pockets were said to symbolize the Four Cardinal Principles of conduct cited in the *Book of Changes*: propriety, justice, honesty, and a sense of shame. The fitted jacket, which demanded an erect posture, was in deliberate contrast to the flowing, loose, and slightly effeminate gowns of earlier times.

After Sun Yatsen died from cancer in 1925, Chiang Kaishek became commander-in-chief of the Nationalist armies of the Guomindang. The Guomindang established itself as the Nationalist government in 1928, and the following year stipulated that the Sun Yatsen suit be official dress for civil servants. The leader of the opposing Communist Party, Mao Zedong, had founded the Red Army to fight against the Nationalist government in August 1927. Mao Zedong adopted the modified Sun Yatsen suit, and soldiers and officers of the Red Army wore the suit as military attire. This later became known as the Mao suit (Fig. 260). Communist sympathizers also adopted the style, including many women, such as Jiang Qing who married Mao in 1939, and American secret agent and foreign correspondent Agnes Smedley. Wearing it was seen as an anti-fashion statement at a time when the popular and curvaceous cheongsam accentuated a woman's figure.

## Women's Dress 1912–1925

The atmosphere of change in the late Qing period and the formation of the Republic in 1912 brought about wide-sweeping reforms for women, including women's clothing. Footbinding was legally abolished, and girls were granted a formal place in the educational system, with some daughters from wealthy families being sent overseas to study.

A number of educated women, especially those in major cities like Shanghai and Guangzhou, adopted Western fashions, a trend which had begun at the end of the nineteenth century when a number of Chinese women in the public eye started wearing Western dress. These women may have been influenced by missionaries or by other Western women with whom they came into contact, or even by foreign magazines and newspapers, which were increasingly available. But the tightly corseted dresses, large hats, gloves, and

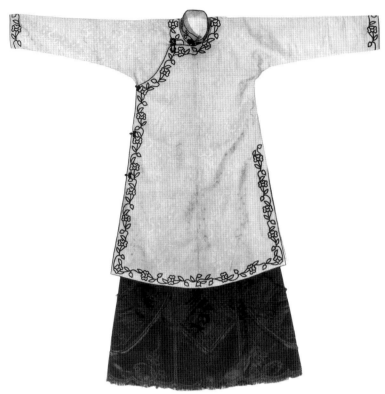

**Fig. 262**

**Fig. 263**

**Fig. 262** Pale green silk *ao* with appliquéd black piping decoration around the edges, and a black satin skirt with elaborate fringing and piping decoration, ca. 1915.

**Fig. 263** Gray damask silk skirt with appliquéd motifs and braid decoration, 1915–20.

**Fig. 264** Shanghai "sing-song" girls wearing headbands and the fashionable, exaggeratedly high collars on the *ao*, ca. 1915.

**Fig. 265** Chinese lady wearing Edwardian-style dress and hat, 1909.

**Fig. 266** Woman in a high-collared sleeveless tunic over a blouse and paneled skirt, ca. 1915.

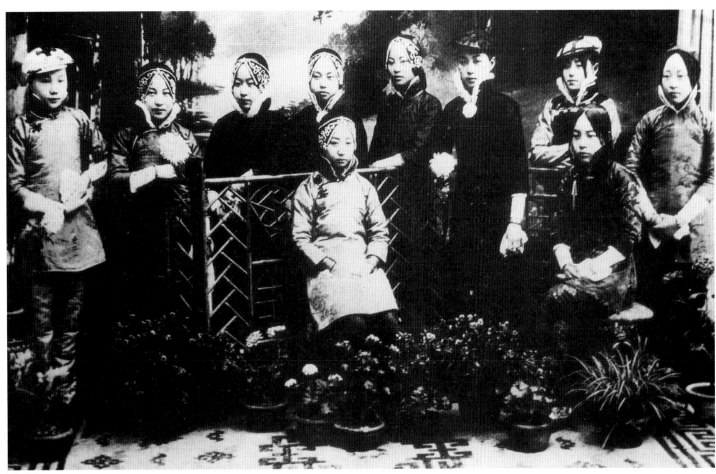

**Fig. 264**

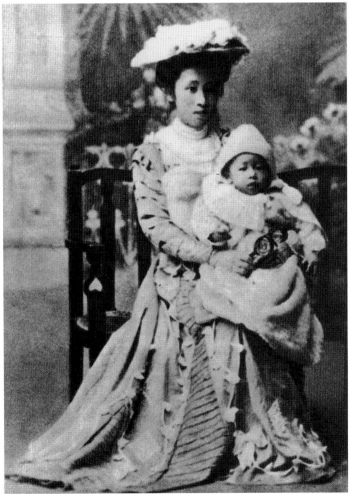

**Fig. 265**

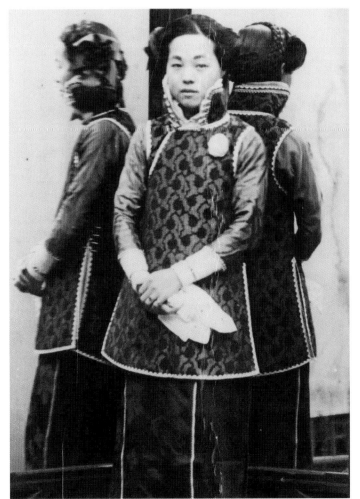

**Fig. 266**

parasols of the Edwardian era looked costume-like on the diminutive Chinese figure, and the trend was short-lived (Fig. 265).

With growing emancipation for middle- and upper-class women, accelerated by the May Fourth Movement in 1919, the bulky robes worn in the past were discarded, being considered outdated and cumbersome. Gradually, a style of dress evolved which was more in keeping with the current way of life yet which continued to maintain the Chinese style. The *ao* upper garment became slimmer and longer, reaching to below the knee; the sleeves narrowed to the wrists; the side slits were shortened, reaching to the lower hip, and all the edges of the *ao* were trimmed with narrow braid instead of the wide bands of embroidery popular in the past (Fig. 262). The collar became as high as it would ever be, with the corners sometimes turned down. Some exaggerated collars reached up to the ears to meet the wide headband, thereby accentuating the wearer's oval face (Figs. 264, 266).

The *ao* was worn over an ankle-length skirt, usually black, which had now become a one-piece garment with panels at front and back attached to pleats or godets at the sides (Figs. 262, 263). Unmarried women who wore the *ao*, donned trousers that were narrower and made in softer colors, often pastels, and usually both garments forming a matching set (Fig. 269).

By the early 1920s, the upper garment had become more fitted and shorter, extending only to the top of the hip, and with a rounded hem. Sleeves became three-quarter length, although very fashionable women preferred wide rounded cuffs, and the collar was reduced to a more comfortable width (Figs. 267, 268, 270–272). With the shortening of the upper garment at the beginning of the 1920s, the skirt became plainer and hem lengths rose gradually. The skirt was now cut in a simple flared style, very often of black silk damask, and worn by both married and unmarried women (Fig. 274). By this time, the wide waistband had been replaced by a narrow band through which a cord or elastic was threaded (Fig. 273). Cloaks were worn with evening dress, a fashion also popular in the West at this time (Figs. 277–280).

In the home, the austere, formal Chinese interiors of a generation earlier were replaced by drawing rooms filled with comfortable European-style upholstered furniture (Fig. 276). Labor-saving devices and servants who were still available meant that wives of wealthy businessmen had more time for new outdoor pursuits such as golf, horse-riding, and driving a car, as well as old favorites like mahjong. Some women studied to become teachers and nurses, or took up employment as secretaries, telephone operators, or waitresses as these service industries developed.

A move away from embroidered clothing to patterned materials like woven jacquards meant those women with more leisure time could enjoy embroidering for its own sake. Previously, woodcut pattern books or paper cuts were used as templates for design. Now, many Shanghai companies produced series of embroidery design books for women to copy (Figs. 275, 281).

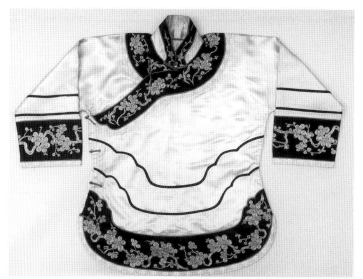

**Fig. 267**

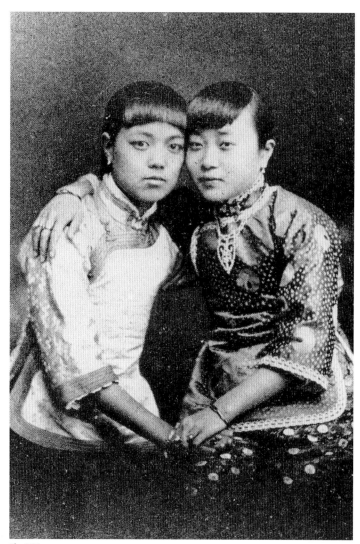

**Fig. 268**

**Fig. 267** Pale green satin *ao* with wide black satin bands embroidered with couched gold plum blossom, Shanghai, 1920s.

**Fig. 268** "Sing-song girls" of Hangzhou wearing the short *ao* with rounded hem and skirt, 1922.

**Fig. 269** Studio photograph of a girl wearing an *ao* and matching trousers.

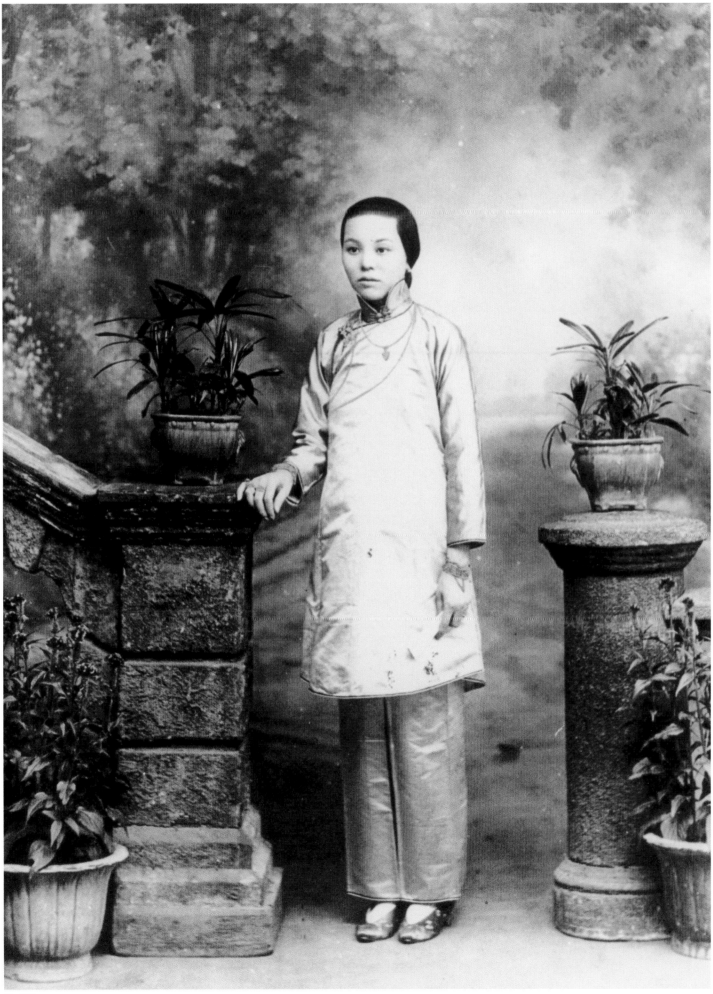

**Fig. 269**

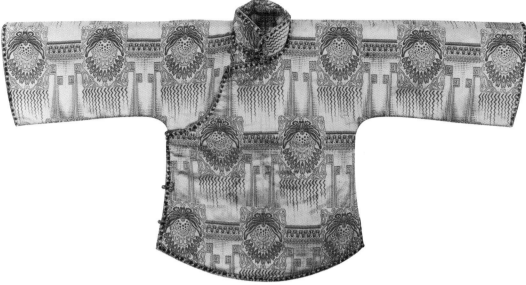

**Fig. 270**

**Fig. 270** Pink and cream patterned silk jacquard *ao* edged with sequins, Shanghai, 1920s.

**Fig. 271** Rust red, brown, and cream patterned silk jacquard *ao* lined with Mongolian lamb, Shanghai, 1920s.

**Fig. 272** Lilac patterned silk jacquard *ao* edged with sequined braid, 1920s.

**Fig. 273** Matching cream silk *ao* and skirt embroidered with floral sprays, the hem edged with sequins and beads, and with an elastic tunnel waist, Shanghai, 1920s.

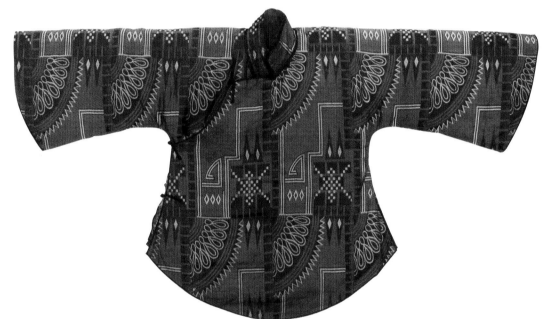

**Fig. 271**

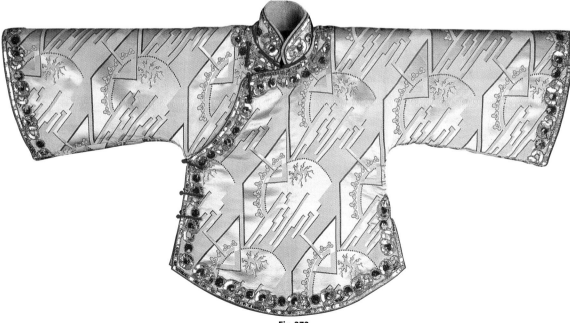

**Fig. 272**

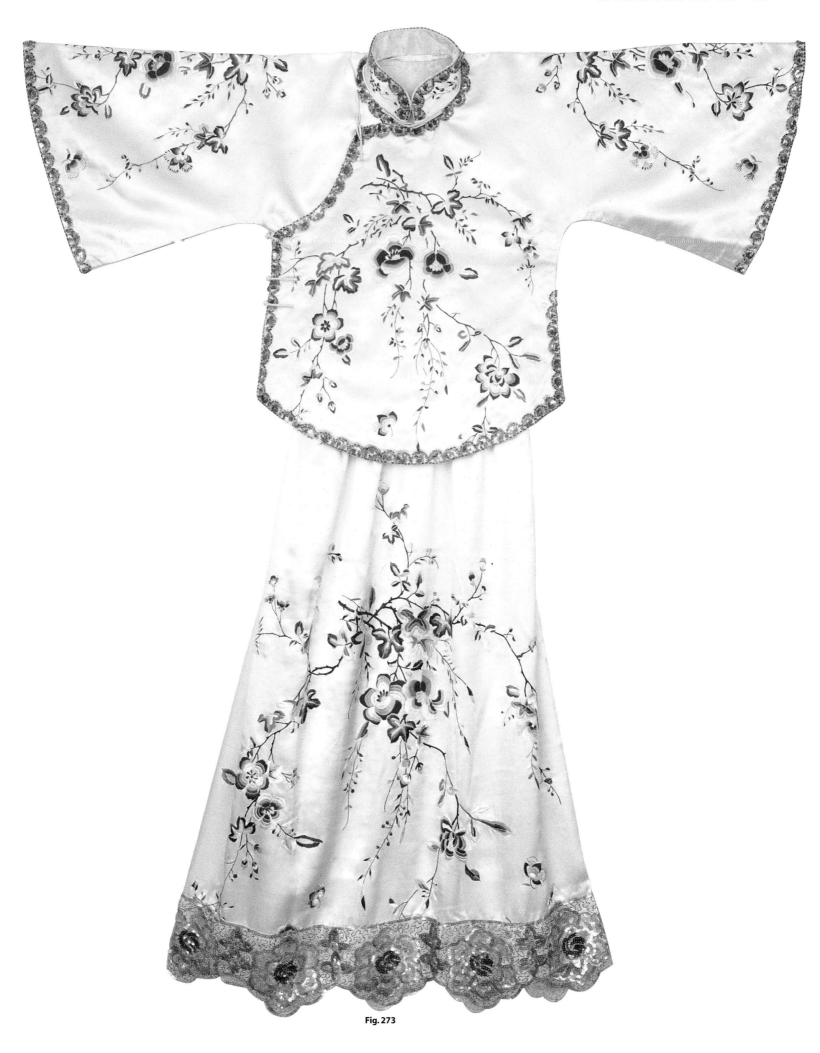

**Fig. 273**